A Century of Artists' Letters

A Century of Artists' Letters

Notes to Family, Friends, and Dealers
Delacroix to Léger

Jacqueline Albert Simon and Lucy D. Rosenfeld

From the Pierre F. Simon Collection at the New York Public Library

4880 Lower Valley Road, Atglen, PA 19310 USA

Front Cover: Letter from Paul Signac to a doctor in 1923. See page 77.

Back Cover: Photoportrait of Henri Matisse by Brossai. Private collection.

Library of Congress Cataloging-in-Publication Data

Simon, Jacqueline Albert.
 A century of artists' letters : notes to family, friends, & dealers : Delacroix to Léger / by Jacqueline Albert Simon and Lucy D. Rosenfeld.
 p. cm.
 ISBN 0-7643-1934-5
1. Artists--France--Correspondence. 2. Art, French--19th century--Sources. 3. Art, French--20th century--Sources. I. Rosenfeld, Lucy D., 1939-II. Title.
N6847 .S6 2004
709'.2'244--dc22
 2003016029

Copyright © 2004 by Jacqueline Albert Simon
 and Lucy D. Rosenfeld

Designed by Ellen J. (Sue) Taltoan
Type set in Bernhard Modern BT/Aldine 721

ISBN: 0-7643-1934-5
Printed in China

Published by Schiffer Publishing Ltd.
4880 Lower Valley Road
Atglen, PA 19310
Phone: (610) 593-1777; Fax: (610) 593-2002
E-mail: Info@schifferbooks.com
For the largest selection of fine reference books on this and related subjects, please visit our web site catalog at
www.schifferbooks.com
We are always looking for people to write books on new and related subjects. If you have an idea for a book, please contact us at the above address.

This book may be purchased from the publisher.
Include $3.95 for shipping. Please try your bookstore first.
You may write for a free catalog.

In Europe, Schiffer books are distributed by
Bushwood Books
6 Marksbury Ave. Kew Gardens
Surrey TW9 4JF England
Phone: 44 (0)20 8392-8585; Fax: 44 (0)20 8392-9876
E-mail: infor@bushwoodbooks.com
Free postage in the UK. Europe: air mail at cost.
Please try your bookstore first.

for
P. F. S.

Acknowledgments

Ideas are the beginning, and in thanking so many people for their enthusiastic support, I must point out that there could not have been this book had there not been a collector and a collection, thus first, my indebtedness to Pierre Simon's sensitivity and integrity as he developed the collection on which the book is based. For reasons I've discussed in the introduction, David Shulson's expertise and encouragement made my belief in the possibility of making the book a reality. I'm so grateful for our phone conversations over many months, and his consistent prodding to hold me to the concept, and my ideas. Lucy Rosenfeld, my co-author has the capacity to overcome any and all blips and the skill to do so. My thanks to her is for her know-how and her generosity in sharing it with me, and handling the research and writing with undaunted enterprise. The long-term interest of Paul LeClerc, President of the New York Public Library, encouraged me to appreciate the archival value of the collection, and to believe firmly that its ultimate home could be only at the Library.

At the Library, H. George Fletcher, Director, Brooke Russell Astor for Special Collections; and Robert Rainwater, Curator, Spencer Collection, Miriam and Ira D. Wallach Chief Librarian of Art, Prints and Photographs; as well as Mimi Bowling, who has since moved on from the Library, were always enthusiastic and generous with support and suggestions, and always there when I needed advice.

At Art Resource, Eileen Doyle has been diligent and knowledgeable in her efforts to find pictures and transparencies for us, and particularly agreeable and cooperative, even in eleventh-hour crises. Not only did I follow the trail of pictures and transparencies to Paris, I was lucky enought to be helped by Beate Marie Bang, in the Photograph Department the Nasjonal Galleriet in Oslo, and Anne-Marie Bergeret, Chief Conservateur at the Museum Eugène Boudin in Honfleur. At the Rodin Museum, Jérôme Manoukian and Anne-Marie Chabot, in the Photograph Section, uncovered the sketches of the façade of Notre Dame we wanted.

In New York, my dear friend Gertje Utley translated the letter of Paul Klee from the German, with the precision evidenced in her monumental book on Picasso. Hélène Potter managed the early transcriptions and translations with dazzling speed and good will, and because of that, I could move on to the next level, now inside the code of difficult and diverse foreign handwriting. I am grateful to Françoise Gramet, Assistant Director at The Institute of French Studies (where I am a research fellow), who volunteered to read and verify the transcriptions of the letters once they were set in galleys. She managed this tedious and unforgiving task with unerring precision. Sheila Kurtz, President of the Graphology Consulting Group, worked through all the letters, without looking at the text in either language, but only the handwriting. We were often astonished by her observations, particularly because of her resistance as a handwriting analyst, to information on the texts and their authors. Her good will and cooperation added to my pleasure in her results.

Now on a familial level, our families deserve more than gratitude for just being there. David Shulson's daughter, Caren (age fourteen), gave up her Saturday out-of-school to studiously take notes that first day we went through all the letters. She was accurate and cheerful and interested and I'm grateful. Marina Rosenfeld managed to combine our two manuscripts into one, in both languages. On her own, she copy edited and pointed out discrepancies, ques-

tions, etc. My daughter, Lisette Jacobs, was as efficient and skilled an organizer as anyone could wish for. Whenever chaos loomed, Lizi came by, surveyed the scene, and astutely reorganized and moved things ahead with her habitual attention to detail and cool good will. As always, I'm in her debt and happy to be. My teenage granddaughters, Alexia and Caroline, offered suggestions, unsolicited but often useful and to the point. Caroline has been my most faithful supporter and serious reader, tactfully pointing to errors of repetition, and grammar, and my competent computer tutor, as needed. Hélène Potter's son Frédéric, took over with his mother's skill and speed, when I added more letters and Hélène was not free to handle them. Lucy and I are grateful to Jerrold Siegel, William R. Kenan, Jr., Professor of History at New York University, for his insight in getting us together originally. I reserve for last my eternal thanks to Lindsay Krasnoff, who had just completed a Master's Degree at the Institute of French Studies and showed up to do a 'bit of typing in French.' She has been a joy to work with for months, as we laboured together on honing and refining the manuscript, and was never resentful that yesterday's effort was today's delete. She remained cheerful and unruffled in spite of my compulsive rewriting and editing, and now that she's back to academia to add a Ph.D. to her training, I have no doubt she'll find it less difficult than that 'bit of typing.' One necessary word to thank my many friends who listened to me, encouraged me, supported my banal complaining, and only rarely pointed out to me the obvious, that I was so fortunate to be engaged in this personal and rewarding project.

J.A.S.

Contents

Introduction

Now that the manuscript is complete, and the art and the photographs of the artists properly placed, I must introduce the reader to the book. There is a story behind every project and perhaps you will enjoy this one, as I have.

The letters in this book have been selected from a larger group, now in the archives of the New York Public Library, that had been collected over twenty five years by my husband. Pierre was surely among the luckiest of men, for he always knew what would be important to him thirty seconds before the event. Curiosity, intuition, and instinct guided him and were his way of life, with his work, with people, with the world he created for himself. One Saturday in Paris in 1968, he was using a free afternoon to look around on the Left Bank— long considered an ongoing treasure cache for art, antiques, books and more by Parisians as well as visitors—and noticed a rather small shop of an auto- graph dealer. Curious about the metier itself, he chatted with the owner about finding letters, and who might buy them. Over time, Pierre and I, too, have discovered that autograph dealers are people who love their work and all its arcana, and are happy to share details with others. More interested in artists than the rest, Pierre asked to look at catalogues, knowing, he told me later, he would find something important to him.

And so he did: a letter from Claude Monet to Emile Bernard, asking the latter if he knew of other painters afflicted with cataracts, and who had diffi- culties distinguishing colors. At the date this letter was written (1923) Monet had had at least two not entirely successful cataract operations. (See the chap- ter on Monet). Deeply moved by such a plight for an artist, Pierre bought the letter and understood that he was at the beginning of a quest for letters that would bring him closer to painters he admired, and in the personal way he wanted to know them. He continued this intriguing search as he travelled in Paris, London, even in Berlin (where he found Paul Klee's letter), and in New York and Boston for the letters he wanted to see, read, and study in detail; not only for their content, but for handwriting, signature, even the kind of paper on which they were written.

Often, he came home from galleries or museums and went directly to his letters, looking at dates to find connections with something he had just seen. The letters were kept in large book folders he had designed, and often, early mornings and evenings at home, he looked at the letters and perused art books to make discoveries, all of which he would tell me about, totally engaged. With the exceptions of Paul Klee (in German) and Mary Cassatt (in English), the letters are in French and written by French artists, or those who chose to live and work in France. It became easy for Pierre to read what are absolutely illeg- ible 19th century handwritings, and the reader will see just how illegible, as he looks with relief at the accompanying transcriptions.

Actually, I had not really understood the full measure of the collection. I've not the instinct of a collector, nor am I especially acquisitive, and though Pierre's enthusiasm was contagious and I went often with him to autograph dealers and auctions, I shared only his pleasure, not the intellectual depth of his interest. To my delight, working with the letters so intensely has made all that clear to me and has been a window to a number of revelations and differ- ent visions. Collecting, when it becomes a dedicated search, with the research

and knowledge it requires, is an absorbing and enriching personal experience. Perhaps I may not know that experience, but I'm grateful to have explored it, from a distance.

When I realized the letters were to find their ultimate home at the New York Public Library, I knew that the book I had so often urged Pierre to write was now mine to do while they were still in their discrete folders in the library at home. My own professional life is distant from this project, but enough related for me to know I was to become involved in a vast learning exercise, with the particular excitement it generates. The structure of the book had been in my thoughts for so long. I wanted especially for it to be accessible and to bring what I could to the reader, something of Pierre's profound pleasure in his letters and a particular rationale for building a collection.

Through a series of conversations and phone calls with knowledgeable people in the field, I was led to David Shulson, an autograph dealer in New York who, I was told, was an authority on both letters and collections. I called, and we made an appointment for him to come by to look over the letters, and perhaps to help me to organize the contents of the book. When David arrived, he said, "I know some of this collection. I worked with Pierre over the years, and in fact I've already been here to your home." We spent hours that Saturday, looking at each letter and finally he said, "I know now what Pierre was doing. Sometimes I couldn't understand why he wanted a certain letter or why he had bought one. There's a thread through all of this, and it's your husband's humanity. He was trying to find something of the artist himself." He went on. "The letters for the most part reveal feelings, even character, sometimes joy but mainly problems, with money, frustration, health worries, dealers. Pierre wasn't looking for a signature or a formal note. He was trying to know the man or woman whose work he admired." Together, that day, we selected letters from forty artists I've included here, realizing that they cover more than a century, and that many tell similar stories over those 100 years. More than a few times, there are two letters from an artist, because the second one seemed to resonate with the first. What surprised me is how little reference there is to the outside world, and yet that is the way with most of us, trying to contain our families, our work, our lives, living our own "dailiness" as best we can. The Franco-Prussian War happened, the Paris Commune, the Third Republic, the Dreyfus Affair, the First and Second World Wars, but all went unmentioned except, occasionally, as a minor inconvenience or event.

Inside that world, I enjoyed so much learning who was friends with whom, and their collegiality. I anguished with them over their misgivings, their money worries, their health, shared their triumphs, and was amused by the letters that were furious about a critic, and even the occasional carping about another painter. In searching for art works to accompany each letter, it was delightful to discover how often these artists painted each other, though not quite as often they apparently appreciated painting themselves.

Again, one conversation after another with 'art people' led me to an art writer. I had only to speak with Lucy Rosenfeld for less than five minutes to know she was so professional and so well qualified to uncover the mysteries in many of the letters and to find the artist's place in the narrative of art history, that I was afraid she wouldn't do it. Lucy liked what she saw that morning and it soon became clear that Lucy's role was as my co-author. We worked separately, noting and discussing progress by telephone, and met infrequently when our shared knowledge was needed.

Now, in the twenty-first century when communication has become so much an affair of keyboards and technology, digitalized and power operated, I've come to believe that it's particularly interesting to look at handwritten letters, and sense the pulse and vibrancy they generate, each one a reflection of the writer.

Occasionally, I have included some correspondence between my husband and someone else, generally an art historian or a museum curator, which I thought might be of interest to a reader of the letters.

In the transcriptions of the letters in this book, I have left errors of spelling, grammar, punctuation, and particularly the absence of accents, so that they remain faithful to the originals. In the translations, I have remained only minimally free, to guard the writers' idiosyncratic French as a first or second language.

Some may question my desire to include graphology, an analysis of each artist's handwriting, and my satisfaction with the result. I had no wish to prove anything, or to show artistic or any other kind of temperament. D.H. Lawrence said, memorably, "Never trust the artist. Trust the tale," and I am one to agree generally with that, but Pierre was looking to know the artist, and that's what the book is about. Almost everyone with whom I discussed this found the concept of looking at the handwritings intriguing, including, happily, our publisher and editor. The idea that handwriting is related to personality dates back to the Greeks and the Romans, but the modern origins of graphology can be traced to a Frenchman, Jean Hyppolite Michon, who coined the term and the empiric technique, in 1875. Should anyone think he has looked through a glass and discovered something he rather thought he knew or had read about a particular painter, or should a working biographer wish to pursue another aspect of his subject's character, then graphology will have earned its place in the book.

It may interest readers to know that it's only in recent years when life is so fast and chaotic, that French companies no longer formally insist on a handwriting analysis before they sign on even a middle level employee, though that is still often asked for, and the tradition is firm. The French in fact are all amateur graphologists. They look very seriously at handwriting and signatures, the latter of which they've developed into a delightful and usually highly unreadable art form. However, most artists want their signatures or initials to be quite clear, a reasonable deviation from the national idiosyncracy.

In 1973, when the collection was still small, Agnes Mongan, the esteemed art historian and curator, had heard about it and came to New York to look through it. At dinner, she suggested the idea of an exhibit at the Fogg Museum in Cambridge (where she was Director), which she would title "The Depressed Impressionists." This did occur, as Ms. Mongan designed it in May, 1974, with the letters in cases, and the absolutely radiant art the artists created on the walls, suggesting that talent has its own logic and will find its way and its discourse, divorced from the every day anxieties familiar to all of us. That is, of course, talent's gift to all of us, and to generations before and ahead of ours.

I leave the letters now to the reader, and the originals to scholars and to the merely curious, at the Library. A toutes et à tous, bonne lecture.

Jacqueline Albert Simon
April 2003

Eugène Delacroix
Letter to Théodore Rousseau in 1855

Mon cher Rousseau,

J'ai rendezvous avec Thoré après demain vendredi à 9 heures pour allez au Luxembourg. Pourriez-vous nous trouver chez lui à cette heure; je serais bien heureux d'y aller avec vous. Demandez à Dupré si vous croyez s'il peut être de la partie qui serait complête.

Recevez mes amitiés bien sincères

E. Delacroix

―――――――

My dear Rousseau,

I am scheduled to see Thoré the day after tomorrow, Friday at 9 a.m., to go the Luxembourg. Could you be there at that time? I would be very happy to go there with you. Ask Dupré if you think he wants to join the party, which would then be complete.

With sincere regards

E. Delacroix

le 2 avril 1855
Monsieur,

Je suis trés confus et trés chagriné de l'étourderie qui m'a fait manquer hier votre seconde visite: une confusion s'était faite dans mon esprit et j'avais cru me rappeler que vous prendriez la peine de passer aujourd'hui. Je regrette d'autant plus cette erreur, qui me trouvant sur le point de partir pour la campagne où je vais pour ma santé, je désespère de pouvoir la réparer par la difficulté où je me trouve d'être certain du moment où je puis rester chez moi. Je vous réitère de nouveau, monsieur, l'assurance de mes bien sincère regrets et celle de ma haute considération,
E. Delacroix

––––––––

April 2, 1855
Monsieur,

I'm very confused and very chagrined at the thoughtlessness that made me miss your second visit yesterday. The confusion in my thinking led me to believe that you were planning to take the trouble to come by today.

I regret my error even more, as I'm just about to leave for the country where I'm going for my health. I'm losing hope of arranging the rendezvous because of the difficulty that I'm in, uncertain of the moment when I can be back at home.

Let me tell you again, sir, of my sincere regrets and my great consideration for you.

E. Delacroix

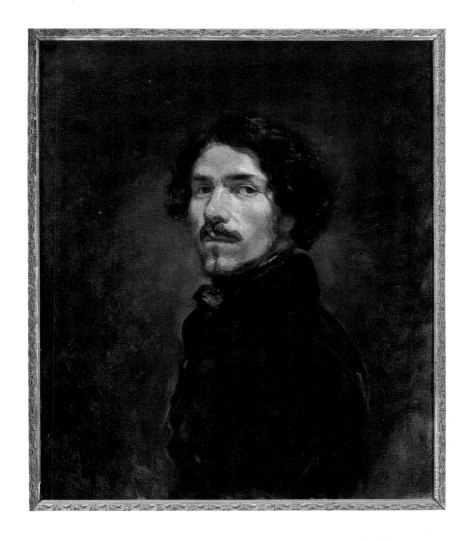

Self Portrait, 1840, by Eugène Delacroix. Alinari/Art Resource, New York.

Eugène Delacroix (1798-1863)

The first short note asking a fellow painter to join him and two other men in a visit to the museum at Luxembourg conveys more than a simple invitation. In a few sentences, the great Romantic painter Delacroix invites his younger friends, the emerging Barbizon naturalist landscape painters Théodore Rousseau and Jules Dupré, and art critic Théophile Thoré to join together to look at art. Written in the mid-19th century when Delacroix was at the height

of his fame and his artistic powers, his letter reflects not only his acceptance of art unlike his own, but also the changing direction of painting. Delacroix, as can be seen in his many letters and his extraordinary journal, had a vast and eclectic circle of friends that included the leading poets and writers and musicians of his day, as well as its patrons and critics. His generosity to his colleagues in the art world included introducing his most admiring critic, Thoré, to their work, and even—as shown here—making up an outing for them to take together. (Georges Sand, one of his closest friends, described Delacroix's "constant nobility of character…and honorable fidelity of his friendships.")

It was Delacroix who brought passionate Romanticism to painting after its long period of classicism. In returning painting to a style that was reminiscent of Rubens and Venetian art, he returned to glowing colors, agitated brushwork, and turbulent animation in his often exotic compositions. Whether in mythological scenes, portraits, or historical paintings, Delacroix was the artistic soul of Romanticism, as well as a precursor of modernism. He was revered in his own day, receiving several major government commissions, among them, the ceiling decorations for the Library at the Luxembourg Palace in Paris, begun in 1840. In addition to his work on this commission, he often went with friends to look at art at the 17th century palace, which at that time housed an important collection of paintings, including his own.

A major supporter of his work was the critic Théophile Thoré (1824-1869), with whom Delacroix had a close friendship. Thoré, a writer, philosopher, and associate of poets and artists, was known as something of a political radical, who believed in "art for man." (Thoré is described by the noted art historian Kenneth Clark as "holding the record for having anticipated the judgement of posterity more often than any critic that has ever lived.") His views on Delacroix were frequently expressed; he considered the artist "one of the two greatest painters of the 19th century." Describing Delacroix's finished commission at the Luxembourg, Thoré wrote, "seeing this majestic, simple painting, as with anything great…one feels in one's soul an ineffable serenity and an eager aspiration toward the ideal…he has attained the goal of his art."

Thoré also became a great supporter of the landscapists who were known as the Barbizon painters, sharing their belief in the "radiance of nature." Two of the artists in the small group who found in Barbizon, at the edge of the forest at Fontainebleau, the tranquility and natural beauty they wanted to paint, were Théodore Rousseau (1812-1867) and Jules Dupré (1811-1889). Both artists were influenced by English and Dutch landscape painting. Rousseau's contemplative landscapes recorded nature exactly as he saw it, stressing its irregularity and odd shapes and forms. Denied admittance to the Salons for twelve years, he became known as "Le Refusé." His cause was taken up by Delacroix and Thoré, and with the change in government in 1848, he finally achieved recognition. Dupré was also a painter of realistic pastoral scenes, which he covered with a heavy impasto of pigment. Though he worked in other areas of France as well as Barbizon, Dupré was an integral part of the 'landscape school,' and a dear friend of Rousseau. Both painters, though so far from Delacroix's passion and exoticism, nevertheless found their own style of Romanticism in the beauties of the French landscape.

In 1855 when the second note was written as well, Delacroix was widely recognized as the leading artist in France. He had just been made a Commander of the Legion of Honor, and had shown forty paintings in the central hall at the Exposition Universelle. He had long been a very prominent figure, and in fact would undertake his final great commission the next year. But in the last decade of his life he felt increasingly unwilling to be a public icon, worrying about his health, and preferring solitude, nature, and privacy to the rigors of official acclaim. "From what savage tyranny have I not been snatched by the weakening of the body?" he asked in the journal that was to become one of his greatest sources of pleasure.

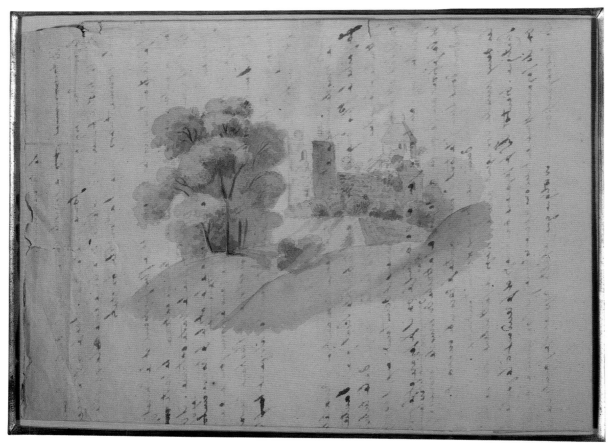

Aquarelle and letter, undated, by Eugène Delacroix. Private collection.

Graphology Notes on Eugène Delacroix

This painter is on an energetic emotional carousel, up and down and around, sometimes impulsive and quirky, sometimes measured and calm.

Stress level is high and pressure may make writer grumpy.

The artist, too, shares similar traits with others in this series: fast, analytical, intuitive thinking and impatience.

While there are signs of aggressiveness, this writer shows none of the argumentativeness of most of these artists.

There is an indication of vanity, which may show itself in exaggerated styles of personal appearance.

Acutely sensitive to unconstructive criticism.

Aptitude for leadership: where he leads many will follow.

A sense of diplomacy: can use tact to solve ticklish situations.

While the writing appears to be muddy, that may be an artifact of the pen used.

Eugène Boudin
Letter to Louis Boudin before 1865

Mon cher Louis

Je viens de nous rentrer un peu de monnaie dormante et je m'apprête de descendre à la poste afin que tu puisses profiter de demain pour aller quérir cette petite somme á la poste.

Nous avons beaucoup de difficultés à faire solder nos créances; c'est cela qui nous retient car je ne travaille plus guère que par désoeuvrement ayant force marchandise en magasin.

On nous promet que nous ne perdrons rien chez les Cadart mais il faut attendre jusqu'à leur expropriation définitive.

Je n'ai pas le temps de te parler de Paris et des grands mouvements de la population; tout cela se passe á cote de nous, acteurs indifférents de ces grands évènements.

Ce qui nous importe avant tout c'est de tirer notre épingle du jeu. Pas eu encore le temps d'aller reclamer tes manuscrits. Mais crois moi ne prodigue pas ton encre en envois stériles. Si tu conaissais l'indifférence de ce monde et sa morgue tu voudrais te contraindre.

Je serais bien heureux d'apprendre que notre mère continue d'aller bien mais nous avons aussi trés peur qu'elle n'ait manqué de beaucoup de choses par ces temps déchirants.

Nous ne comptons pas rester bien longtemps à Paris. Ce que je puis t'affirmer c'est que nous voudrions déjà pouvoir en être proche de partir.

Embrasse bien notre mère pour nous. Clementine, les amis et toute la famille enfin.

Nous te serrons les mains

Ton frère E. Boudin

Ecrit moi un mot si le temps ne te fait défaut.

My dear Louis,

I just got us some cash and I am about to go down to the post office so that you may take advantage of tomorrow to go get this small sum at the post office.

We are having a lot of difficulty settling our debts; that is what is holding us back, because I work only out of idleness since there is so much in inventory.

We were promised we would not lose anything at the Cadarts' but we must wait for their final expropriation.

I have no time to tell you about Paris and of the great movements of the people; all of that goes right by us, indifferent actors in those great events.

What matters to us most is to get out of a ticklish situation. Have not had the time yet to go get your manuscripts. But believe me, do not waste your ink on fruitless dispatches. If you knew this world's indifference and arrogance you would want to restrain yourself.

I would be truly happy to hear that our mother continues to be well but we also fear that she may not have gotten everything she needs in these harrowing times.

We do not plan on staying in Paris very long. What I can tell you for sure is that we wish we were close to leaving.

Do kiss our mother for us, Clementine, the others, and the whole family.

We hold your hands

Your brother, E. Boudin

Drop me a line if you have the time.

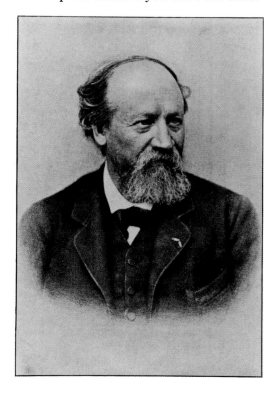

Photograph of Eugène Boudin, 1908. © Musée Eugène Boudin, Honfleur, France.

Eugène Boudin (1824-1898)

Between 1853 and the end of his life, the painter Eugène Boudin wrote some 120 letters to his brother Louis, a struggling writer. In them he described his work, his aspirations, his efforts to make enough money to live on, and his eventual success as a landscape artist. He also enclosed money when he could. This letter, which was probably written before 1865, comes from Paris, where he briefly rented studios twice within those years (always returning to the countryside as soon as possible).

A native of Honfleur on the Normandy coast, Boudin never enjoyed his time in Paris as much as being back with his family on the seaside, either in Normandy or Brittany. His experiences with city life and the poverty he experienced as a young artist there gave him a general distaste for the city. He found the reception for his early work tepid at best; he cynically describes "indifference and arrogance" and advises Louis not to "waste his ink on fruitless dispatches." "I work only out of idleness, since there is so much in inventory."

When this letter was sent, the artist was without a steady income, and was helping to support Louis, too. But he was determined to pursue his own direction as an artist, even if it meant not selling his paintings. "I still persist in following my own little road, however untrod it may be, wishing only to walk with a surer and firmer step," he wrote to his friend Martin at about the same time. "One can find art in anything if one is gifted."

But Boudin would shortly find that the art world did have a place for him. Though he began his career as a Barbizon painter—those first landscapists to work outdoors—it was his emphasis on light and atmosphere, particularly in depicting sky and sea, that separated him from the other landscapists of his time and made possible the innovations of the Impressionists. He was a dear friend and inspiration to the younger Monet, giving him letters of introduction to the art world, and urging the truthful observation of nature and changing light. Boudin's influence can be seen in the seascapes and beach scenes of several of the Impressionists, including Monet. By the 1870's Boudin was exhibiting both with realists like Courbet and the newcomers to the Paris art world—the Impressionists. After a long, agonizingly slow start, his painting finally brought him critical and financial success—apparently just after this letter mentioning his difficulty settling his debts and selling his paintings.

Despite the gloomy tone of these words to his brother, his fortunes were changing. The Paris art dealer Cadart, who is mentioned rather uncertainly in the letter ("we were promised we wouldn't lose anything"), had ambitious plans. In the spring of 1866 Cadart arranged a show of paintings by Boudin, Courbet, and Corot (along with one seashore painting by the as yet unknown Monet) to go to Boston for exhibition. Boudin exhibited his seascapes and beach scenes in his native Normandy and at the Salon the next year. An auction of his works in Paris in 1868 brought him acclaim and significant sales. By 1870, when Paris was caught in the Franco-Prussian War, he was finally on his way to a successful career and in 1874 he took part in the first Impressionist exhibition. "I am so busy painting," he wrote after his paintings began to sell, "I barely have time to breathe."

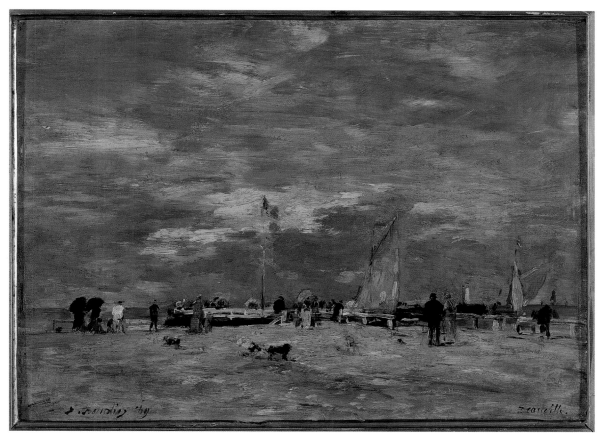

Jetty at Deauville, France, by Eugene Boudin. © Erich Lessing/Art Resource, New York.

Graphology notes on Eugène Boudin

The artist sets the highest possible achievable goals, and follow-through is moderate to strong, there are clear signs of initiative, persistence, and tenacity that achieves many of the goals set.

Thinking patterns are logical, and his conclusions are speeded by a powerful intuition. Writer thinks independently, and comes to decisive conclusions.

Among a few personal characteristics clear in the sample: resentment, a tendency to hermit-like behavior, a short-lived temper that can be sarcastic (also see Braque), profoundly impatient, and irritable.

What makes life bearable for this writer is a quirky sense of humor, some of which bites.

This writer talks but seldom listens. There is a narrow-mindedness apparent that may stem from a tradition of repressed emotions.

The delta d's look like musical notes and many indicate a person with literary potential. Unlike many of the artists in this series, Boudin shows signs of a better-than-bumbling manual dexterity, a person who build things in three dimensions.

Edouard Manet
Letter to M. Bazille in 1876

Juin 1876
Monsieur,

Je reçois le tableau que vous avez bien voulu m'envoyer. Je m'empresse de vous en accuser reception tout en ne vous cachant pas le regret que nous avons eu ma famille et moi de nous séparer du portrait de notre jeune ami Frédéric Bazille dont nous savions apprecier la charmante nature et l'égale amitié.

J'avais trouvé juste, au moment où un groupe d'artistes faisait une protestation, qu'un hommage fut rendu par l'exposition de son portrait au modeste et sympathique héros qu'ils avaient compté parmi eux dans leurs rangs. Mon idée avait du reste été acceptée avec enthousiasme par les amis de Frédéric Bazille dont le souvenir est toujours présent parmi eux.

Veuillez agréer, Monsieur, l'expression de ma consideration.

Ed. Manet

————

June 1876
Sir,

I just received the painting you kindly sent me and I rush to acknowledge its receipt, while not concealing from you the regret my family and I felt to part with the portrait our young friend, Frédéric Bazille, whose charming nature and friendship we came to appreciate.

I thought it right, at the time when a group of artists were offering a protest, that a tribute was made to the modest and attractive hero whom they considered one of their own, in their ranks, through an inclusion of his portrait in the exhibition. My idea was in fact enthusiastically accepted by the friends of Frédéric Bazille, whose memory is always with them.

With my consideration,
Ed. Manet

Photograph of Edouard Manet, 2nd half of 19th century. © Giraudin/Art Resource, New York.

Edouard Manet (1832-1883)

Among the close-knit circle of avant-garde painters in the 1860's were Edouard Manet, the brilliant artist and central figure in the evolution of Western art, and Frédéric Bazille (1841-1870), an enthusiastic young painter. This letter from Manet, the younger artist's friend and greatly admired older colleague, was sent to Bazille's father six years after Bazille was killed in the Franco-Prussian War. Manet laments the loss of the talented painter, a "modest and friendly hero…whose charming nature and friendship we so appreciated."

The portrait mentioned by Manet is an 1867 likeness of Bazille by their mutual friend, Renoir. Manet, who owned the painting, lent it for exhibition as a form of tribute to the fallen artist, and Bazille's family wished to acquire it. Manet gave it to them. He acknowledges receipt of a different painting that he was given in exchange, but he nonetheless regrets parting with Bazille's portrait.

No one painter did more to advance the cause of avant-garde art in the second half of the 19th century than Manet. His art was both grounded in the traditions of the old masters and modern in its composition and approach. He sought to express the truth as he experienced it, without formulas or academic theories. His work was striking in its directness and lack of pretense; his viewers were often stunned by the impact of its close-up, almost two-dimensional composition and its bold and brilliant color. His paintings today look as immediate as when they were created.

Although Manet never became an Impressionist, he did share with them an interest in light and observation of nature. And while he never gave up black for a light-filled palette, never resorted to the short brushstrokes or ephemeral landscape scenes so beloved of the Impressionists, he was nonetheless a leader and colleague of the new style of artists. It was Manet who fought for a new art that was based on both a renewal of inspiration and the direct observation of nature. Though he did not exhibit with the Impressionists in any of their independent shows, he supported them and helped advance their careers, fighting within the Salons for acceptance of the new.

The exhibition at which the portrait "of our young friend" was shown was the second of the Independent Impressionist group shows, held in April of 1876. The exhibition, in protest against the continuing attacks on the new art, was held as an alternative to the traditional art world Salon, which refused to accept their work. Nineteen artists took part, but not Manet. In the same month Manet opened his studio for another exhibition of paintings—including his own—that had been rejected by the Salon.

As a brilliant painter and precursor of modernism, he was a major influence on his fellow artists, including Bazille. "Manet," said Bazille, "is as important to us as Cimabue or Giotto were to the Italians of the Quatrocento." Bazille had met Monet and Renoir on his arrival in Paris in 1862, and had begun painting out-of-doors with them. He met Manet soon after. His interest in capturing the effects of atmospheric light predated by some ten years the first Impressionist shows, and he was at the center of the 'plein air' movement. Bazille became a good friend of their circle and was willing to offer generous financial help time and again to his penniless colleagues, especially Monet. It was Bazille who had the idea for the first joint exhibition of the 'new painting.' When the Franco-Prussian War began in 1870, he enlisted in the French army and was killed some three months later at the age of twenty-nine, and his loss was deeply felt by the entire Impressionist circle.

Manet also refers to the young Bazille's place within the Impressionist circle. Bazille did not live to see the full flowering of Impressionism. But his memory was still fresh as the group gathered to support one another in a hostile art world. Manet seems to write for all the Impressionists when he comments that Bazille "was one of their own."

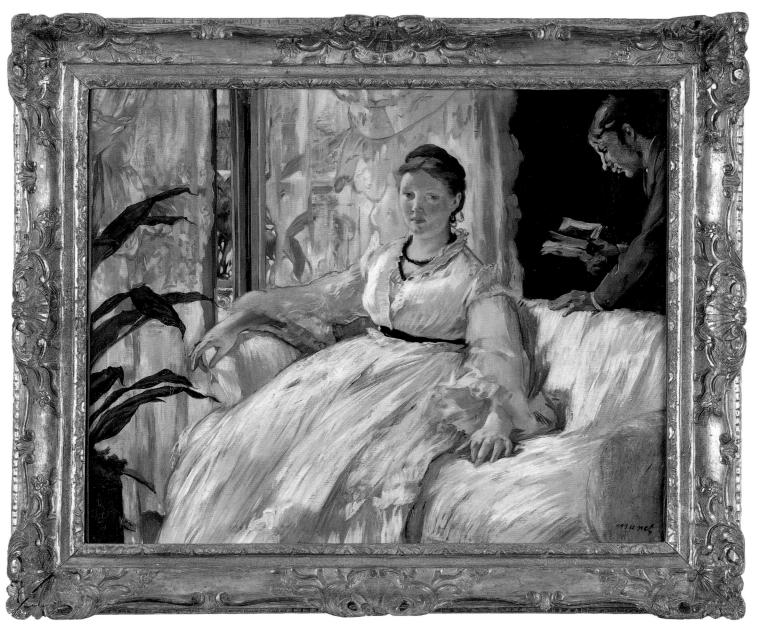

Reading: Madame Monet and her Son, 1868, by Edouard Manet. © Réunion des Musées Nationaux/Art Resource, New York.

Graphology notes on Edouard Manet

This artist appears to have a very addictive personality with intense likes and dislikes.

Problems and pressures stay with him for some time and affect his personality and others will feel the effects of his stress.

He has a very high energy level and moves quickly.

He is intuitive and hyperanalytical.

He is an independent thinker who resents anyone encroaching upon his time and space.

His goals are set high; however, his drive and determination to see them through are moderate.

When a new opportunity presents itself he can take the initiative with persistence, if he is up to it.

He has a wonderful color appreciation.

Pierre Bonnard
Letter to his father in 1885

Paris Samedi 7 Novembre 1885

Mon cher père

Je t'informe d'une décision que
je viens de prendre et que j'espère
tu ratifieras. J'ai été vendredi
m'inscrire à l'école de Droit et je
compte bien arriver à la licence
sinon au doctorat. Tu vois que c'est
un changement complet et pas
mal brusque je vais tâcher de
te l'expliquer. Arrivé à Paris
j'ai été voir Mr Boesvilwald

qui ne m'a pas reconnu bien entendu,
qui ne se souvenait pas plus de
maman mais qui a cru se rap-
peler vaguement le nom de Mr
Mertzdorff il m'a donné tout de
même une lettre de recommandation
pour le directeur de l'école le priant
de me diriger un peu. Aussitôt
je vais à la recherche de ce monsieur
impossible de le trouver ni à l'école
des arts décoratifs niche lui. Enfin
de guerre lasse je me dis, je vais
toujours m'inscrire à l'école des
arts décoratifs j'arriverai bien à
voir un jour le directeur. Me voilà
entré dans une classe je copie de
l'antique pendant 2 heures. Déni
on me dit que si je veux retourner
l'après midi je pourrai continuer
à travailler d'après l'antique
en effet je retourne travailler dans
une salle de 1h à 4h. Cette

journée a suffi pour me faire
faire de profondes réflexions et
me causer un dégoût aussi profond.
En effet le résultat en est la
perspective de ce même travail
jusqu'à une époque dont je ne
vois pas le terme et un travail
qui pour moi qui ai pris toujours
l'art par le côté agréable et un
peu naturaliste, me semble
fastidieux. Ensuite un véritable
un véritable isolement, aucune
direction, des camarades qui ne sont
pas tous dans les mêmes conditions que
moi enfin surtout ce qui a été
dans ma détermination c'est cette
idée qui me poursuivait sans cesse
c'est qu'il fallait que je fasse de
l'art un métier et que en somme
je marchais à un grand point

Samedi 7 novembre 1885

Mon cher père

Je t'informe d'une décision que je viens de prendre et que j'espères tu ratifieras. J'ai été vendredi m'inscrire à l'école de Droit et je compte bien arriver à la licence sinon au doctorat. Tu vois que c'est un changement complet et pas mal brusque. Je vais tâcher de te l'expliquer. Arrivé à Paris j'ai été voir Mr. B qui ne m'a pas reconnu bien entendu; qui ne se souvenait pas plus de maman mais qui a cru se rappeler vaguement le nom de Mr. Mertzdorff. Il m'a tout de même donné une lettre de recommandation pour le Directeur de l'école le priant de me diriger un peu.

Aussitôt je vais à la recherche de ce monsieur—impossible de le trouver ni à l'Ecole des arts Décoratifs ni chez lui. Enfin de guerre lasse je me dis je vais toujours m'inscrire à l'École et j'arriverai bien à voir un jour le directeur.

Me voila entré dans une classe. Je copie de l'antique pendant 2 heures. Puis on me dit que si je veux retourner l'après-midi je pourrai continuer à travailler d'après l'antique—en effet je retourne travailler dans une salle de 1h à 4h. Cette journée a suffi pour me faire faire de profondes reflexions et me causer un dégout aussi profond. En effet le résultat en est la perspective de ce même travail jusqu'à une époque dont je sais pas le terme et un travail qui pour moi qui ai pris toujours l'art par le côté agréable et un peu naturaliste, me semble fastidieux. Ensuite un véritable isolement, aucune direction, des camarades qui ne sont pas dans les mêmes conditions que moi.

Enfin surtout ce qui a pesé dans ma determination c'est cette idée qui me poursuivait sans cesse. C'est qu'il fallait que je fasse de l'art un métier et qu'en somme je marchais à un grand point d'interrogation. Ce qui a surtout brusqué les choses c'est que dès que j'ai senti les premières atteintes de ce dégout j'ai pensé tout de suite à parer à toute éventualité et à m'inscrire pour le droit.

Mais je me suis alors aperçu que j'étais à la veille de la clôture de l'inscription et que je n'avais pas ton autorisation écrite que, m'avait dit Dolbeau, il fallait présenter entre autres papiers.

Alors l'imagination aidant ainsi que les regrets la carrière des beaux arts a fait dans mon esprit des progrès rétrogrades étonnants et je me disais en me retournant dans mon lit, me rappelant quelques conversations que j'avais eu avec quelques camarades, que pour arriver à quelque chose dans cette carrière il fallait être façonné exprès pour la lutte et remuer des pieds et des mains et que je n'étais pas du tout de ce caractère la, même à faire de l'antique seulement j'en ferai comme bon il me semblera et autant que je sentirai que cela m'est utile...

Enfin je suis très content. J'espére que vous le serez aussi et que vous ne vous moquerez pas trop de moi. Je n'ai jamais écrit une si longue lettre. Grand-mère va très bien elle a reçu les fleurs et les a trouvées très belles, elle mande à mère que sitôt qu'elle aura vu des foies et des truffes elle lui en enverra. Tu pourras aussi dire à Charles que sa lettre de convocation n'est pas encore arrivée au boulevard Denfer et que s'il veut écrire à Mr. Dolbeau c'est toujours 10, rue des Carmes.

Je t'embrasse tendrement ainsi que mère et Charles.

P. Bonnard

Paris, Saturday November 7, 1885

My dear father,

I am informing you of a decision I just made and which I hope will please you. I went over to enroll in law school on Friday and I am determined to get my degree if not a doctorate. You can see this is a total and sudden change. I will try and explain to you. Upon my arrival in Paris, I went to see Mr. B. who of course did not recognize me, who had no better recollection of mother, but who thought he remembered vaguely Mr. Mertzdorff's name. He nevertheless gave me a recommendation letter for the director of the school, asking him to give me some advice. I immediately started looking for the gentleman. Impossible to find him, neither at the School of Decorative Arts nor at home. I finally gave up and decided to enroll anyway at the School, thinking that eventually I would succeed in meeting the director.

So here I am in a classroom copying classical art for two hours. Then I am told that if I want to come back in the afternoon I will be able to continue my work of copying. Indeed I go back to work in a room from 1 to 4 p.m. That day was enough to make me think hard and to leave me deeply disgusted. Indeed, the result is the prospect of this kind of work for an indeterminate period of time and a kind of work that seems laboured to me, who always took art from a pleasant and naturalistic angle. And there is also real isolation, no guidance, fellow students who are in conditions different from mine.

Lastly what really weighed in my determination is this idea that has been pursuing me ceaselessly that I had to turn art into a profession and that, in sum, I was headed toward a major question mark. What really precipitated matters is that as soon as I felt the first waves of disgust I immediately thought of preparing for what may happen and of enrolling in law school. But then I realized that we were on the eve of the closing of registrations and that I did not have your written authorization, which, Dolbeau had told me, I had to show among other documents.

So, challenged by both imagination and regrets, a career in fine arts has been making astonishingly retrograde progress in my mind, and I told myself as I tossed and turned in bed, remembering some conversations I had had with friends, that, in order to get anywhere in this career, one had to be specially fitted for the struggle and be ready to give it all and that I did not have at all what it takes, even to do antiques, except that I will do some when and as much as I please and only however I think it may be useful to me...

Anyway, I am very happy. I hope you will be too and that you will not laugh at me too much. I never wrote such a long letter. Grandmother is very well; she received the flowers and thought they were very beautiful. She asks that mother send her livers and truffles as soon as she sees some. You may also tell Charles that his letter of convocation has not arrived yet at Boulevard Denfert, and that if he wants to write to Mr. Dolbeau, the address is still 10, rue des Carmes.

Tender hugs to you and to mother and Charles.

P. Bonnard

Letter to Francis, a cabinetmaker, in 1920

56 rue Molitor
Paris
2 février 1920
 Mon cher Francis

Voulez vous me rendre un service. C'est de donner un moment d'entretien à mon pauvre ami Frédéric Luce, le fils du peintre, qui travaille dans la menuiserie à son compte. Je lui ai dit que vous pourriez lui donner des tuyaux sur les moyens comme il opére seul. Ce n'est pas un concurrent. Je vous ai répondu dernièrement à propos du paravent. Je pars demain pour Arcachon où je vais passer quelque semaines. J'aurai peut-être mon meuble pour le mois d'avril? Tout à vous et merci d'avance pour Luce. Voulez-vous lui donner un rendez-vous fixe? Voici son adresse:

Frédéric Luce 3 rue Gudin, 16ème.
Bonnard

———————

56 rue Molitor
Paris
2 February 1920

 My dear Francis,

Would you be kind enough to do me a favor and take a moment to aid my poor friend Frédéric Luce, the son of the painter. He's working as a carpenter, on his own. I told him that you might be able to give him some tips on how he could acquire wood, and even help him with the basic procedures, since he's doing this alone. He's not a competitor.

I've already replied to you about the screen: I'm leaving tomorrow for Arcachon where I'm going to spend several weeks. Will I, perhaps, have my furniture for April?

Best to you, and thanks in advance for Luce. Would you arrange a definite date for a meeting? Here's his address:

Frédéric Luce 3 rue Gudin, 16ème.
Bonnard

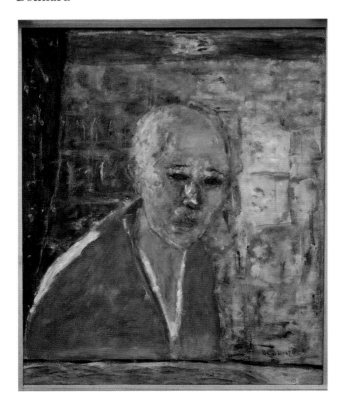

Self Portrait, 1945, by Pierre Bonnard. © Giraudon/Art Resource, New York.

Pierre Bonnard (1867-1947)

It is rare to come upon a letter by a great artist that so clearly discusses his choices—and opts for law school! In this letter Pierre Bonnard writes to his father of making this decision only a few short years before selling his first work (a poster), joining the Nabis or Symbolists, and becoming a recognized artist with his own distinctive style. In fact, Bonnard is increasingly seen as a major figure in the development of modern art. With Edouard Vuillard he shared the leadership of the Nabis group at the turn of the century. Though there are echoes of Impressionism in his painting, he became more interested in depicting a world of color, light, and form. His paintings though, still observant, became more dreamlike, spatially interesting, luminous, and ultimately unaffected by the changing movements of the art world. Bonnard's work—which often pictured interiors and domestic scenes of the bourgeois life he had himself known—transformed the familiar into colorful, abstractly seen and deeply felt compositions.

Born into a stable middle-class family, Bonnard had a traditional upbringing in a Paris suburb, doing well in school, and preparing to enter the university. But he enjoyed the decorative arts and painting, and he craved a more bohemian existence. In 1885 he moved in with his grandmother in Paris and enrolled at the Ecole des Arts Decoratifs. It took only a short time before he was disillusioned with art school.

This letter to his father describes his brief, unfortunate introduction to the study of art. And so, after only a short period in art school, the future painter decided to enroll in law school and work at his copying in the afternoons, devoting his free time to the serious study of painting. He was quite sure his family would be pleased with his decision. He graduated with a degree in law in 1888.

But Bonnard did not give up painting. By 1887—though still studying law—he had enrolled at the Académie Julian in Paris where he met such artists as Paul Serusier and Maurice Denis. He was admitted to the painting division of the Ecole des Beaux-Arts shortly after. Before very long he was surrounded by artists and found himself leading the life he had dreamed about.

Although he worked for a while at a registry office (and failed a civil service exam), by 1889 he had begun painting with the Nabis, sharing a studio with Edouard Vuillard and Maurice Denis. Two years later he exhibited in "Peintres impressionistes et symbolistes" and the following year at the Salon des Indépendants. Soon after he wrote to Vuillard, "Painting, especially in oils, has kept me very busy; it's going slowly, very hesitantly, but I believe I am on the right track." Three years later he was able to say that "color, harmony, the relationship between line and tone, and balance...seemed to have lost their abstract implication and become concrete. In a flash I understood what I was looking for and how I could set about achieving it."

Many years after writing this letter to his father, Bonnard, now a highly respected artist, assumes the parental role. Both his handwriting and his message in this brief note reveal the mature elder; he asks a favor of the cabinet-maker who is apparently making a screen for him. Referring to Frédéric Luce, the son of his friend the Post-Impressionist painter, Maximilien Luce, Bonnard hopes the "menusier" will start the young man on his way. with a few tips and help with the "basic procedures." It is hard to imagine the recipient of this kind of letter turning down Bonnard's request.

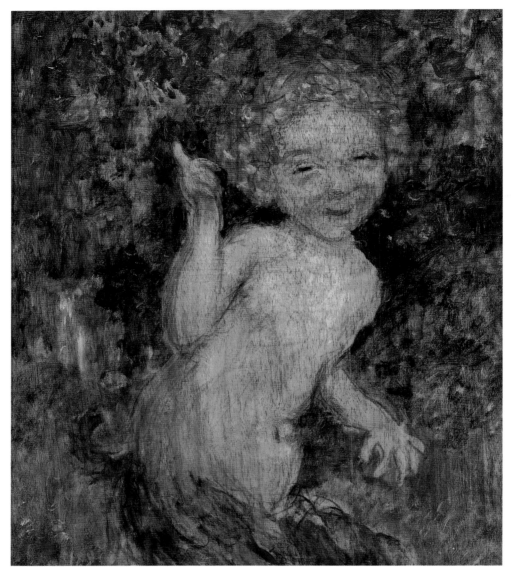

Faune, 1896, by Pierre Bonnard. © private collection.

Graphology notes on Pierre Bonnard

The artist will fool himself but not entirely fool others. Self deceit plays a constant role in this person's life. When and if these self deceits are faced and corrected, the writer may experience a revised viewpoint on life and work.

Thinking is extremely fast, analytical, and investigative with a sporadic use of intuition which speeds fast thinking into ultra-fast thinking. Writer uses and respects the practicalities of logic.

Writer has no imagination to speak of and will describe what is seen and experienced without embroidery but with intensity.

There is a sense of unexplained self-consciousness, perhaps having to do with a physical disadvantage or infirmity.

This writer thinks things through and calculates the minimum risk before taking action. However, writer will grab the initiative whenever suitable.

As with many artists in this series, confusion and scattering of interest is evident, as is argumentativeness. Do all these artists simply write this way, or does a remarkable percentage of them enjoy fussing intellectually and emotionally?

There are signs of a fair amount of manual dexterity.

Berthe Morisot
Letter to Madame Camille Monet in 1887

Chère Madame. Vous êtes bien
aimable de vous inquiéter de
moi, je suis mieux, je me
lève et reprends le travail y mettant
de la conscience jusqu'au dernier moment
mais sans grand espoir

Petit m'a écrit d'un style qui
n'admet pas la réplique, en note bene
d'envoyer mes tableaux le 1er mars
dernier délai, on me dit aussi que
cet homme furieux n'accepte pas
les cadres blancs ce qui complique encore

ma situation, enfin, écrire à
Mr Monet que je suis fort
ennuyée et que tout cela finira
par une mauvaise exposition.

Je suis bien fâchée de vous
savoir souffrante également.
C'est bien aussi parce que je me
me soignais pas depuis plusieurs
semaines que j'ai dû me mettre
au lit — Je me suis levée pour
la petite réunion d'enfants qui
m'a beaucoup fatiguée. C'était

Chère Madame. Vous etes bien aimable de vous inquièter de moi. Je suis sérieuse. Je me lève et reprends le travail y mettant de la conscience jusqu'au dernier moment. Mais sans grand espoir.

Petit m'a écrit d'un style qui n'admet pas la réplique, en *nota bene* d'envoyer mes tableaux le 1ère mai dernier délai. On me dit aussi que cet homme feroce n'accepte pas les cadres blancs ce qui complique encore. Fort gentil.

Je regrette bien que Germaine et un compagnon n'aient pu prendre part à la joie commune. Julie me charge d'embrasser Germaine, et moi, chère Madame, je vous pris de me croire bien reconnaissante.
a vous
Berthe Morisot

———

Dear Madam,

How kind of you to ask about me. I am serious. I get up and go back to work very conscientiously up to the last moment, but without much hope.

Petit wrote to me in a tone that admits no argument: *nota bene* to send my pictures no later than May 1st. I am also told that this ferocious man rejects white frames, which makes things that much more complicated. Really pleasant!

I am truly sorry that Germaine and a companion were not able to participate in everyone's joy. Julie asks me to send kisses to Germaine, and I, dear Madam, please understand how grateful I am.

Yours,

Berthe Morisot

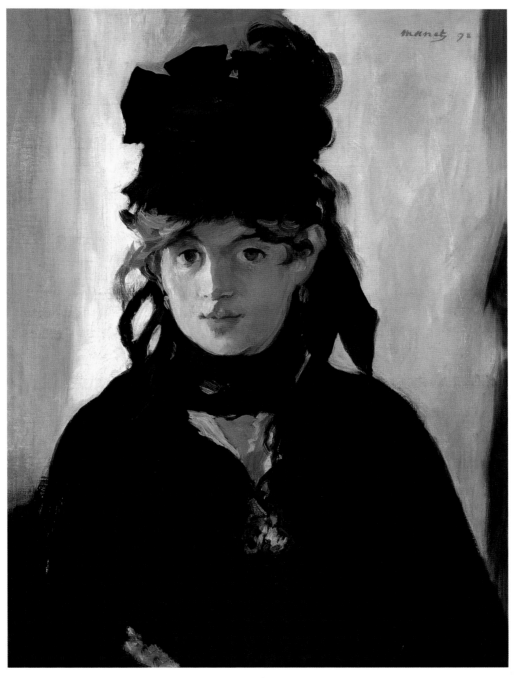

Berthe Morisot with a bouquet of violets by Edouard Manet. © Réunion des Musées Nationaux/Art Resource, New York.

Berthe Morisot (1841-1891)

Berthe Morisot was at both the artistic and social centers of the Impressionist circle. One of the only women to exhibit at the independent exhibitions, Morisot was a dear friend and colleague of Monet, Renoir, Degas, and Manet (whose brother she married). Her correspondence with the artists and their families suggests the warm and frequent social meetings among the group, as well as the development of the new painting. In this letter, Morisot, who had been ill, addresses Madame Monet with warmth, thanking her for her concern, sending news of an upcoming exhibition to M. Monet, and including the regards of her little daughter Julie, whom she adored and painted frequently.

One of the organizers of the independent show of 1874, which became known as the first Impressionist show, Morisot was closely associated with the Impressionists for the next two decades. She faced the same obstacles and hostility from the academic art world, and was undeterred, filling the complex roles of female artist, new-style painter, and wife and mother with equal grace. But life for the Impressionists was not easy; they had few sales and little opportunity in the early days. Though Morisot was financially secure, many of the other members of the group could barely find food for their families. At the center of the problem was the need for galleries and dealers—as well as patrons—to buy paintings.

The already well-known Durand-Ruel Gallery was the first to show the Impressionists, despite the harsh reviews of their work from traditional critics. Paul Durand-Ruel provided the group with exhibition space and agreed to deal in their paintings. However, his insistence on isolating the Impressionists and avoiding the Salons did little for the painters. After some years, Monet and Renoir became unhappy with his handling of their works (Monet wrote to Durand-Ruel, "I remain stupefied by your indifference"), and turned to another dealer, Georges Petit, who had a gallery on the Rue de Seine in Paris.

Petit, who was Durand-Ruel's greatest rival, decided that the way to further the work of the Impressionists was to exhibit them wherever possible and in large shows of his own devising. In 1887, when this letter was written, Morisot—along with Monet, Pissarro, Renoir, Sisley, Rodin, and Whistler—was prepared to show seven works at Petit's Gallery on May 7, in one of his "International Exhibitions" (though she continued to show with Durand-Ruel as well).

Morisot, who was her own harshest critic, found Petit commercial and intimidating, as this letter indicates. She wrote in her diary at the same time, "Today I am sending my pictures to the Internationale with a great fear that they'll all look atrocious." In fact, Morisot did not sell any works at the exhibition and had to give Petit one of her paintings in payment. But while she frequently described her shows as "disasters," Morisot continued to work in her own spontaneous style, producing some of the most enduring and beloved images of any of the Impressionists, though she died at only fifty-four.

Morisot's quick and delicate brushwork, her glowing portraits of familiar domestic scenes and picturesque open-air subjects, and her aerial mobility and lightness brought her paintings the special qualities sought by the Impressionists, but she never allowed ideology to interfere with her spontaneity. As the critic Paul Mantz wrote in 1877, "Her painting has all the frankness of improvisation; it does truly give the idea of an 'impression' registered by a sincere eye and rendered again by a hand completely without trickery."

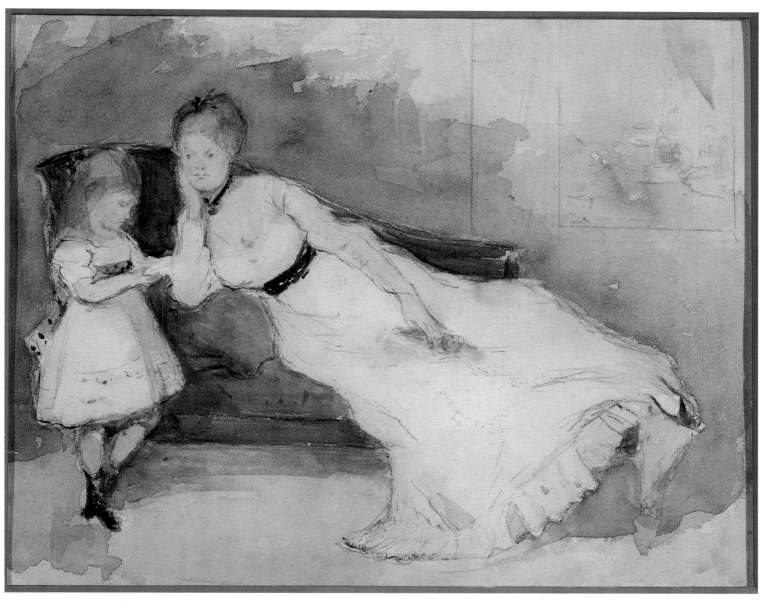

Madame Gobillard with her Daughter Paule, aquarelle, by Berthe Morisot. © private collection.

Graphology notes on Berthe Morisot

This artist is a friendly and outgoing person. Not one to hold grudges, she is very resilient to stress and moves on quickly.

She is a methodical thinker who will think things through carefully and will then take the time to analyze her data. Her intuitive abilities will speed up the process.

She pays close attention to details, and will be very cautious about taking risks.

She works well with her hands and is precise in her movements.

She can be diplomatic with others in difficult situations but is evasive about herself.

Her drive and follow-through are weak and there is a tendency towards procrastination.

Camille Pissarro
Letter to a dealer in 1887

Paris 26 mars 1887
Monsieur
 Vous seriez bien aimable de me donner des nouvelles de mes 3 tableaux à vendre. Vous ne sauriez croire combien je suis anxieux d'avoir une solution qui me permette de continuer mon travail commencé; le temps presse!
 Ne pourriez-vous me les prendre? Je baisserai les prix. Faut-il vous en porter d'autres.
 Recevez, Monsieur, avec mes remerciements, mes salutations amicales.
C. Pissarro
42 rue des petites Ecuries

———————

Paris, 26 March, 1887

Monsieur,
 Would you be so kind as to give me news about my three paintings for sale. You wouldn't believe how anxious I am to have a solution which would allow me to continue the work I have begun. Time is pressing. Could you take them from me? I will lower the prices. Ought I to bring others? Very truly yours,
C. Pissarro
42 rue des petites Ecuries

Letter to Julie Pissarro in 1901

Moret
28 rue de la pêcherie
7 mai 1901
Ma chère Julie

Ci-inclus le reçu pour Durand il faudra y mettre un timbre de 10 centimes. Je n'ai pas répondu encore à la deuxième lettre de Durand, je n'aurai pas autre chose à lui dire que ma première lettre. C'est une affaire décidée, je tiens absolument à être libre. J'ai appris que Durand est allé chez Monet et lui a acheté pour une centaine de mille fr. de tableaux, je ne vois pas en quoi cela a fait du tort à Monet de vendre à qui il veut.......au contraire, il faut que je tienne bon. Du reste j'ai vendu tout çela ce que j'ai fait ici 5 tableaux

 1. T de 20.......2500
 1. T de 20.......2500
 1. T de 20.......2000
 1. T de 20.......2000
 1. T de 20.......2000
 <u>1. Gouache......1500</u>
 12,500 FF.

Je demanderai à Durand les mêmes prix pour mes vues de Paris.

La toile vendue en vente 'les Boulevards' a été retirée à par Depeaux à 8 mille fr.... Tant qu'il n'y aura pas concurrence je ne monterai pas. C'est Bernheim qui a acheté ma 'Paysanne Assise' 4 mille fr.

Oui, tu peux mettre en order les tableaux dans la chambre de Cocotte, mais arrangés de façon à pouvoir retrouver mes tableaux, car il y en a que je vais vendre en arrivant, il y a les vues de Paris pour Durand. Attention à ne pas les crever.

Moret
28 rue de la pêcherie
May 7, 1901
My dear Julie,

Here are the receipts from Durand; you must attach a stamp of 10 centimes. I have not yet answered the second letter from Durand; I will not have anything different to tell him from my first letter. It's decided. I must be absolutely free, I must insist on that. I've heard that Durand went to see Monet and bought some paintings from him for 100,000 francs. I don't see what harm it can do to Monet to sell to whomever he wishes...on the contrary. As for the rest I've sold everything I've painted here, five paintings:

 1. T de 20.......2500 francs
 1. T de 20.......2500
 1. T de 20.......2000
 1. T de 20.......2000
 1. T de 20.......2000
 1. Gouache......1500
 12,500 Fr.

[Note that the painter includes a gouache he did not mention in his letter. A franc in 1901 would be the equivalent of 3.12 Euros in 2003.]

I will ask the same price from Durand for my views of Paris.

The canvas offered at auction, 'Les Boulevards,' was withdrawn by Depeaux at 8000 francs. While there's no competition, I won't go up. It's Bernheim who has bought my 'Seated Peasant' for 4000 francs. Yes, you can put my paintings in order in Cocotte's room, but arranged in such a way that I can find them because there are some that I am going to sell when I arrive. There are the views of Paris for Durand. Be careful not to damage them.

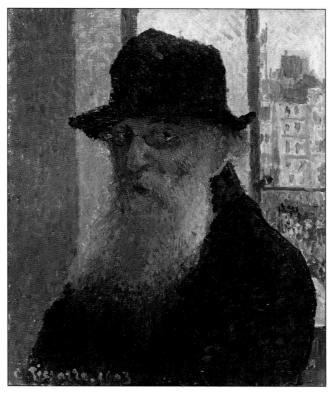

Self Portrait, 1903, by Camille Pissarro. © Tate Gallery, London/Art Resource, New York.

Camille Pissarro (1830-1903)

These two letters, dated 1887 and 1901 by Camille Pissarro, reflect the continuous pressure on the artist to sell paintings to support his family of eight. The anxious tone of the first letter, written when he was still unknown, contrasts with the second when he had finally achieved recognition. By the end of the quarter century following the first Impressionist exhibition of 1874, acceptance of the new style of painting had become widespread. After the success of Monet, Impressionist paintings were in demand, and the often penniless Impressionist painters of the 1870's and 1880's were able to choose their own dealers and dictate their own terms.

In the first quite frantic letter of 1887 Pissarro writes, perhaps to his dealer, Paul Durand-Ruel, of the three paintings for sale. His worry is palpable. "You understand how anxious I am to have a solution that will allow me to get back to work—time is passing!" He will take any amount he can get. "I will lower the price." His plight was typical of the Impressionists, who were forced to rely on occasional sales and loans from their friends to get by.

Pissarro was a central figure, and the eldest, in the Impressionist movement. He was a founder and innovative leader of the group and the only one to show at all eight of the Impressionist exhibitions between 1874 and 1886. As an elder figure, he welcomed younger artists, was supportive of his colleagues, and was the indomitable fighting spirit of the group. "Of all painters," said Cézanne, "Pissarro was the nearest to Nature." In fact, the great Impressionist's artistic life was devoted to observing, and recreating upon canvas and paper, the effects of the changing seasons and natural light on the world around him. Setting up his easel to paint 'en plein air,' Pissarro pictured the same places— a village church, a market place, a Paris boulevard—over and over, noting minute differences in atmospheric light and color. Always seeking a way to replicate more clearly what he observed, he moved during his career through various phases of expression, but always with the same end in mind. Whether eliminating various colors from his palette or moving from oils to pastels to gouache, or changing from long brush strokes to a pointillist style espoused by Seurat, he remained faithful to recreating the fugitive effects of nature. His emphasis on idyllic rural landscapes corresponded closely with his political ideas; he was an avowed anarchist who believed in a classless rural lifestyle.

But the idyllic scenes he pictured were seldom replicated in his own life. Like other members of his circle, despite deep friendships with his colleagues, including Monet, Seurat, and Renoir, his life as a painter was difficult; his letters reveal a constant struggle with hostile critics, a lack of income for his large family, and problematic dealings with galleries and collectors.

In 1887 Pissarro was working in the pointillist technique that was close to Seurat's. His dealer was Durand-Ruel, who had handled his work since the first Impressionist show, but the amounts Pissarro received were not large. In 1882 Durand-Ruel had decided on a group of one-man shows for the Impressionists; Pissarro's produced no sales. Literally living from painting to painting, Pissarro was always anxious for money and sometimes was forced to rely on friends for help in supporting his long-suffering wife, Julie, and their large family.

By 1901, in the last years of his life, times had changed quite dramatically for Pissarro. As always, relying on Julie to handle his financial dealings, he writes to her from Moret-sur-Loing where he spent April and May painting. He sends her the money he has received from Durand-Ruel (five paintings for a total of 12,500 francs), but he no longer needs Durand-Ruel: "it is all decided, I must be absolutely free." He notes the large amount of money Durand-Ruel is supplying to Monet, and that Monet is using other dealers as well, and that he will do the same thing. He writes that he is selling a painting through the rival Bernheim Gallery for more money than Durand-Ruel asks. He ends his letter with a series of admonitions for Julie about organizing his pictures so that he can sell them when he returns, and being careful not to damage them. Though still preoccupied with the selling of his paintings, Pissarro now, in his old age, (his handwriting has become cramped) has at last added financial success to his mastery as an artist. At seventy-one he is continuing to observe nature and to paint what he sees.

"What is an Impressionist?" Matisse once asked him. "An Impressionist is a painter who never makes the same painting twice," Pissarro said.

Le Pont Neuf, Paris, 1902, by Camille Pissarro. © Visual Art Library/Art Resource, New York.

Graphology notes on Camille Possarro

This artist has a very emotional nature and his reactions are rarely detached from his emotions. He can act on impulse alone and at times will show instant likes and dislikes for people, places, or things.

He is smart and thinks very quickly on his feet.

He takes lots of pride in himself and his abilities, and it is important for him to be held in high esteem.

He is a generous and sharing person, and that would usually be with others who have similar temperaments.

He has a wonderful line and color appreciation and expresses himself fluently and well.

Claude Monet
Letter probably to Gustave Geffroy in 1888

Giverny par Vernon. Eure
Mon cher ami

 Je reçois un mot de Vangogh qui me parle de l'article que vous avez fait sur son exposition. Il parait qu'il est très bien et je voudrais bien le lire (envoyez le moi donc vous serez bien aimable). Je n'ai pas bougé d'ici depuis le diner d'Asnière et ne sais rien de rien si ce n'est que Vangogh me parait triomphant. Madame Hoschedé étant parti avec sa fille, me voilà cloué ici. Je n'ai pas encore repris le travail.

 Je crois qu'à cause de ces sacrés Américains je vais renoncer à reprendre mes figaros, ça m'embête bien. Je voudrais tant prouver que je peux faire autres choses.

 Si vous avez un moment écrivez moi et dites moi ce que vous savez de l'effet produit par mes tableaux. Quand je ne travaille pas cela m'inquiète.
Amitiés
Claude Monet

———

Giverny par Vernon. Eure
My dear friend,

 I've had a note from van Gogh who tells me about the article you wrote about his show. It seems it's very good and I would very much like to read it (please be kind enough to send it to me). I have not moved from here since the dinner at Asnière and I know nothing at all, except that van Gogh seems to me to be triumphant. I have been stuck here since Mrs. Hoschedé went away with her daughter. I have not resumed working yet.

 I think that because of those damn Americans I shall have to give up on my present, intriguing series, (*figaros/figures?*) which really annoys me. I so much want to prove that I can do something else.

 If you have a moment, write to me and tell me what you know of the effect my paintings are having. I'm uneasy about that when I don't work.
Regards
Claude Monet

Letter to Emile Bernard in 1923

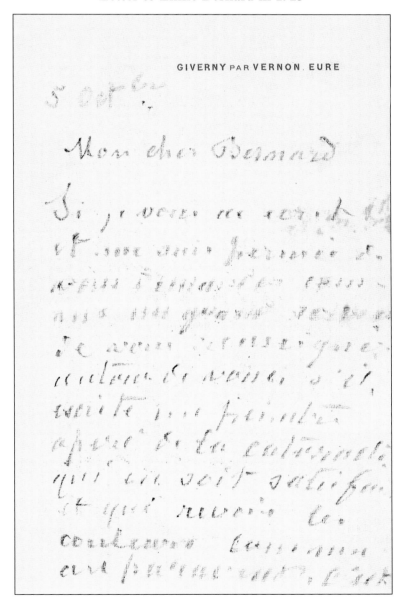

que je suis bien mal
heureux de mes
travaux et de toute
ma vie. Dans la
situation pénible
où je me trouve,
J'ai espérer de
vous je me de-
mande si votre
première lettre m'
est bien parvenue
et qui m'étonne
de votre silence
et me cause ...
...

... pour affluer à mes bien ...
... jours, pour me renseigner
si vous le pouvez.
Bien cordialement
Claude Monet

Giverny par Vernon. Eure
5 octobre [1923]

Si je vous ai ecrit et me suis permis de vous demander comme un grand service de vous renseigner autour de vous s'il existe un peintre opere de la cataracte qui en soit satisfait et qui revoit les couleurs comme auparavant, c'est que je suis très malheureux de me trouver à la fin de ma vie dans la situation penible où je me trouve. Sans reponse de vous, je me demande si ma première lettre a vous est bien parvenue ce qui m'excuse de vous importuner une seconde fois.

Je fais appel a nos bons rapports de jadis pour me renseigner si vous pouvez.
Bien cordialement
Claude Monet

Giverny par Vernon. Eure [1923]
October 5
My dear Bernard,

If I wrote to you and permitted myself to ask you a great favor, to find out if there is an artist who underwent cataract surgery and is satisfied with it and can see colors again as before, it is because I am very unhappy to find myself at the end of my life in the dreadful situation I am in. In absence of an answer from you, I wonder if my first letter ever reached you, which excuses me for troubling you for a second time.

I call upon our longtime good relations, to ask you to find this information for me, if you can.
Very cordially,
Claude Monet

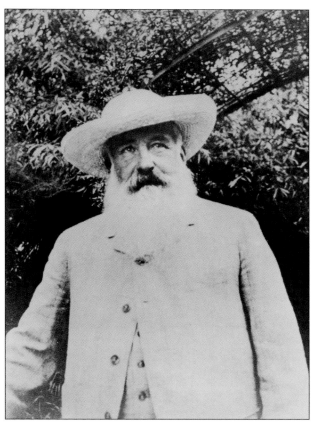

Photoportrait of Claude Monet by Sacha Guitry. ©
Giraudon/Art Resource, New York. Musée Marmottan-
Claude Monet, Paris.

Claude Monet (1840-1926)

In each of these revealing letters, the great Impressionist painter Claude Monet is anxious and worried. He refers in the first to his burgeoning career, but his inability to find time to work, and in the second, to serious problems with his sight. The first was written in 1888; he was already widely exhibited and admired. The second was written after his cataract surgery in 1923. (He had been having problems with his sight since 1867, when doctors forbade him to work in the open; by 1918 his eyes were failing.) Despite these problems, in the years of more or less constant difficulties with his sight, Monet produced much of his greatest work, becoming the acknowledged star of French painting.

The first letter, written on the 20th of June 1888 from Giverny, where Monet had settled, is addressed to a dear friend. The letter was apparently addressed to the noted art critic and Monet's close friend, Gustave Geffroy. In a recent article, Geffroy referred to Vincent van Gogh's brother, Théo van Gogh, with whom Monet was in close touch. Théo was an art dealer, then working with a Parisian firm called Boussod and Valadon. On June 4th Monet had sold Théo ten paintings, one quarter of the forty landscapes he painted during his several spring months at Antibes, and Théo had put them on display at the gallery on Boulevard Montmartre. All of the paintings were sold in that year. Among the reviews of the show was one by Gustave Geffroy, which appeared in "La Justice" several days before this letter was written. "Monet," he wrote, "has been able to capture all that was characteristic about the area and all the deliciousness of the season." The "damn Americans" who are keeping Monet from trying something different refers to the onslaught of American painters, would-be Impressionists, who were thronging to Giverny to watch him work and copy his methods. "I worry when I don't work," he concludes.

In the years between these letters Monet's sight deteriorated. By 1922 he was unable to see certain colors at all. He put off surgery several times, terrified that he would lose what sight he had. "I am working hard," he wrote his dealer Durand-Ruel in 1922, "and I would like to paint everything before not being able to see anything anymore." Finally in 1923, in the presence of his old friend, Georges Clemenceau, he underwent the first of several cataract operations. He was left with a state of half vision. Six months later he again underwent surgery; his sight was saved but veiled. The artist found himself seeing everything yellowed. The doctor prescribed tinted eyeglasses. Monet wrote to ask if any other painters had had experience with similar treatments. This letter, apparently to fellow artist Emile Bernard, wonders if other artists were satisfied with the results of such surgery.

It is not surprising he wrote hoping for encouragement; he found painting under these conditions frustrating. But the doctor was quite satisfied with the results. "If all nature were in black and white," he told Monet, "everything would be perfect." But the artist was less pleased. "I am haunted by what I am trying to realize," he complained. "My anxiety returns as soon as I put my foot in the studio."

His work, in the last year of his life, became broader and less detailed, free in line; the colors deepened. In response to the distortions of his sight he used larger brushes, working in a greater scale, at close range. As one writer commented, "he was learning to paint blind," relying less and less on visual images and his own idea of the landscape he 'saw.' And these startlingly abstract paintings put Monet clearly in the twentieth century, perhaps inadvertently presaging much of the art that was to come.

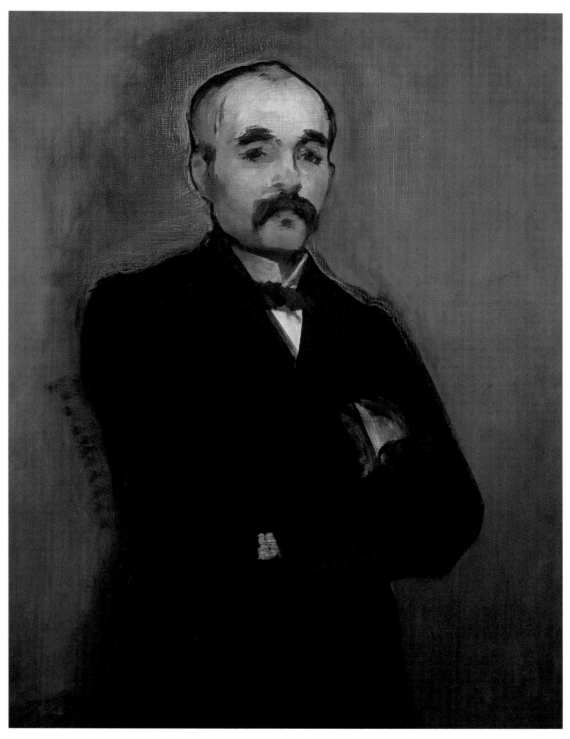

Georges Clemenceau, 1879-1880, by Claude Monet. © Erich Lessing/Art Resource, New York.

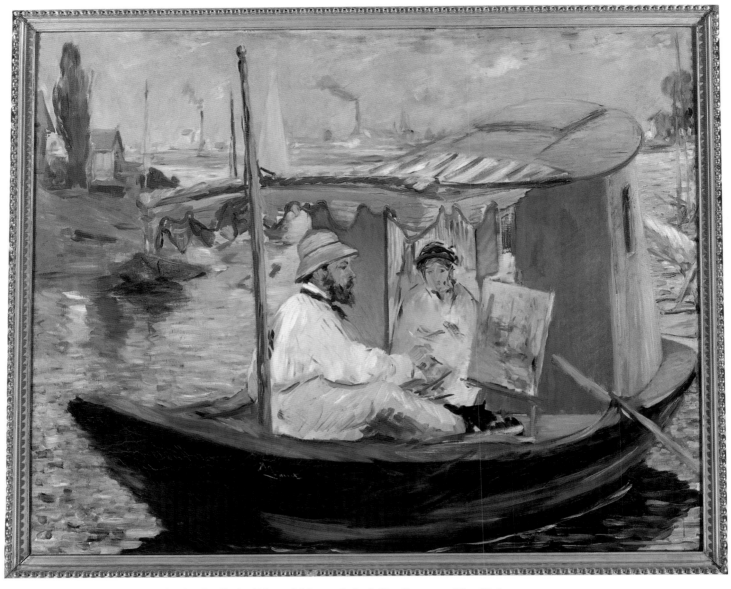

Claude Monet with his Wife in his Floating Studio, by Edouard Manet. © Scala/Art Resource, New York.

Graphology notes on Claude Monet

This artist has a consistent rhythm with strong follow-through. His emotions appear to be well balanced.

He concentrates well on the tasks on hand and works well with details. He has the ability to conceive a plan and put all the elements together.

He has a strong need to acquire things including knowledge, and this trait spurs him on to even greater achievement.

He is a strong self-starter, and has a good sense of humor.

His great enthusiasm can inspire others.

He has a wonderful flair, color sense, and good line appreciation.

He has strong literary aptitudes and can express himself well both verbally and on paper.

Alfred Sisley
Letter to a potential buyer in 1888

21 mars 1888
Cher monsieur

 Je viendrai à Paris samedi 24. Voulez vous me faire le plaisir de venir voir les pastels dont je vous ai parlé dernièrement?

 Je vous attendrai à l'Hôtel Byron, 20 Rue Laffitte de 10½ à midi.

Recevez cher monsieur l'assurance de mes sentiments les plus sympathiques.

A Sisley

———

March 21, 1888
Dear Sir,

 I shall come to Paris Saturday the 24th. Please do come to see the pastels I mentioned to you recently.

 I'll await your visit at the Hotel Byron, 20 rue Laffitte, from 10:30 a.m. until noon.

With most friendly regards,

A. Sisley

Letter to M. Hainman in 1888

Mon cher Monsieur Hainman

Je suis rentré immédiatement à la maison et n'ai pas eu le temps de vous revoir pour vous remercier de l'affaire que vous m'avez fait faire et qui me rend bien service.

Si vous voulez m'être particulièrement agréable, choisissey parmi mes pastels celui qui vous plaira le mieux et croyez moi cher Monsieur

Votre devoué
A. Sisley
Les Sablons
2 août 1888

My dear Mr. Hainman,

I came back home immediately and did not have time to see you again and thank you for the transaction you enabled me to make, which helps me considerably.

It would be especially agreeable to me if you would choose whichever one you like best among my pastels, and consider me, dear sir,

Your devoted
A. Sisley
Les Sablons
August 2, 1888

Photoportrait of Alfred Sisley, end of 19th century, by Clement Maurier. © Giraudon/Art Resource, New York.

Alfred Sisley (1839-1899)

In 1888 these two letters were sent by the Impressionist landscape painter Alfred Sisley from Moret-sur-Loing, a lovely waterside village with a fine old church, timbered homes, and two gothic gateways, near the fabled forest of Fontainebleau. Sisley was of English ancestry but a Frenchman by choice, and his views of the rural French landscape had an idyllic pastoral vision. Sisley had first visited the area of Moret in 1879. He returned again and again, eventually settling in the region and painting numerous views of Moret's church, its winding main street, and especially its complex, intertwined waterways—the Loing River, the Seine, the Orvanne, and the Canal—and their picturesque bridges. He found he preferred the solitude of life in the country to the bustle of Paris, though he missed his colleagues and the art world of the metropolis. Little by little, he lost touch with his old friends, and perhaps somewhat undermined his own career at the same time.

Eventually, in 1888, encumbered by debt and poor health, he left the center of Moret for Les Sablons, a small settlement of farmhouses and orchards nearby, at the edge of the forest of Fontainebleau. Sisley rented a house there, painting landscapes and waterscapes of the area in different seasons and times of day. Many of his major works picture the serenity of the waterways, the empty fields, and the changing light on rural scenery. He rarely left Les Sablons, only occasionally visiting Paris for exhibitions and in the hope of selling pictures.

These two letters, one written in March and the other in August of that year, suggest the careful wooing of patrons by the hopeful artist. Though he had exhibited seventeen works along with Renoir and Pissarro at Durand-Ruel in May and June of 1888 (and sold one), he was in dire financial need. Unlike Monet and Renoir, he had little success selling his paintings, though Durand-Ruel periodically purchased a few of them for future sales, and, of course, Sisley tried to sell his works himself. In each letter the artist mentions meeting with a prospective buyer—once in a hotel—to display his work. And in one instance he offers a choice of one of his pastels to the man who helped him to sell an oil painting.

[The undervaluing of pastels was not uncommon, though today Impressionist pastels are highly prized.]

Sisley had to cast about for quick ways to make money with his art. He had even thought of painting fans to sell. In an apparent decision taken with the dealer Durand-Ruel, he turned to making a series of pastels. They took a shorter time to create, required less expensive materials, and were more easily, though not expensively, sold. Other painters, like Degas and Morisot, had found pastels a fresh and appealing medium, and Sisley took to working with them as well. He made at least eight pastels of the Moret area, several of which are snowy winter views drawn from his upstairs windows at Les Sablons.

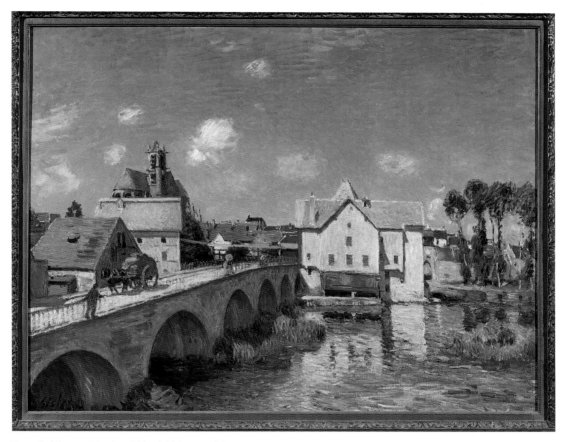

Pont de Moret, 1893, by Alfred Sisley. © Giraudon/Art Resource, New York.

Graphology notes on Alfred Sisley

This artist has an emotional nature and can be sympathetic to the needs of others.

He is a cursory thinker who uses the data on hand. Very rarely will he probe below the surface.

He appears to be resilient to stress and can "bounce back" quickly when encountering problems.

His goals are high and practical, and his drive and determination to see them through are very strong.

When a new opportunity presents itself he can take the initative without being urged. The only problem he has is procrastination, which is a fear of commitment.

He enjoys talking and uses tact in his communcations. He can be with others, but he is a loner by nature.

His integrity is moderate, and he can tell a tall tale from time to time.

Odilon Redon
Letter to Octave Maus in 1889

30 juillet, 1889
Mon cher Maus,

Je reçois à l'instant votre lettre qui me donne le plaisir de vous savoir si près de nous.

Les moyens de communication sont ceux-ci: à Paris vous descendriez naturellement à la Gare du Nord, prendre Gare de Lyon, où il y a des trains pour Fontainebleau toutes les heures.

De Fontainebleau à Samois, il y a des voitures. Le trajet est court—un quart d'heure en forêt. Vous m'aviserez pour la semaine prochaine, entendu.

Vous nous feriez le plus grand plaisir de vous joindre à mon excellent ami Picard.

Sans adieu et tout à vous,
Odilon Redon
Samois, près Fontainebleau
S. et -M

———

toutes les heures.
De fontainebleau à
Samois, il y a de voitures.
Le trajet est court — un
quart-d'heure en forêt.
Vous m'aviseriez pour
la semaine prochaine, en-
tendu.
Vous nous feriez le
plus grand plaisir de
vous joindre à mon excellent
ami Picard.
J'aurai adieu et
tout à vous
admir Redon

Samois, près fontainebleau
S.-et- M.

July 10, 1889
My dear Maus,

I've just received your letter which gives me much pleasure to know you're so near us.

The way to arrive is this: in Paris, naturally, you go to the Gare du Nord, to get to the Gare de Lyon, where there are trains for Fontainebleau every hour.

From Fontainebleau to Samois, there are cars. It's a short distance—quarter of an hour in the forest. You'll let us know for next week, of course.

You'll give us much pleasure to join us with my really good friend, Picard.
Looking ahead,
Affectionately,
Odilon Redon
Samois, near Fontainebleau
S. -et –M

10 avril, 1915
Mon cher Aubry,
 Pour ne pas laisser Montaigne… Voudriez-vous me redire le titre du chapitre des Essais dont, hier, vous nous recommandiez la lecture et qu'Armaingaud trouvait une lecture tout-à-fait de circonstance?
Vous m'obligeriez.
Amitiés
Odilon Redon

April 10, 1915
My dear Aubry,
 Not to drop Montaigne—would you tell me again the title of the chapter in the Essays which you recommended to us yesterday, and that Armaingaud believed to be a reading absolutely appropriate to the circumstances?
You would help me.
Good wishes,
Odilon Redon

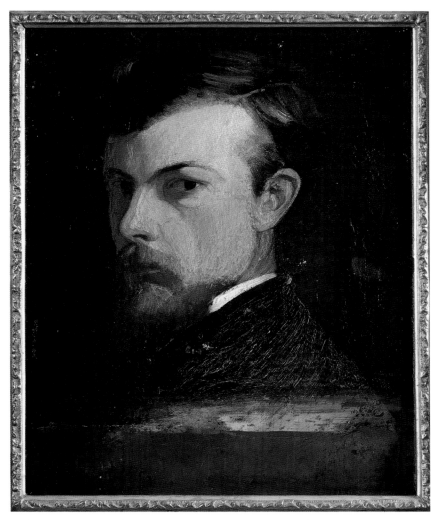

Self Portrait, 1867, by Odilon Redon. © National Portrait Gallery, Smithsonian Institution/Art Resource, New York.

Odilon Redon (1840-1916)

In the summer of 1888 Odilon Redon rented a house in Samois, deep in the forest of Fontainebleau. The artist, who was devastated by the recent death of his baby, had had little success in his Paris career, and he hoped that the bucolic surroundings would cheer and inspire him. As this pleasant letter suggests, Samois was a haven for the artist and his wife; they had many guests, including Octave Maus, the Belgian intellectual to whom this letter with travel instructions to Samois is written. As he had hoped, the summer in Samois was to be somewhat of a turning point for Redon

The artist was working in a highly original style; he was a maker of lithographs, images of dreams and fantasies, monsters and nightmarish creatures. "There are those," he wrote, "who want to confine the art of painting only to what they see... the great painters have proved...that the artist is genuinely free to take his subjects from history or the poets, or to see it in his imagination. While I recognize the necessity of the things seen as a base, true art is in reality felt."

Symbolism, Decadent art, and poetry had a certain vogue in Paris, but despite the efforts of his good friend, the writer Stephane Mallarmé, Redon had not received commissions, and he showed his works only rarely. Although

his black and white lithographs (he had not yet 'discovered' color) were included in Durand-Ruel's exhibition of painters and engravers, of particular importance to him were his contributions to the notable 1886 Salon des XX in Brussels.

It was in Brussels that his work created a stir. It brought him into contact with the small but influential group of avant garde artists and writers calling themselves Les XX. These twenty progressive artists, believers in 'pure art,' brought to Belgium many of Europe's most significant new art in their annual exhibitions (as well as concerts and lectures) between 1884 and 1893. In close touch with their Parisian counterparts, their influence was felt well beyond Brussels.

Among the champions of Redon's art in Belgium was Octave Maus. A founder in Brussels of a journal called "L'art Moderne," it was he who, after seeing the artist's lithographs at the Salon des XX, arranged for Redon's most important commission to date, the illustrations for a new mono-drama. The play was called "Le Juré," and it was written by Edmond Picard (who is also mentioned in this letter). Picard was a prestigious member of Les XX, as well as a critic, lawyer, Senator, and Marxist. He was the centerpoint of the radical arts in Belgium. His play concerned a juror's conscience as he condemned a man to death.

Picard was delighted to have Redon make the illustrations to be exhibited during the play's performance, and for the published edition. "Art that makes one think! Art that makes one dream! Art that mixes reality and mysticism!" he exclaimed. By the summer of 1888, Redon's lithographs for Picard's thoughtful drama were completed, to the evident satisfaction of both Maus and Picard. The artist went on to several other collaborations with the poets of Les XX, and Redon soon found himself taken up by Parisian artists and writers as well. His subsequent career blossomed—both as draftsman, and soon afterwards, as a painter.

Many years later, toward the end of his now highly regarded career, Redon sent a brief note to his friend Georges Aubry. A painter, critic, dealer, and friend to many artists, Aubry is best known today for his witty journal filled with anecdotes about painters and Parisian life in the first decade of the twentieth century. It would be intriguing to know which Montaigne essay had caught the attention of the two artists.

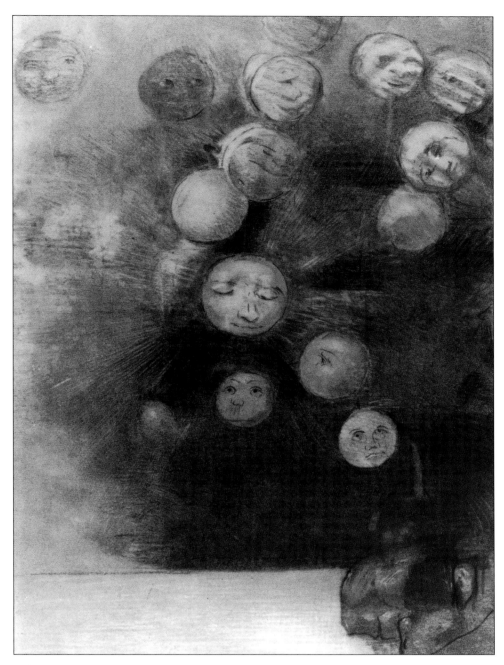

Pourquoi n'existerait-il pas un monde… (Why wouldn't a world exist…), by Odilon Redon. ©
Snark/Art Resource, New York.

Graphology notes on Odilon Redon

This artist is very intense and can block out all external stimuli when he is working.

He is a logical thinker who thinks things through carefully before making a decision.

He has a good consistent rhythm which keeps him balanced emotionally.

He has a dominating aspect to his personality, and he can be very stubborn at times, even when he knows he is wrong. There is evidence of impatience and a temper that can erupt. He is very sensitive to criticism that isn't constructive.

He tends to be clannish, choosing to be with people who are similar to him.

Emile Bernard
Letter to Albert Aurier in 1889

Mon cher Aurier.

Je devais vous envoyer une
épreuve de campagne mélan-
colique et douce de ma chère
Bretagne. et au lieu c'est
une lettre navrante que
je vous écris.

Pardonnez moi de le faire, mais
je suis tellement peiné, que j'ai
besoin de quelqu'un qui
daigne m'écouter un peu et
me comprendre.

Mon meilleur ami. mon
cher ami Vincent est fou.

2/ Depuis que j'ai appris cela je le sens presque moi même.
Voici.
atteint du mysticisme le plus profond, lisant la bible, et faisant des sermons dans tous les mauvais lieux aux gens les plus immondes, mon cher ami était arrivé à se croire un christ, un Dieu.
Sa vie de souffrance et de martyre me semble bien appropriée à faire de ce cerveau étonnant un être de l'au delà.
C'est ce qui est arrivé en effet prêtre à l'âge de 25 ans, et apportant déjà dans le protestantisme des reformes sur les theories anti-. naturelles de

certains lieux communs, député, rejetté du monde, il a commencé la vie du saint.
C'est plus tard qu'il va dans les mines et qu'il soigne dans la Sorcière un ouvrier en partie carbonisé par le grisou, et portant sur le front les traces d'une couronne d'épines. ses longs voyages à pied dans les campagnes Hollandaises et ses toiles mourantes d'ouvriers de la terre. voila une bonne partie de son existence anterieure à son séjour à Paris
Puis à Paris son extrème humanité pour les filles, car j'ai été temoin de scenes sublimes de devouement de sa part.

Enfin son départ a Arles 4
Gauguin revenant précipitam-
ment. Il y a 4 jours. Et la
nouvelle de Vincent. à l'hopital
J'ai couru voir Gauguin qui
m'a dit ceci.

La veille de mon départ (car
devait quitter Arles) Vincent
a couru après moi (il sortait
c'était la nuit) je me suis
retourné car depuis quelques
temps il devenait très drôle, moi
Je m'en défiais. Alors il m'a dit
Vous êtes taciturne, mais moi
je le serai aussi.

Depuis que je devais quitter
Arles il était tellement bizarre
que je ne vivais plus. Il m'avait
même dit "Vous allez partir

Et comme je lui dit "oui" il
a arraché d'un journal cette
phrase et me l'a mise dans la
main "le meurtrier a pris
la fuite"
Je suis allé coucher a l'hotel
et quand je suis revenu tout
Arles était devant chez nous.
Alors les gendarmes m'ont
arrêté, car la maison était
pleine de sang. Voici ce
qu'il s'était passé.
Vincent était rentré après
mon départ avait pris le
rasoir et s'était tranché net
l'oreille. Alors il s'était
couvert la tête d'un beret
profond et était allé dans
une maison publique

Mon cher Aurier

Je devais vous envoyer une épreuve de campagne mélancolique et douce de ma chère Bretagne, et au lieu c'est une lettre navrante que je vous écris.

Pardonnez moi de le faire, mais je suis tellement peiné, que j'ai besoin de quelqu'un qui daigne m'écouter un peu et me comprendre.

Mon meilleur ami, mon cher ami Vincent est fou. Depuis que j'ai appris cela, je le suis presque moi-même. Voici.

Atteint du mysticisme le plus profond, lisant la Bible, et faisant des sermons dans tous les mauvais lieux aux gens les plus immondes, mon chèr ami en était arrivé à se croire un Christ, un Dieu. Sa vie de souffrances et de martyr me semble bien appropriée à faire de ce cerveau étonnant un être de l'au-delà.

C'est ce qui est arrivé en effet. Prêtre à l'âge de 25 ans, il apportait déjà dans le protestantisme des réformes sur les théories anti-naturelles de certains lieux communs, dépité, rejeté du monde, il a commencé la vie du Saint.

C'est plus tard qu'il va dans les mines et qu'il soigne dans la Sorcière un ouvrier en partie carbonisé par le grisou, et portant sur le front les traces d'une couronne d'épines. Les longs voyages à pied dans les campagnes hollandaises et les toiles navrantes d'ouvriers de la terre. Voilà une bonne partie de son existence antérieure à sa séjour à Paris.

Puis á Paris son extrême humanité pour les filles, car j'ai été témoin de scènes sublimes de dévouement de sa part. Enfin son départ à Arles. Gauguin revenant précipitamment, il y a 4 jours, et la nouvelle de Vincent, à l'hopital. J'ai couru voir Gauguin qui m'a dit ceci.

La veille de mon depart (car il devait quitter Arles), Vincent a couru après moi (il sortait, c'était la nuit), je me suis retourné car depuis quelque temps il devenait très drôle, mais je m'en défais. Alors, il m'a dit: "Vous êtes taciturne mais mois je le serai aussi." Depuis que je devais quitter Arles il était tellement bizarre que je ne vivais plus. Il m'avait même dit: "Vous allez partir?" Et comme j'avais dit oui, il a arraché d'un journal cette phrase et me l'a mise dans la main: "Le meutrier a pris la fuite." Je suis allé coucher à l'hotel et quand je suis revenu tout Arles était devant chez nous. Alors les gendarmes m'ont arrêté, car la maison était plein de sang. Voici ce qu'il s'était passé. Vincent était rentré après mon départ, avait pris le rasoir et s'était tranché net l'oreille. Alors il s'était couvert la tête d'un béret profond et était allé dans une maison publique porter à une malheureuse l'oreille, en lui disant: "Tu te souviendras de moi, en vérité, je te le dis." Cette fille s'est évanouie immédiatement. Les gendarmes se sont mis sur pied et on est venu au logis.

Vincent a été mis à l'hôpital. Son état est pis, il veut coucher avec les malades, chasse la soeur, et se lave dans la boite à charbon. C'est à dire qu'il continue les macérations biblique.

On a été forcé de l'enfermer dans une chambre.

Quant à Gauguin, il a été relaché, indemné naturellement. Voici mon chèr Aurier cette chose navrante de laquelle je voudrais pleurer, mais je ne puis plus.

Maintenant pardonnez-moi de vous avoir raconté cela, mais c'est un soulagement pour moi car je vous crois assez mon ami pour compatir à mon chagrin, parce qu'aussi vous étiez intéressé à lui.

Mon cher ami est perdu, et ce ne serait qu'une question de temps pour sa prochaine mort. J'espère pourtant qu'il en sera autrement, préférant encore cette fois la douleur à la mort, et l'enfer au néant.

Je termine en avérant que je viens de perdre mon meilleur ami et un des cerveaux les plus admirables et puissants que j'ai connu. Je termine en vous serrant la main, vous demandant votre discrétion pour ces tristes choses qui nous abattent tant et qu'on doit cacher. Car il se trouve encore des gens assez misérables pour en rire. E. B.

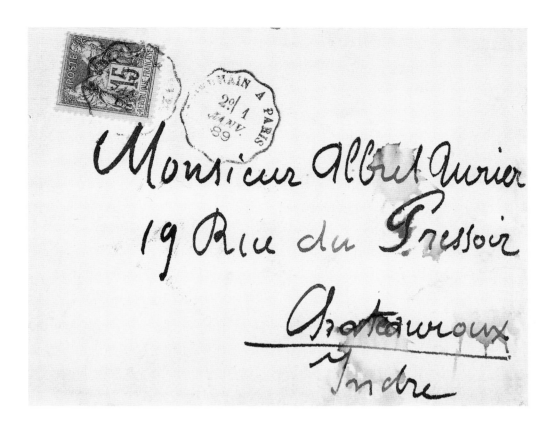

1 Jan '89
Monsieur Albert Aurier
19 rue du Pressoir
Chateauroux, Indre

My dear Aurier,

I was to send you an example of the melancholy and gentle countryside of my beloved Brittany, and instead I am writing to you a disturbing letter.

Forgive me for doing so, but I am in such pain that I need someone who's willing to listen and to understand me.

My best friend, my dear friend Vincent, has gone mad. I have been feeling almost the very same ever since I heard about it.

Moved by a profound mysticism, reading the Bible and preaching in all sorts of treacherous places to the lowest kind of people, my dear friend arrived at a moment where he thought he was Christ, a God. His life of suffering and martyrdom seems to me quite appropriate to turn that remarkable mind into a being beyond reach.

That is indeed what happened. A pastor at age 25, he already brought to Protestantism the reformed views of the anti-natural theories of commonplaces. Despised, rejected by the world, he started living a saint's life.

Later on he went down into the mines, one known as La Sorcière [*the witch*], and treated a worker partially burned in an incident of firedamp, wearing on his forehead the marks of a crown of thorns. Then too, his long trips on foot through the Dutch countryside, and his disturbing paintings of farm workers. That tells the story of a good part of his life before his stay in Paris.

Now, in Paris, he showed his extreme humanity towards street-girls, and I witnessed some sublime moments of his devotion. Finally, his departure for Arles, Gauguin leaving precipitously four days ago, and the news of Vincent's hospitalization. I rushed to see Gauguin, who told me this:

On the eve of my departure (he had to leave Arles) Vincent ran after me (he was going out, it was nighttime). I turned back because he had become very odd recently, though I didn't face it. Then he told me: "You are taciturn, but I will be as well." He had been so bizarre ever since I had to leave Arles, I couldn't live with it anymore. He said to me: "Are you going to leave?" And when I said yes, he tore a sentence from a newspaper and put it in my hand: "The murderer escaped."

I spent the night in a hotel and when I got back all of Arles was in front of our house. Then the gendarmes arrested me, because the house was full of blood. Here is what happened. Vincent went home right after I left, took the razor and just cut off his ear. Then he covered his head in a deep beret and went to a 'public house' to offer his ear to one of those unfortunate girls, to whom he said: "You will remember me, verily, I say unto you."

The girl fainted immediately. The gendarmes were called and came to the house.

Vincent was placed in a hospital. His condition has worsened, he wants to sleep with the sick, chases the nun away, and washes himself from the coal box. All of this to say that he continues his macerations, as in the Bible. They were forced to lock him up in a room.

As for Gauguin, he was released unharmed, naturally. There it is, my dear Aurier, the appalling thing I wish I could cry over but no longer can.

Now you must forgive me for telling you this, but it is a great relief to me, because I believe you are enough of a friend to empathize with my grief, and too, because you had shown an interest in him.

Now you understand why I am sending you this letter rather than the drawing, because having lost my own mind I have not been able to do anything since Sunday.

My dear friend is lost, and it is only a matter of time until he dies. Yet I hope this won't happen, preferring still pain over death, hell over nothingness.

I close confirming that I have just lost my best friend and one of the most admirable and powerful minds I have ever known. I close shaking your hand, asking for your discretion in these sad tales that wear us down, and that we must hide, because there are still some people miserable enough to laugh about such things. E. B.

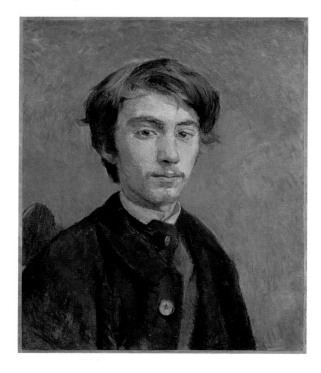

Portrait of Emile Bernard, 1885, by Henri de Toulouse-Lautrec. © Tate Gallery, London/Art Resource, New York.

Emile Bernard (1868-1941)

This poignant letter describing Vincent van Gogh's madness brings us both Emile Bernard's great dismay for his fellow artist and close friend, and a view into the complex relationships of the close-knit circle of Symbolist painters and writers that included Paul Gauguin and poet/critic Albert Aurier. On New Year's Day, 1889, Bernard (who signs himself simply E.B.) wrote to his friend Aurier to describe the terrible event that Gauguin had just been part of in Arles.

Bernard, who was only in his early twenties, had met Gauguin just three years before these events, and van Gogh in the past year. The artists painted together and when van Gogh went to live in Arles, they corresponded. Bernard's interest in Japonisme and his 'invention' of Cloisonnisme influenced van Gogh (and perhaps Gauguin), and the artists sent paintings and descriptions and criticisms of their work back and forth. But the nature of these relationships—and those of Bernard and Gauguin's with van Gogh—were the subject of much dissension. Who among them was responsible for leading the Symbolist group? Who influenced whom? Why did Bernard backdate a number of his paintings? Albert Aurier, a Symbolist poet and important and innovative critic of art, was also involved in these disputes. The year before this letter, he had dedicated a long article in the "Mercure de France" to van Gogh's work, and had given the artist credit for a concept that Gauguin claimed to have originated. (Both artists agreed that Aurier should have written an article about Gauguin first.)

Bernard was a painter who was as well known for his advocacy of other artists as for his own work. As a young man he was strongly influenced by the expressive outline and design of Japanese prints, and by Medieval enamels and stained glass (and the role of the artisan in making them). With these ideas in mind, he and his colleagues worked out a theory of art Bernard called "Cloisonnisme," which featured linear design, strong colors, and bold flat surfaces. It was a dramatic departure from naturalism. Bernard was also a forceful and articulate writer about art, as well as something of a religious mystic. With Gauguin and Maurice Denis he was a member of the Pont-Aven school in Brittany, and was one of the artists who formed a " brotherhood of Symbolists" in 1888.

Van Gogh's stormy friendship with Gauguin, particularly during the two months they had spent painting together in Arles, living at the "Maison Jaune" which van Gogh had rented, is the the most vague in their biographies. In this letter Bernard relates the horrifying story he had just heard from Gauguin, who had described to him the violent act in which van Gogh cut off his own ear with a razor. That story is perhaps the clearest version of it Gauguin ever told, or wrote. Bernard, learning of the declining state of van Gogh's sanity, was overcome by despair; his letter to Aurier is one of the only descriptions (other than Gauguin's later account, and Vincent's own letters, somewhat influenced by his illness) of this now legendary moment in the artist's descent into madness.

The anguish expressed here by Bernard suggests that van Gogh's human tragedy briefly transcended the artistic disputes that had colored these intense relationships. Bernard turns to Aurier for solace ("I believe you are enough of a friend to empathize with my grief"). Shortly thereafter Bernard and Gauguin had a falling out, and Gauguin later refused to help in a memorial exhibition for van Gogh. (On hearing of Van Gogh's suicide, Gauguin said merely "It was fortunate for him, the end of his sufferings."

Bernard eventually published the many letters he had received from van Gogh and Gauguin (among other artists)—letters that are most valuable to the study of the origins of modern art.

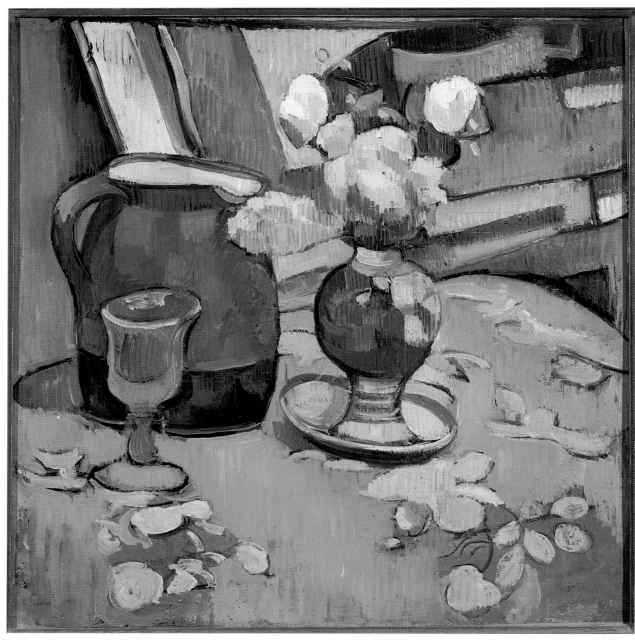

Still life with Pitcher and Vase with Yellow Flowers, by Emile Bernard. © private collection.

Graphology on Emile Bernard

This artist shares similar traits with others in this series: *confusion, fast, analytical, intuitive thinking, and argumentativeness.*

Writer has a tendency (*delta d's and Greek e's*) toward the literary, with a clear ability to think abstractly and on philosophical levels.

Very strong enthusiasm (*sweeping t bars*) that rival Mary Cassatt's.

Stress level is high, and when problems and traumas arise, he has a difficult time dealing with the pressure. Others around him feel the stress like a nearby storm. A short-lived temper. However, there are signs of poise, objectivity and good judgement.

Good mechanical skills, works well with hands.

Paul Signac
Letter to Henri Guérard in 1891

Paris 5/3/91
Cher Monsieur
Seriez-vous disposé à bien vouloir vouz associer à nous pour rendre hommage à notre pauvre Dubois-Pillet en consentant à nous prêter pour la durée de notre exposition, la très belle étude de notre camarade que vous possédez.

Nous faisons aux "Indépendents" une exposition aussi complète que possible de ses oeuvres et celle-là manquerait fort.

Dans l'attente de votre consentement, recevez, Monsieur Henri Guérard, mes très cordiales salutations.
P Signac
20 Avenue de Clichy

Paris 5/3/'91

Dear Sir,

Would you join us in a tribute to our poor Dubois-Pillet by agreeing to lend us, for the duration of our show, our comrade's very beautiful étude that you own.

We are putting together as complete an exhibit of his work as possible, at the "Indépendents," and that piece would be greatly missed.

While I wait to hear that you agree, please accept, Mr. Henri Guerard, my very cordial greetings.

PSignac
20 Avenue de Clichy

Letter to an editor of *Le Coeur* c. 1893

Cher Monsieur

De jour en jour je me promettais de vous écrire pour vous remercier de la bonne hospitalité que m'a offerte, si gracieusement "Le Coeur."

Excusez moi, je vous prie, d'avoir tant tardé à la faire et veuillez agréer avec mes remerciements, mes félicitations pour la campagne contre le muflisme contemporain qu'a entreprise "Le Coeur." C'est là le bon combat: et je suis fier d'avoir mon nom dans ces pages, entre le votre et celui d'Huysmans.

Cordiales poignées de main

PSignac
Place de Granier
St. Tropez

Dear Sir,

Day after day I have been promising myself that I would write to thank you for the warm hospitality *"le Coeur"* offered me so graciously.

Please forgive me for the delay in doing so and, together with my thanks, accept my congratulations for the campaign against contemporary boorishness launched by *"Le Coeur."* This is indeed the good fight: and I am proud to have my name in those pages, between yours and Huysmans.

A cordial handshake

PSignac

Place de Granier

St. Tropez

Photograph of Paul Signac.
© H. Roger-Viollet, Paris.

Paul Signac (1863-1935)

By May, 1891, when this first note was written, the influential French painter Paul Signac had assumed the leadership of the Neo-Impressionists. Among his undertakings were the organization of several memorial exhibitions on behalf of the "Société des Artistes Indépendents" in Paris. One featured an extensive retrospective of thirty-seven paintings and drawings by Seurat who had died in March. Another was a retrospective for Vincent van Gogh, a year after his death. The third was a tribute to another painter, an integral member of their circle—but today almost forgotten—named Albert Dubois-Pillet (1846-1890).

As a follower and colleague of Seurat, Signac was a driving force in the development of theories of Neo-Impressionism or "Divisionism," with its separation of pictorial space into small optical units based on the colors of the prism. Seeking a "scientific aesthetic," Signac wrote the definitive text on the scientific and artistic theories of Neo-Impressionism. By 1887 he had already become the spokesman and theoretician for the movement; Pissarro wrote to him, "the whole weight of Neo-Impressionism rests on your shoulders." Along with Seurat, Dubois-Pillet, and Pissarro, Signac did much "plein air" landscape painting (like their predecessors, the Impressionists). But they later re-worked their paintings in their studios using optical theories in an effort to balance the different elements of nature, "to achieve," according to Signac, "the most harmonious, luminous, and colorful result possible." It was an attempt to find a unity between science and art, nature and culture, a seeking of universal laws to govern "the harmonies of the senses." An avid sailor, Signac spent several years in St. Malo and St. Tropez, beginning in 1892.

Signac was joined by Dubois-Pillet in explaining and practicing Neo-Impressionism. Though an army officer by profession, Dubois-Pillet still managed to work as an artist in his spare time. He studied the treatises of scientific researchers, and in 1884 joined the band of rebels who founded and drew up the rules for the independent movement. Their slogan: "No jury, no prizes." A painter of "limpid landscapes," as one critic commented, Dubois-Pillet was also described as a "stimulating painter of twilight, morning, and spring in Paris." He was close to Signac both as a friend and artistic colleague, and when he died Signac was quick to organize a retrospective.

One of the owners of a work by Dubois-Pillet was Henri Guerard, to whom Signac sends this request. Saying that it would be greatly missed, he asks Guerard for "our comrade's very beautiful study" to be loaned for exhibition. Guerard, a recognized print maker and engraver himself, also wrote about art for various publications. Married to the Impressionist painter Eva Gonzales, he was a great friend and admirer of Manet, Gonzales' mentor, and he was well known in artistic circles.

In the brief note to "Le Coeur," where two different reviews of his work appeared in 1893, Signac thanks the paper for its "campaign against boorishness." He comments that it is a worthy cause, and mentions the noted novelist and critic Joris-Karl Huysmans whose writing had increasingly turned against materialism. "I am proud to have my name in those pages, between yours and Huysmans," he adds.

May 18, 1928
Mon cher Docteur:
J'arrive de St. Milo où je suis allé passer une quinzaine pour asíster à la partance de Terre Nuevas pour le Grand Banc.
Quelle leçon d'energie voir souvent ces rudes gars. Et pour la peinture, quelle joie! Ça vaut mieux que d'aller faire l'esthetique à la Rotonde. D'ailleurs, Stendahl, n'a-t-il pas ecrit: "Il faut toujours revenir à cet axiom—la voisinage

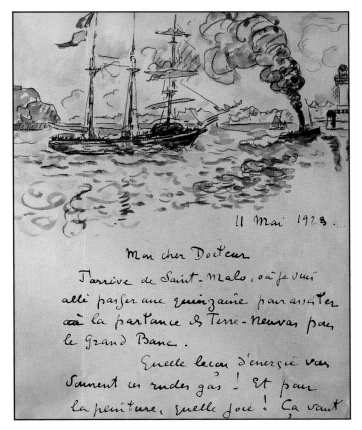
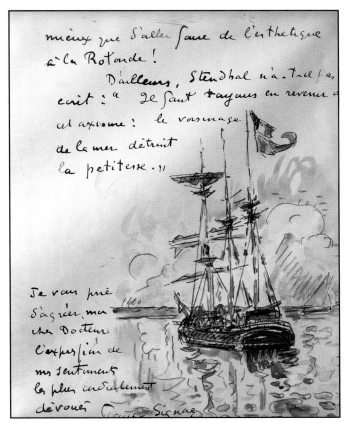

Letter with drawings of sailboats, aquarelle, by Paul Signac. © Private collection.

de la mer detruit la petitesse."
Je vous prie d'agréer, mon cher docteur, l'expression de mes sentiments les plus cordialement dèvouées.
Paul Signac

May 18, 1928
My dear doctor:
I'm back from St. Malo, where I spent two weeks watching the departure of "Terre Nuevas" for the Grand Banks.
What a lesson in energy to watch those husky fellows so often! And as for painting, what joy! Far better than talking about it at the Rotonde. Actually, didn't Stendahl write: "One must always go back to that axiom, 'Proximity to the sea destroys pettiness.'"
I assure you, my dear doctor, of my cordial and devoted feelings for you.
Paul Signac

> ### *Graphology notes on Paul Signac*
> *This artist is a slow and methodical thinker who uses logic instead of his emotions.*
> *He thinks things through very carefully before committing to a decision.*
> *He is very decisive and is also intuitive. This trait will speed up the decision making process.*
> *His willpower and drive are very strong, but he will never plunge headlong into anything before thinking things through.*
> *He is self conscious and is somewhat sensitive to criticism that isn't constructive.*
> *He is argumentative and defensive and on occasion can display a temper.*
> *His mechanical aptitudes are strong. He is precise and displays a consistent rhythm.*

Mary Cassatt
Letter to Camille Pissarro, undated

10 rue de Marignan
Thursday

My Dear Mr Pissarro

I thank you
& Madame Pissarro very
much for your kind re-
ception of Mrs Cranston and
her daughter. They came
to me with a letter from
Alden Wier. & I think
there can be no doubt as
to their solvency, I was
very much pleased with
them both. Mrs Cranston
told me that they had had
some losses since they

left America & for that
reason they wish to be
economical. They were
charmed & most grateful
for your kindness & I
think you will find
the daughter intelligent
& artistic. I must
apologise for troubling
you so much with
Americans, but I hope
to see some advantage to
your american reputation
come from American
pupils, they tell me
that it was through
an American pupil
that Monet first found
sale for his pictures in

America. As Mrs Cranston
told you we are going
South but only for a
few weeks to get my
Mother away from
the Paris winter & give
us both as well as my
sister-in-law & her little
boy a change of scene.
I hope to be able
to go with my sister in
law to Florence for
a few days leaving
my Mother on the Riviera.
I am pining for a sight
of the Botticelli's. We
expect to return to Paris
in March & I hope
to Bachvillers for

the summer. I so love the country I long to be back there — Mrs Cranston & her daughter were most enthusiastic over one of your last landscapes I wish I could see it. You will see something of mine at Durand Ruel's when you go there, I never saw such a dreary place as it seems just now in the rue Laffitte.

With kindest regards to Madame Pissarro & your children ... me my Mother & me believe me very very sincerely Mary Cassatt

10 rue de Marignon
Thursday

My Dear Mr. Pissarro,

Thank you and Madame Pissarro very much for your kind support of Mrs. Cranston and her daughter. They came to me with a letter from Alden Weir and I think there can be no doubt as to their solvency. I was very much pleased with them both. Mrs. Cranston told me that they had some losses since they left America and for that reason they wish to be economical. They were charmed and most grateful for your kindness and I think you will find the daughter intelligent and artistic. I must apologize for troubling you so much with Americans but I hope to see some advantage to your American reputation come from American pupils. They tell me that it was through an American pupil that Monet first found sale for his pictures in America. As Mrs. Cranston told you,

we are going south but only for a few weeks to get my mother away from the Paris winter and give us both, as well as my sister-in-law and her little boy, a change of scene.

I hope to be able to go with my sister-in-law to Florence for a few days leaving my mother on the Riviera. I am longing for a sight of the Botticellis. We expect to return to Paris in March and I hope to Bachivillers for the summer. I so love the country. I long to be back there. Mrs. Cranston and her daughter were most enthusiastic over one of your last landscapes. I wish I could see it. You will see something of mine at Durand-Ruel's if you go there. I never saw such a dreary place as it seems just now in the rue Lafitte.

With kindest regards to Madame Pissarro and the children from my mother and me, believe me ever yours,

Sincerely,
Mary Cassatt

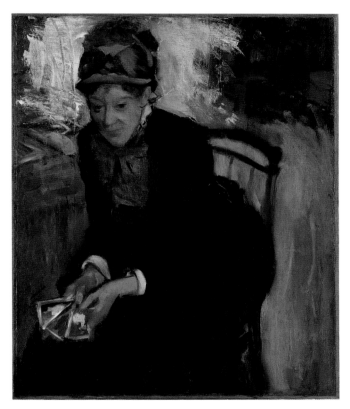

Portrait of Mary Cassatt, by Edgar Degas. © National Portrait Gallery, Smithsonian Institution/Art Resource, New York.

Mary Cassatt (1845-1927)

In this typically gracious letter, the Impressionist painter Mary Cassatt discusses a couple of well-to-do Americans with her great friend and colleague Camille Pissarro. One of the most generous of painters, she not only collected her fellow artists' works herself, but regularly steered prospective buyers and students to them. Her efforts to bring French Impressionism to the taste-makers of America were vital.

Cassatt, who was an American who made her home and her career in France, was nonetheless in touch with many collectors from the United States. It was through her introductions to artists and her guidance that many of the great American collections of Impressionism exist today. "It has been one of the

chief pleasures of my life," she wrote in 1909, "to help fine things cross the Atlantic." (Among the American patrons was her dear friend Louisine Havemeyer, who said of her, "I felt that Miss Cassatt was the most intelligent woman I had ever met...no one could see art more understandingly.") Cassatt introduced her and numerous other Americans taking 'The Grand Tour' to her colleagues.

In this letter she writes of a mother and daughter named Cranston whom she has sent to see Pissarro, in hopes that they might take lessons from him or purchase his paintings. Like many Americans whom she introduced to Paris and to the art world, they had come to her with a letter from the American painter, J. Alden Weir. Perhaps with Pissarro's great financial need in mind, she describes the visitors as having had some losses and wanting to be "economical," but says, "there can be no doubt of their solvency."

Cassatt was admitted into the close-knit circle of the Impressionists after becoming a student of Degas. She became a central member of the group, associating also with Monet, Pissarro, Morisot, Renoir, and Manet, both as an artist and as a dear friend. She also exhibited with them at the Impressionist Salon, and her works, like the other Impressionists', were handled by the Durand-Ruel Gallery. In 1891 she had her first solo show there. One of the few women artists in the nineteenth century to succeed professionally, she was admired by the French, even receiving the Legion of Honor, while Americans took little notice of her. (At the height of her career, she arrived back in her native Philadelphia for a visit and the local paper commented that "Miss Cassatt has been studying painting in France.") Her works—many of them domestic scenes of mothers and children—combined traditional subject matter with strong, interesting compositions and elegant draftsmanship.

Cassatt's unconventional life as a professional artist was, in fact, devoted as well to her family. She never married and she became the mainstay for both of her parents, who came to France to live with her. After her father's death, her beloved mother was her constant companion, and whenever she travelled she took her mother with her. She also frequently cared for (and painted) the children in her family.

In this undated winter letter, written from the rue de Marignan in Paris, where she moved in 1886, she is soon to leave on a trip for her mother's health and for a change of scene for her sister-in-law and her little boy. It was probably written in 1892, when she made the first of many trips to the South of France. (The black-bordered stationary suggests that less than a year had passed since the death of her father in 1891.) In the summer she hopes to return to Bachivillers, the chateau found for her—probably by Pissarro—in 1883. This great estate was in Seine-et-Oise, not far from his home in the country, and for a decade the Cassatts rented it as a summer home until it was suddenly sold in 1894.

Cassatt's efforts on behalf of her fellow Impressionists were already quite successful by this time. In the last decade of the nineteenth century, led by the success of Monet, Impressionism would become not only acceptable, but in demand. Most tellingly in her letter Cassatt remarks to Pissarro that she "hopes to see some advantage to your American reputation."

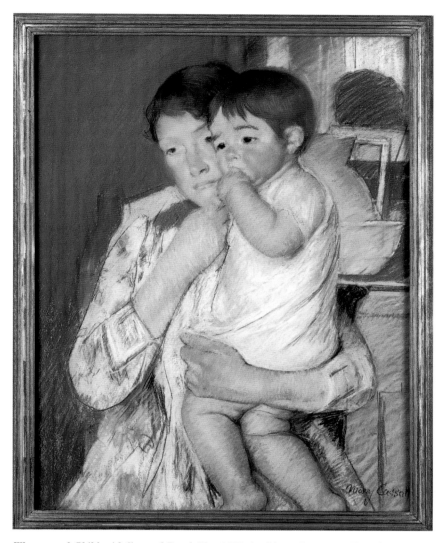

Woman and Child with Jar and Bowl, Var, 1889, by Mary Cassatt. © Réunion des Musées Nationaux/Art Resource, New York.

Graphology notes on Mary Cassatt

The artist is emotional with a hand writing that leans about as far as sane people can get to the right. This volcanic emotionality is mainly controlled by pride in self, and in the writer's abilities. Writer supports an inflated self-esteem that requires endless adoration from others, and this is moderated by common sense attention to manners and traditions.

The writer is wildly enthusiastic, with a confusion of interests that provoke disorganization and may limit productivity. The writer keeps too many irons in the fire, but it is both tenacious and persistent in an effort to keep all of them moving.

Initiative is clear in the breakaway stroke at the ends of the letters, but usually the t. Writer is quite sensitive to criticism, and takes unconstructive criticism personally.

There is deep resentment of anyone who tries to tell writer what to do, or lurks too close in an authoritative posture.

Showmanship and flair are apparent in the stylish and fluid formations of most letters.

There is some intuition exhibited, but mostly the writer's thinking is analytical and investigative. This person takes the time to slow down emotional impulsiveness with the application of logic and reason.

There are some indications of jealousy, envy and a worrisome fear that the writer's powers may in some way be usurped.

Henri-Edmond Cross
Letter to Georges Lecomte in 1893

26 mars 1893

Mon cher M. Lecomte,

 J'éprouve le besoin immédiat de vous remercier pour les heures d'émotion féroce que je vous dois et de vous féliciter de grand coeur pour le bel ensemble de "Mirages", cette analyse profonde.

 N'est-ce pas beaucoup de nous, les torturés, les inquiéts; beaucoup de notre coeur et de notre cerveau, les mille observations parsemées dans votre beau drame!

 La pensée que je vais pouvoir demain soir replonger mon esprit dans cet état d'enveloppante tristesse, me charme. Encore mes bien sincères félicitations et les remerciements de votre reconnaissant et dévoué

 Henri Cross

 18 rue de Siam

———

*tristesse, me charme.
Encore mes bien sincères
félicitations, et les remercie-
ments de votre reconnaissant
et dévoué
Henri Cross*

18 rue de Siam

26 March 1893

Dear Mr. Lecomte,

I feel I must thank you warmly for the hours of fierce emotion I owe to you, and to congratulate you from the bottom of my heart for the marvelous text of "Mirages," that profound analysis...

Isn't it many of us, the tortured, the restless, so much of our hearts and minds, the thousand observations strewn through your gorgeous play!

The thought that I'm going to be able, tomorrow night, to replunge my spirit into that all-enveloping sadness delights me. Again, my sincere congratulations and thanks, from your grateful and devoted

Henri Cross

18 rue de Siam

Portrait, Henri-Edmond Cross,
1898, by Maximilien Luce. Musée
d'Orsay, Paris © Erich Lessing/
Art Resource, New York.

Henri-Edmond Cross (1856-1910)

Henri-Edmond Cross had just been to see a drama by a French writer named Georges Lecomte. In 1883, when Cross sent this note, both men were important figures in the new cultural movements of their time. Cross was a painter who exhibited at the Impressionist Salons and had become a leading theorist of Neo-Impressionism. Lecomte was a knowledgeable writer on art, a champion of Pissarro and other avant-garde painters, and an editor of a Symbolist journal called *La Cravache parisienne*. He became a member of the Académie Française, and was its "perpetual secretary." (He also tried his hand at writing plays, including a drama called "Mirages," which Cross admires in his note.)

Interaction between artists and writers was a characteristic of this time of cultural ferment in Paris, when new movements, new journals, brilliant critics, and changing definitions of art were so prevalent. Both Cross and Lecomte were friends and colleagues of the leading cultural critic, Félix Fénéon, and were active in formulating new directions in the arts. As is evident from this letter (and so many others written by artists and writers to one another), they were attentive to one another's works, and did not hesitate to send a note or a critique.

Cross (who was born with the name Delacroix) had been a founder in 1884 of the Société des Artistes Indépendants, along with Signac and Seurat. Abandoning his rather academic Impressionist style, Cross became a believer in—as well as a leading theorist of—"Divisionism" (or what is now known as Neo-Impressionism). When Cross wrote this admiring note, he was a member of the small group of Neo-Impressionist painters, including Seurat and Signac, who formed the nucleus of the movement. They devoted themselves to painting outdoors, and to scientifically rendering in tiny dots the changing light and color they observed in different times of the day and year. ("I am engrossed in this question of exactitude, seeking it in the laws of contrasting colors," he wrote.)

But Cross was not satisfied for long with his search for "exactitude." He was torn between theory and his desire for a form of self-expression in art. This note predates his break with the more formal aspects of Neo-Impressionism, and his turn toward a more lyrical, sensation-filled style. Eventually his high-keyed landscapes moved away from theory to a more sensual, lyrical use of color. ("Can the goal of art be nothing more than to set fragments of Nature in a rectangle, with what taste the artist has at his disposal?...I come back to the idea of chromatic harmonies created outside of Nature.")

By the turn of the century, his work, particularly his watercolors of Provence, had some passing influence with the first Fauvist painters, including Matisse, Braque and Derain, thus creating a bridge between the Neo-Impressionists and those first modernists who divorced visual reality from art. Matisse, in particular, became friendly with Cross, and it's been said that Cross helped the younger artist "rediscover color."

With its vividly descriptive phrases, Cross' note suggests a freer more emotional personality than that of the quasi-scientific color theorist.

Les Iles d'or, Iles d'Hyères, Var, 1891-1892, by Henri-Edmond Cross. © Erich Lessing/Art Resource, New York.

Graphology notes on Henri-Edmond Cross

Artist enjoys a stylish, well balanced personal rhythm.

Handles stress well; in the face of pressure, writer moves on.

Thinking is investigative, analytical, and intuitive. Writer is direct.

Writer is open-minded and organized with a fluid manner of expression.

Signs of secretiveness, and sensitivity to unconstructive criticism. Pride in himself and his abilities.

Writer prefers to talk rather than listen.

A literary bent (delta d's).

Abstract imagination (mystical, religious, scientific).

A pleasant sense of humor.

Pierre-Auguste Renoir
Letter to an unknown recipient

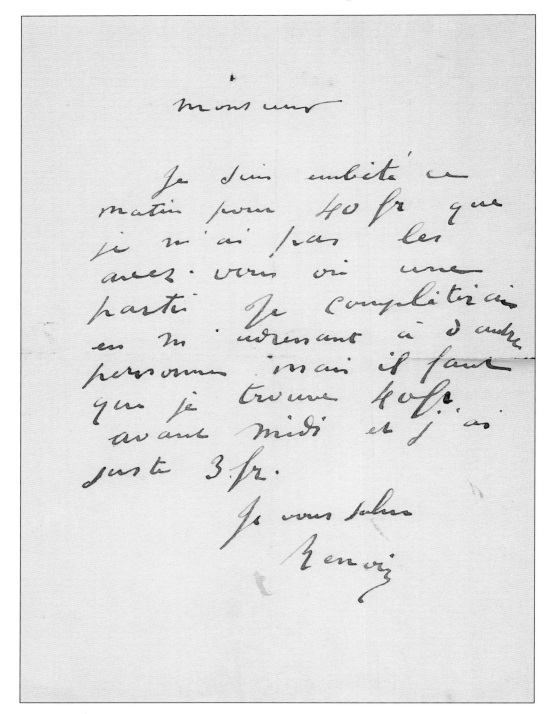

Monsieur

Je suis embêté ce matin pour 40 francs que j'en ai pas. Les avez-vous ou une partie. Je complêterai en m'adressant à d'autres personnes mais il faut que je trouve 40 francs avant midi et j'ai juste 3 francs.

Je vous salue

Renoir

————

Sir,

I'm in difficulty this morning for 40 francs, which I don't have. Would you have it, or part of it? I'll make up the difference by asking others, but I have to find 40 francs before noon and I have only 3 francs.

Salutations

Renoir

[*Written in the late 1870s or early 1880s, one franc in 2003 would be worth approximately 3 euros.*]

Letter to Claude Monet in 1894

Mon cher ami,

Je quitte la commission. Il y avait un amiral et le conservateur des antiquités égyptiennes, entre autres. Ils sont partis sans rien dire après une réunion à huis-clos. Ils étaient bien une vingtaine.

La vente Duret n'a pas marché presque tout ayant été racheté par Durand-Ruel.

Je vais être tranquille pendant quelque temps, ces messieurs de la commission prenant leur congé de Pâques. J'espère pouvoir travailler un tantinet—si mes sacrés dents veulent bien me ficher la paix. Charlotte est venue déjeuner à la maison—elle m'a dit qu'elle t'avait entrevu à la vente.

Je n'ai je crois plus rien à t'apprendre. Je n'ai plus qu'à souhaiter une plus prompte guérison à Madame Monet. J'ai toujours l'intention d'aller te voir aussitôt que ma santé permettra. Decondy m'accompagnera peut-être, mais je t'écrira d'avance sachant que tu dois aller à Argenteuil chercher des plantes ou graines.

A toi,
Renoir, mardi soir

My dear friend,

I've just left the commission. Among others, there was an admiral, and the curator of Egyptian antiquities. They left without saying anything, after a closed meeting. There were about twenty in all.

The Duret sale didn't go well, and almost everything was bought back by Durand-Ruel.

I won't be disturbed for some time as these gentlemen take a holiday at Easter. I hope to work for a bit if my damn teeth give me some peace. Charlotte came here for lunch at home—she told me she caught a glimpse of you at the sale.

I have nothing else to tell you. Mainly, I hope Madame Monet will be well very soon. I'm still planning to come to visit you as soon as my health permits. Decondy will come with me, perhaps, but I'll write ahead, since I know you must go to Argenteuil to look for plants and seeds.

Yours, Renoir
Tuesday night

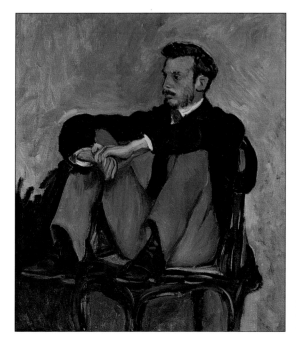

Portrait of Renoir, 1867, by Frédéric Bazille. © Erich Lessing/ Art Resource, New York.

Pierre-Auguste Renoir (1841-1919)

Pierre-Auguste Renoir, who was to become so central to the art of his period, began, like so many of his colleagues, in need of funds. In this short, desperate appeal, he asks for help.

Clear evidence of the painful financial situation endured by the Impressionists can be found in this very brief note written by Renoir to an unknown, hopefully generous, benefactor. Renoir has only three francs and needs to find forty francs by noon. He writes he will try to collect the money from other people as well.

Only a few years later, Renoir and Claude Monet, leaders of the Impressionist movement, received both the acclaim and the insults of an art world that found their style of painting either thrilling and new, or disgraceful and unseemly. In a letter, written by Renoir to his good friend Monet, we find a sample of the on-going battle between the status quo of the museum world in Paris and the "new" art. The letter, dated 1894, refers to meetings of a "commission" and to Renoir's irritation with art-world politics.

The situation was precipitated by the death of their fellow painter Gustave Caillebotte. Both an artist and a well-to-do collector, Caillebotte had amassed a collection of paintings by his friends, including Monet, Renoir, Pissarro, and Cézanne. Caillebotte had been a strong and helpful force for the Impressionists during his lifetime. When he died in 1894, he left his extraordinary collection to the Musée de Luxembourg and made Renoir his executor. Shortly thereafter a great battle over artistic taste ensued.

The bequest included sixty-seven paintings. A commission of twenty people was set up (including, as Renoir scornfully notes in his letter, an admiral and a curator of ancient Egyptian antiquities). On the advice of the Institut de France, the government rejected Caillebotte's donation to the museum. Venerable painters of the old school like Gérome and Bouguereau gave dire warnings. "Renoir doesn't even know how to hold a pencil!" commented Gérome, describing him as "a veritable 'malfaiteur' *[a real criminal]* who has detracted from the education of young artists and who has nothing to excuse him…" And, noted Bouguereau, "There are some people who like Impressionism, since it sells." Negotiations went on and on. The meeting described in this letter was one of many; at this one, Renoir, as executor of the estate, was present but not allowed into the closed-door discussion.

The press found out about the situation and protests were printed. Even Clemenceau intervened. The museum's advisory committee was forced to reconsider and yielded, in part. They were willing to accept more than half of the paintings, but refused one Manet, eight Monets, two Renoirs, three Cézannes, three Sisleys, and eleven Pissarros. (Among the discarded works were Renoir's "Moulin de la Galette," and Pissarro's "Red Roofs.") But this decision was yet to come.

Bouguereau was, in fact, right in his assessment, for the Impressionists were beginning to find their work in demand. Both Théodore Duret and the Gallery Durand-Ruel were exhibiting Impressionism. Renoir notes in this letter that Duret was putting on a show of their painting and that works were being resold by Durand-Ruel, long the champion of the Impressionists. A painting by Renoir, "La Toilette," that had been purchased in 1875 by Duret for 460 francs was sold twenty years later for 17,200 francs. Paintings by Renoir and Monet were being acquired for ever increasing prices by collectors both in France and the United States, and the museum's grudging acceptance of Caillebotte's collection was soon to appear embarrassing. It wasn't until 1928 that the Louvre officially accepted the remainder of the original bequest. Today the Caillebotte collection forms a nucleus of Impressionist art at the Musée d'Orsay.

In this letter Renoir, thoroughly annoyed by both his experience at the commission and by the pain his teeth are giving him, hopes to get back to work, and to visit with his dear friends.

The travails of the now-famous Renoir on a government commission of 1894, as seen in this second letter, make a sharp contrast with the hand-to-mouth existence experienced by the unknown Renoir some years before, as illustrated by the first note.

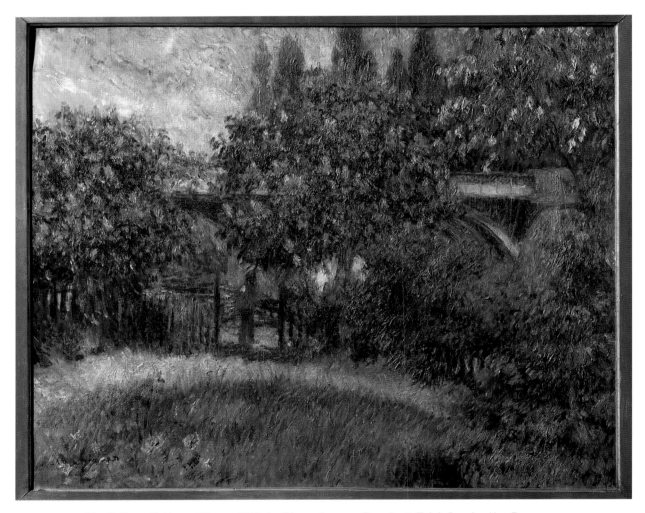

The Railway Bridge at Chatou, 1801, by Pierre-Auguste Renoir. © Erich Lessing/Art Resource, New York.

Graphology notes on Pierre-Auguste Renoir

This artist is narrow in his approach to life. He is more comfortable with "the tried and the true."

He can get his own information first-hand and can weigh and evaluate his findings.

His imagination lies in the abstract, philosophical area.

He is not direct, but he is frank in his communications and his integrity level appears to be strong. He enjoys being with people, and he can be sympathetic to their needs.

He exerts good self control when pursuing an objective.

He enjoys talking and is not a good listener.

He is decisive, and the ability to take the initiative is a strong trait.

Henri de Toulouse-Lautrec
Letter to an unknown recipient, in 1884 or 1885

Rendez-vous au bar à 6 1/2 aujourd'hui ou lundi. Je veux vous parler de l'aff. Chap Book
Votre TLautrec

Rendezvous at the bar at 6:30 today or Monday. I would like to talk to you about the Chap Book.
Yours, TLautrec

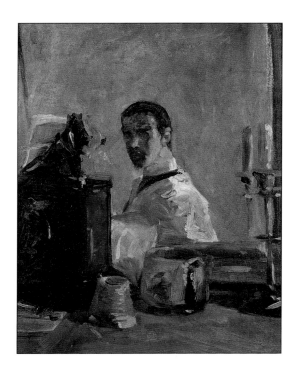

Self Portrait, by Henri de Toulouse-Lautrec. © Giraudon/Art Resource, New York.

Henri de Toulouse-Lautrec (1864-1901)

The letter paper on which Henri de Toulouse-Lautrec wrote this typically short note bears the names of two of the artist's important venues: "La Plume" (a review) and "Salon des Cents" (an exhibition space). "La Plume" was a bimonthly literary magazine, founded in 1889 as a review for the avant-garde in both art and literature and published by the Galerie de la Plume. It was this gallery that organized some fifty "Salon des Cent" between 1894 and 1900, a series of monthly exhibitions that featured "peinture, sculpture, gravure, et objets d'art industriel." In 1895 Toulouse-Lautrec made the poster for their international poster show, and subscribers received a copy of his poster as a premium. During the 1890s he showed many prints there, and in the Third Salon he even exhibited the lithographic stones from his café concert series (contending that the process was as important as the finished art).

Also in 1895 Toulouse-Lautrec's cover introducing an American literary review called "The Chap Book" was published in Paris by "La Plume." Known for his brief and imperious letters, the artist typically invites the recipient to a rendezvous at a bar. He wants to discuss "The Chap Book." Like all of his work, the subject he chose to make for the cover reflected his own life and experiences. His picture for the magazine, a lithograph printed in color, shows the Irish American Bar on the rue Royale, where the artist presided over a varied circle of clients and friends, excluding those he disliked, and, as a noted Anglophile, favoring English racing fans and trainers, as well as assorted bohemians and circus performers. (The bartender shown in the picture was a San Franciscan of Chinese-American descent named Ralph; and Tom, coachman to the Rothschilds, is at the far right.) The bar was described in its time as "a sour atmosphere of pale ale, gin, and smoke," but Toulouse-Lautrec, with his typically spare and eloquent line, used it to create another memorable image. This might be the bar where the 6:30 meeting is to occur.

Toulouse-Lautrec was a painter and print-maker of many such dashing pictures of fin-de-siecle Paris. He was also the artist who revolutionized the field of lithography, and with it, art for commercial use. His brilliant depictions of the Parisian demi-monde—the music halls, bars, theaters, and brothels that he frequented—created a stunning pictorial mythology of the nightlife of his time. Despite his congenital dwarfism and early death at thirty-seven

from a combination of heavy drinking and probably syphilis, Toulouse-Lautrec was an extraordinarily prolific and vibrant artist, creating dozens of memorable images. His dashing style with its brilliant asymetrical design was influenced both by his colleague, Edgar Degas, and by Japanese prints that had been lately shown in Paris. But his work was unmistakably his own, with its strong interest in character, its exceptional draftsmanship, brilliant color, and above all, its sense of immediacy.

Unlike most of his illustrious colleagues in later nineteenth century Paris, Toulouse-Lautrec devoted himself as much to posters, drawings, and print-making as to painting. It was this predilection for various methods of reproduction that led to the fashion for art in advertising, for Toulouse-Lautrec was one of the first artists to combine an original pictorial image with the printing of titles, such as those of plays, reviews, and magazines. His dynamic designs were put to the use of numerous venues in Paris in a mutual enterprise benefitting both artist and patron. His posters were available for sale to anyone who could afford the very reasonable price. These posters, illustrated books, program covers, and magazine designs combine to present a visual history of their time. Thus, although Toulouse-Lautrec cannot be said to have had disciples, nor to have created a "movement" in art, his work had a profound effect, for the illustrated program or artistic advertisement for dance or drama or pictorial poster of today have their origins in his contribution.

Poster, the Chap Book, by Henri de Toulouse-Lautrec. © Scala/Art Resource, New York.

Graphology notes on Henri de Toulous-Lautrec
This artist has an expansive personality and requires lots of space.
He would get claustrophobic in a small area.
He is very open-minded, and enjoys being with all different types of people.
He is analytical as well as being a logical thinker.
He is secretive about himself. Even though his exterior is outgoing, he is not always frank and will be evasive when talking personally.
He has strong determination and his persistence works well for accomplishing the practical goals that he has set.

Paul Gauguin
Letter to Ambroise Vollard in 1901

Mai 1901

Cher monsieur

Le courrier nous arrive avec beaucoup de retard;
malgré cela je n'ai reçu aucune lettre de
vous. Cependant la Caise Agricole a reçu avis
du Crédit Lyonnais de votre chèque de 350ᵗ.
Peut-être le double va arriver dans quelques jours
par voie Marseille cependant cette voie met
2 mois pour venir tandisque celui de San-Francisco
met un mois. Enfin un petit bonheur et espérons
ces jours-ci sinon il faudra attendre à nouveau
4 mois.
Désormais vous m'enverrez l'argent par
la Société commerciale à Tahiti à sa maison
mère à Hamburg et me paiera aux Marquises
d'après ordre d'Hamburg.
Mettez-vous donc en correspondance avec cette maison
qui vous donnera toutes les indications.
Voici l'adresse.
Mʳˢ Scharf et Kayser
Ferdinandstrasse 30
Hamburg-
Quant aux lettres vous m'écrirez désormais
Monsieur Gauguin à la Dominique
aux marquises
Etablissᵗ dᵗ Océanie -

Quant aux colis postaux.
écrire - Société Commerciale Tahiti
pour faire parvenir à Mʳ Gauguin.

Nos correspondances vont se trouver reculées et
mettre 5 à 6 mois entre une demande et
une réponse aussi je vous prierai autant que
possible de traiter toute affaire en vous concertant
avec Daniel en qui on peut avoir toute confiance
et qui a ordre de traiter de lui même pour
éviter tous ces retards.
Oui je me décide à aller aux Marquises à cause
de ma santé d'abord puis surtout à cause du
travail. Ce sera du retard je sais mais nous
y gagnerons tous deux car j'ai un peu usé
de Tahiti et là bas je vais trouver un élément
tout à fait nouveau qui me fera faire du bon
travail - Pour votre vente à la clientèle vous
aurez alors tout autre chose à montrer.
Enfin écrivez-moi au reçu de ma lettre aux
marquises. Même si je n'étais pas parti votre
lettre me parviendrait car la correspondance
passe par Tahiti auparavant et la Société
Commerciale a son siège à Tahiti et succursale
aux marquises. Pour argent elle est de toute
sûreté -
Je n'ai pas encore reçu la toile que vous

m'aviez promise. Celle que vous m'avez
envoyée est très difficile à travailler et mange
beaucoup de couleurs.
Ce qu'il me faut c'est de la toile non préparée
et alors de la colle de Peau
Ou bien de la toile que vous ferez encoller
seulement sans préparation à l'huile.
Avec la colle de peau que vous m'enverrez
j'y ajouterai une deuxième préparation avec blanc.
Il me faut aussi du blanc d'argent
pas mal de tubes car dans quelques temps
je vais en manquer
Merci à vous
Paul Gauguin.

7 mai 1901
Cher monsieur
 Le courrier nous arrive avec beaucoup de retard; malgré celà je n'ai reçu aucune lettre de vous. Cependant la Caisse Agricole a reçu avis du Crédit Lyonnais de votre chèque de 350F.
 Peut-être le double va arriver dans quelque jours par voie Marseille, cependant cette voie met deux mois pour venir tandis que celui de San Francisco met un mois. Enfin au petit bonheur et espérons ces jours-ci sinon il faudra attendre à nouveau quatre mois.
 Désormais vous m'enverrez l'argent par la Société Commericale à Tahiti et sa maison mère à Hambourg me paiera aux Marquises d'après d'Hambourg.
 Mettez-vous donc en correspondance avec cette maison qui vous donnera toutes les indications. Voice l'addresse.
 Messrs. Scharf et Kayser
 Ferdinandstrasse 30
 Hamburg
 Quant aux lettres vous m'écrirez désormais
 Monsieur Gauguin à la Dominique aux Marquises
 Establisses d'Océanie

Quant aux colis postaux
 Ecrire—Société Commerciale Tahiti
 pour faire parvenir à M. Gauguin.

Nos correspondances vont se trouver reculées et mettre 5 à 6 mois entre une demande et une réponse aussi je vous prierai autant que possible de traiter toute affaire en vous concertant avec Daniel en qui on peut avoir toute confiance et qui a ordre de traiter de lui même pour éviter tous ces retards.

Oui je me décide à aller aux Marquises à cause de ma santé puis surtout à cause du travail. Ce sera du retard je sais mais nous y gagnerons tous deux car j'ai un peu usé de Tahiti et là bas je vais trouver un élément tout à fait nouveau qui me fera faire du bon travail. Pour votre vente à la cleintèle vous aurez alors tout autre chose à montrer.

Ainsi écrivez-moi au reçu de ma lettre aux Marquises. Même si je n'étais pas parti votre lettre me parviendrait car la correspondance passe par Tahiti auparavant la Société Commerciale á son siege à Tahiti et succursale aux Marquises. Pour argent elle est de toute sûreté.

Je n'ai pas encore reçu la toile que vous m'aviez promise. Celle que vous m'avez envoyée est très difficile à travailler et mange beaucoup de couleurs.

Ce qu'il me faut c'est de la toile non préparé et alors de la colle de peau.

Ou bien de la toile que vous ferez encoller seulement sans préparation à l'huile. Avec de la colle de peau que vous m'enverrez j'y ajouterai une deuxième préparation avec blanc.

Il me faut aussi du blanc d'argent pas mal de tubes car dans quelques temps je vais en manquer.
 Tout à vous
 Paul Gauguin

———

7 May 1901
Dear Monsieur,
The courier arrives here very late; even allowing for that I have not received any letter from you. However the Caisse Agricole has been notified by the Crédit Lyonnais of your check for 350 francs.

Perhaps the duplicate will arrive in several days by way of Marseille, however, that route takes two months to come, while that of San Francisco takes one month. Anyway, here's to a stroke of good luck, and let's hope that it comes one of these days, otherwise it will again be a wait of another four months.

Henceforth you can send me money by the Société Commerciale of Tahiti and its parent house at Hamburg will pay me at the Marquises after orders from Hamburg.

So write to that bank which will give you all the details. Here is the address
 Messrs. Scharf et Kayser
 Ferdinandstrasse 30
 Hamburg
As to letters you can write to me henceforth
 Monsieur Gauguin at Dominique
 Marquises
 Establishment of Oceania
As for packages
Write—Société Commerciale Tahiti
 To be forwarded to Mr. Gauguin.

Our correspondence is going to be drawn out and take five or six months between a request and a reply, so I ask you to deal in all affairs with Daniel, in whom you can have entire confidence, as soon as possible. He is empowered to handle all matters on his own in order to avoid such delays.

Yes I have decided to go to the Marquesas first because of my health and especially because of my work. That will be delayed, I know, but we shall both

of us gain by it because I am a little tired of Tahiti and there I am going to find an element entirely new, which is going to make me do good work. For sales to your clientele, you will have very different things to show.

So, write me on receipt of my letter, to the Marquesas. Even if I have not yet left, your letter will reach me, for all letters pass though Tahiti first and to the Société Commerciale at its place in Tahiti and later at the Marquesas. As for money, it's absolutely safe.

I have not yet received the canvas which you had promised me. That which you sent is very difficult to work with, and absorbs the paint. What I need is sized canvas, or better, canvas that is only sized without preparation for oil paint.

With the sizing which you will send me I will add to it a second preparation with white.

I need also quite a bit of silver white in tubes, for I shall be in need of it soon.
Yours,
Paul Gauguin

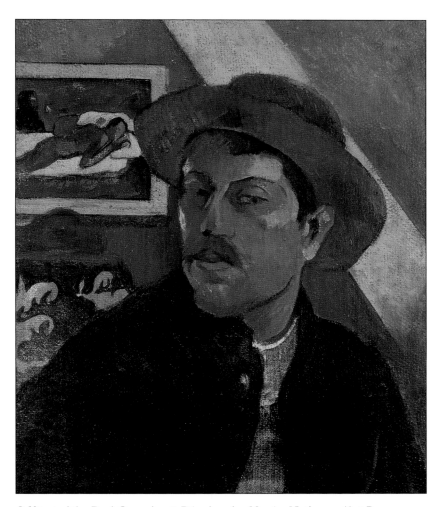

Self-portrait by Paul Gauguin. © Réunion des Musées Nationaux/Art Resource, New York.

Paul Gauguin (1848-1903)

This letter to his dealer, Ambroise Vollard, was written in May of 1891, a few months before Gauguin arrived in the Marquesas Islands from Tahiti, ill and almost penniless. The remoteness of the islands ("five or six months for a request and a reply") appeared to please him. The move seemed a good one for him despite his increasing ill health, for not only did he find the new environment stimulating, but it coincided with his first financial success. For Gauguin at last had begun to sell his paintings through Vollard, and the post was soon bringing small, but regular, amounts of money from the dealer—the first stipends he had ever received for his art. As we see in this letter, Vollard also supplied him with canvas and oil paints and sizing. The artist assured his dealer: "We will both of us gain by it...You will have entirely different things to show." Gauguin was able to build a house there decorated with carved wood panels that reflected native Maori design.

However, the Marquesas provided even less primitive culture than Tahiti. Gauguin did little painting and fell behind in his contract with Vollard. The artist's health gave out not long after a virulent bout with island politics and his arrest by local authorities. By 1903 he was dead of syphilis, leaving behind what would become one of the most sought after collections of paintings in the French art world: his visions of a South Sea island paradise.

When Paul Gauguin had first fled France for Tahiti in 1891 he was rejecting Western civilization for what he hoped would be a more primitive and innocent existence. Like many 19th century European romantics, he was seeking aesthetic and spiritual inspiration, an unsullied paradise, and at the same time, a new, worthy platform for his career. He wrote that he wanted to "see no one but savages, to live their life...The primitive means of art (are) the only means that are good and true." He spent most of a decade in Tahiti (including one trip back to France that he described as "a total defeat"), seeking that natural state of unity with nature and "ecstasy, calm, and art." But what he found was a superficial paradise with colonial politics and oppressed natives, and he was increasingly miserable. Ill health, grinding poverty, and solitude all contributed to his unhappiness, but nonetheless he was able to create some of the most impressive works of his career there.

Back in Paris, Gauguin's paintings were shown by Vollard, who would eventually bring the artist his first small success. Vollard was a complex man with an extraordinary eye for new and original art (he also gave Cézanne his first exhibition). He was variously described by Gauguin as a "crafty cheat" and an "alligator of the worst sort," buying six canvases at once for only 1000 francs. But it was he who recognized Gauguin's genius, eventually providing the artist with supplies and a contract in exchange for twenty-five paintings to sell per year.

In 1901 Gauguin decided to leave Tahiti for what he hoped wold be a still more primitive society. He had learned of the Marquesas Islands, which were part of French Polynesia, on a stopover in New Zealand. He had been impressed by Maori artifacts from the Marquesas, and imagined that the native culture of the islands would have survived intact. "I think it will be easier to find models there, and with landscapes to discover and new and more primitive sources of inspiration, I will make beautiful things. Here my imagination is freezing up," he wrote. Gauguin is one of the rare artists whose lifestyle and work merged in the public's eye.

Despite his disillusionment with island life, he found inspiration in its native people and its rich and colorful landscape. His flat, decorative surface design with its curving, abstract shapes, was augmented by strong, pure, not necessarily naturalistic color. His native figures were often invested with ceremonial dignity and symbolism. Gauguin's freedom from realistic imagery combined a kind of romantic escapism with non-Western imagery, and it also

anticipated the Expressionist movement. His work influenced a generation of younger artists and proved to be of lasting fascination to both other painters and the public.

Tahitian Women on the Beach, 1891, by Paul Gauguin. © Erich Lessing/Art Resource, New York.

Graphology notes on Paul Gauguin

This artist has a consistent rhythm, with his mind and body working in close coordination. He is inclined to move gracefully, his emotions are in balance, and there is no mental stuttering or hesitancy.

He is a very fast and intelligent thinker with analytical skills as well.

His goals are high and practical, and he appears to have the right skills to attain them.

His determination to see his goals through is strong.

He has desires to acquire things, and this may act as a motivational trait for him. He is also tenacious and will find it difficult to let go of that which he has attained.

He has strong literary aptitudes with a good color sense, as well as a love of writing, which could include poetry.

Letter to Pierre Simon in 1985

V. Merlhès
12, rue Léon-Cogniet
75017 Paris.

<div align="right">Lannion, 9 octobre 1985.</div>

Monsieur Pierre Simon

Cher Monsieur,

Avec un long retard, que je vous prie d'excuser,
je vous adresse mes vifs remerciements pour votre
geste généreux. Monsieur Jacques Spiess m'a remis,
en juin dernier, quelques photocopies de votre part
d'une lettre d'Émile Bernard à G.-A. Aurier. J'étais
allé la consulter chez l'expert, en mars dernier,
mais il m'est très profitable d'en détenir un fac-
similé.

Monsieur Spiess me dit que vous compteriez de
même dans votre collection deux lettres de Paul
Gauguin à Ambroise Vollard : celle de septembre 1900
(ornée d'un bois gravé aux oiseaux, n'est-ce pas?)
et une autre, de mai 1901, qui doit débuter sans doute
par ces mots : "Le courrier nous arrive avec beaucoup
de retard ..."? Pousseriez-vous l'obligeance, cher
Monsieur, jusqu'à me permettre de disposer d'une
photocopie de ces lettres? (xx)

J'ai bien du mal, comme vous pouvez le penser,
à établir la Correspondance de Paul Gauguin d'après
les documents autographes, si dispersés. L'intérêt
d'une édition repose cependant pour une large partie
sur la fidélité au texte original. Puis-je espérer
que vous voudrez bien à nouveau m'aider?

A l'avance, merci, cher Monsieur, et veuillez
croire, je vous prie, en l'expression de mes sentiments
reconnaissants et les meilleurs.

Merlhès.

(xx P.-S. A propos de cette seconde lettre, M. J. Spiess
m'indique la date du 7 mai 1901; je trouve cela étrange
car le courrier n'arriva à Papeete que le 13.)

Lannion, October 9, 1985
V. Merlhès
12, rue Léon-Cogniet
75017 Paris.

Mr. Pierre Simon
Dear Sir,

With great delay, which I hope you will forgive, I send you my sincere thanks for your generous gesture this past June. Mr. Jacques Spiess gave me on your behalf some copies of a letter from Emile Bernard to G.-A. Aurier. I had a look at it in the expert's office this past March, but it is very useful to me to have a facsimile.

Mr. Spiess tells me that you also have in your collection two letters from Paul Gauguin to Ambroise Vollard: one dated September 1900 (decorated with a piece of wood engraved with birds, is it not?) and another one, from May 1901, which no doubt starts with these words: "Mail arrives here with great delay..."? Would you be kind enough, dear Sir, to let me have a photocopy of these letters? [xx]

As you may very well understand, I am having a difficult time putting together Paul Gauguin's correspondence on the basis of autographed documents that are so scattered. Nevertheless, the value of such a publication depends in large part on remaining true to the original text. May I hope that you will accept to help me again?

I thank you in advance, dear Sir, and please trust in my sincerest gratitude.
Merlhès

([xx]P.S.: In reference to the second letter, Mr. J. Spiess points to the date of May 7, 1901; I find this strange because the mail did not arrive in Papeete until the 13th.)

[There seems to be some confusion, but in fact, on May 7th, Gauguin wrote "mail arrives here with great delay," and he had not apparently received what he hoped for. M. Jacques Spiess, an art dealer, lived in Paris at this time.]

Henri Rousseau
Letter to Ambroise Vollard in 1906

Reçu de Mr. Vollard la somme de deux cents francs, pour un tableau intitulé: Le Lion ayant faim que je lui ai vendu, et ayant figuré au Salon d'automne.
> Paris, le 31 mars 1906
> Rousseau
> 2 bis, rue Peyrel

Received from Mr. Vollard the sum of two hundred francs for a picture titled "The Hungry Lion," which I sold to him and which had appeared at the Salon d'Automne.
> Paris, March 31, 1906
> Rousseau
> 2 bis, rue Peyrel

[1 Franc in 1906 would be the equivilent of 3.3 E in 2003.]

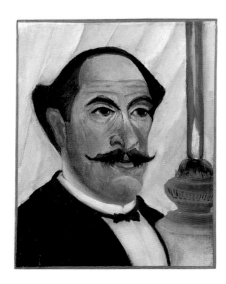

Self Portrait with a Lamp, 1902-1903, by Henri Rousseau. © Réunion des Musées Nationaux/ Art Resource, New York.

Henri Rousseau (Le Douanier) (1844-1910)

By the time Henri Rousseau exhibited "The Hungry Lion," his reputation as a painter was assured. The huge painting—seven by eleven feet—appeared at the Salon d'Automne in 1905 and was so well received that his dealer, the influential and farsighted Ambroise Vollard, to whom this note is addressed, paid two hundred francs for it. Rousseau, who had begun as an amateur painter employed as a minor customs official (or douanier) was by the early twentieth century a *bona fide* success as an artist.

The curious juxtaposition of Rousseau's naïve, primitive style and his acceptance by the avant-garde (Picasso became one of his champions) indicates the many new directions of modernist art in the first years of the century. However, Rousseau, who greatly admired academic painting, did not think of himself as a "modern" painter, but as a realist. In order to create the lush tropical settings of his jungle paintings like "The Hungry Lion," he collected leaves and branches at the Botanical Garden and carefully re-created what he conceived to be the vegetation of the tropics. He painted the wild animals from photographs and engravings and drawings sketched at the Paris Zoo. The sheer size and scale of his painting reflected his admiration for the huge realist paintings accepted at the juried academic shows.

His intuitive sense of wonder and imagination, however, turned his carefully conceived, but primitively executed paintings into masterpieces with their own dreamlike reality. His compositions, with their flat picture planes and enlarged forms, fresh but formal detachment, and exceptional rhythm and color fascinated modernists—including Fauvists and Cubists, who were discovering in primitivism a new freedom of expression. Perhaps inadvertently, he helped to liberate painting from imitating reality. Instead, Rousseau's bold creation of a kind of subconscious reality was a striking precursor of surrealism. "It is not I who paint," he said, "but someone else who holds my hand." His immersion in the dreamy universe he created was so intense that he reportedly had to open his windows to breathe fresh air away from the steamy jungles he was creating.

Unable to exhibit in academic exhibitions, he sent his work to alternative shows, including the Salon des Indépendants and Salon d'Automne, whose aim was to oppose the banality of official and semi-official Salons. (By 1905 the Salon d'Automne had presented both Gauguin and Cézanne exhibitions, and had become the leading center for modernist art.) Ironically, it was in this progressive milieu that Rousseau became something of a celebrity, for it was the modernists who admired him. "The Hungry Lion" was hung in the central exhibition room next to works by Matisse, Derain, Braque, and Rouault. Ambroise Vollard, the sponsor of the Impressionists, Cézanne and the Cubists, took up his work. Rousseau enjoyed the acclaim but kept firmly to his own dreamlike visions.

"The douanier," commented Apollinaire, "went to the very end of his work...his paintings were made without method, system, or mannerism...He did not distrust his imagination any more than he did his hand. From this comes the grace and richness of his decorative compositions." It was Picasso who threw a gala party in 1908 for the simple old customs collector, who found himself fêted by the major figures of modernism.

The Hungry Lion, 1905, by Henri Rousseau. © AKG, Paris.

Paul Cézanne
Letter to Paul Cezanne, his son, in 1906

Aix, 22 Septembre 1906,

Mon cher Paul,

J'ai répondu une longue lettre à Émile Bernard, la lettre qui se ressent de mes préoccupations, je le lui ai dit, mais comme je vois un peu plus que lui, et comme la façon de lui faire part de mes réflexions ne peut le froisser en rien, bien que je n'aie pas le même tempérament ni la façon de ressentir, enfin

et je finis par croire qu'on ne sert en rien aux autres, bref, il est vrai avec Bernard développer des théories indéfiniment, car il a un tempérament de raisonneur. Je vais au paysage tous les jours, les motifs sont beaux et je passe ainsi mes jours plus agréablement qu'ailleurs.

Je vous embrasse toi et maman de tout mon cœur, votre père dévoué

Paul Cézanne

Mon cher Paul, je t'ai déjà
dit que je me trouve dans
beaucoup de troubles cérébraux,
ma lettre t'en repent. D'
ailleurs je vois assez en
noir, je ne suis donc de
plus en plus obligé de me
reposer sur toi, et de trouver
en toi mon orient. —

Monsieur
Paul Cézanne,
16, rue Duperré,
Paris. (IXe arron)

Aix, 22 septembre 1906
Mon cher Paul—

J'ai répondu une longue lettre à Emile Bernard, la lettre qui se joindre de mes préoccupations, je le lui ai dit, mais comme je vois un peu plus que lui, et comme la façon de lui faire part de mes réflexions ne peut le froisser en rien, bien que je n'ai pas le même tempérament ni sa façon de ressentir, enfin, et je finis par croire qu'on ne sert en rien aux autres. On peut, il est vrai, avec Bernard, développer des théories indéfiniment, car il a un tempérament de raisonneur. Je vais au paysage tous les jours, les motifs sont beaux et je passe ainsi mes jours plus agréablement qu'autre part.

Je vous embrasse toi et maman de tout mon coeur, votre père dévoué.
Paul Cézanne

[*la lettre continue*]

Mon cher Paul, je t'ai déjà dit que je me trouve sous le coup de troubles cérébraux, ma lettre l'en ressent: d'ailleurs, je vois assez en noir, je me sens donc de plus en plus obligé de me reposer sur toi et de trouver en toi mon orient.—

[*envelope*]
Monsieur
Paul Cézanne
16, rue Duperré
Paris 9 arrow

—————

Aix, September 22, 1906
My dear Paul,

I wrote a long answer to Emile Bernard, a letter in which I let him know of my concerns. I told him about it, but only because I see a little more clearly than he does, and because the way I convey my thoughts to him will not offend him in any way, even though I have nothing of his temperament nor of his way of feeling. Anyway, I end up thinking that one is just useless to others. It's true, however, that one can develop theories with Bernard endlessly, because he is of a reasoning nature. I go to the out-of-doors every day. The elements of the scenery are beautiful and this is how I spend the days, more pleasantly than in other places.

I send kisses to you and to mother, your devoted father,
Paul Cézanne

[*the letter continues*]

My dear Paul, I've already told you I'm having some cerebral difficulties. My letter shows that; and beyond that, in fact, I see most things as black. I therefore feel more and more obliged to rely on you and to consider you my guide, my support.

Letter to Louis Vauxcelles from Ambroise Vollard in 1906

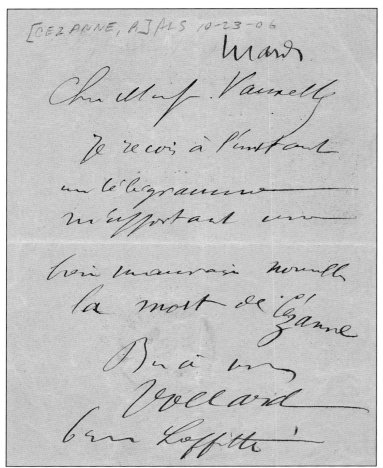

[*envelope*]
 M. Louis Vauxcelles
 15, rue Gustave Zédé
 Paris
 39. E.B.

 Mardi
Cher Mr. Vauxcelles
 Je reçois à l'instant un télégramme
m'apportant une très mauvaise
nouvelle, la mort de Cézanne.
 Bien à vous,
 Vollard
 6, rue Laffitte

M. Louis Vauxcelles
15, rue Gustave Zédé
Paris
39. E.B.

Tuesday
Dear Mr. Vauxcelles
 I just received a tele-
gram bringing me some
very bad news, Cézanne's
death.
 Truly yours,
 Vollard
 6, rue Laffitte

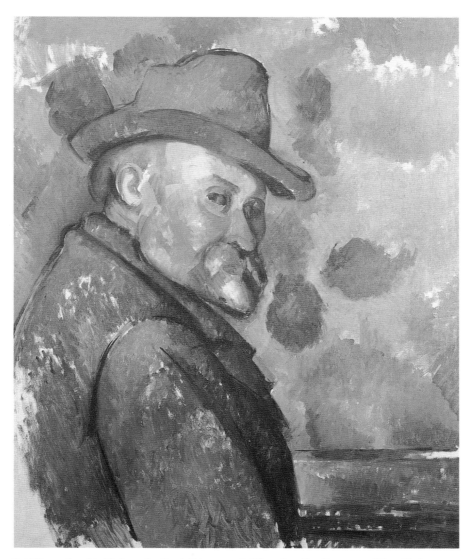

Self Portrait with Fedora, by Paul Cézanne. © Giraudon/Art Resource, New York.

Paul Cézanne (1839-1906)

Paul Cézanne's tremendous dedication to his art and his impact on the development of painting can be felt through two letters—one from 1906 written just a month before he died, and the other two days after the great artist's death. The first was written by Cézanne from Aix-en-Provence to his beloved son Paul; the other, by the noted dealer and art book publisher Ambroise Vollard, (1865-1939), to his friend, Louis Vauxcelles, after hearing of Cézanne's death.

By the fall of 1906 Cézanne was in increasingly failing health, but continued his daily rigorous climbs with his pack on his back to paint in the mountains surrounding Aix. "I go out-of-doors every day," he writes. He painted Mont Saint-Victoire over and over. "Only oil painting can keep me going," he said. "I must struggle on. I simply must produce after nature...I have sworn to die painting." In the final month of his life, with the last of his strength and his eyesight failing ("I see most things as black"), he not only went on with his painting, but continued frequent correspondence with his son, as well as with the younger painter Emile Bernard (1868-1941).

It was to his son Paul, who was living in Paris, that Cézanne confided his most personal thoughts. It was Paul who sent him art supplies, who helped the rather hermetic painter maintain his career in the outside world, and upon whom the aging painter depended for emotional and artistic support. A hint of this closeness is in the touching passage of an ill father to his son: "I feel myself more and more obliged to rely on you, and to consider you my guide."

Nonetheless, Cézanne continued both his work and his theorizing. He was a serious thinker as well as one of the greatest artists of modern times. His radical precepts about pictorial space and color and light formed the bridge between his art of the nineteenth and twentieth centuries. The artist devoted his life to discovering how to reproduce in paint nature's forms—whether apples on a table, or a view of Mont Saint-Victoire. To this end he worked tirelessly and with increasing influence over other artists. It was in his years of correspondence with Bernard that many of his revolutionary principles were directly stated. In 1904 Bernard gathered together the letters and published Cézanne's beliefs in a book of aphorisms called "Souvenirs de Paul Cézanne."

In the letters Cézanne analyzed color and form and the laws of nature and art. "Reproduce nature by the cylinder, the sphere, the cone, all placed in perspective for us men. Nature is more depth than surface..." Such opinions would strongly influence the development of Cubism. "We all start from Cézanne," said Braque and Léger. Cézanne considered his own artistic eye better than Bernard's ("I see a little better than he does.") But he continued to debate the younger artist by letter, "because he is of a reasoning nature" until the end of his life. Within three weeks of the writing of this letter, after an ill-advised climb up a mountain carrying all of his equipment, the great painter was dead.

Two days after Cézanne's death, Ambroise Vollard sent a "carte pneumatique" to the noted art critic, Louis Vauxcelles. (Vauxcelles was the writer who coined the terms "fauvism" and "cubism.") Vollard had presided over the first major exhibition of one hundred and fifty of Cézanne's works in 1895. The show created a scandal, but Vollard's gallery or "cellar" became a center for new art, sponsoring not only Cézanne, but Rodin, Pissarro, Degas, Gauguin, Matisse, and Bonnard. In addition to exhibiting art, Vollard produced some of the greatest illustrated books of the period. His own works—mostly portraits—included a likeness of Cézanne.

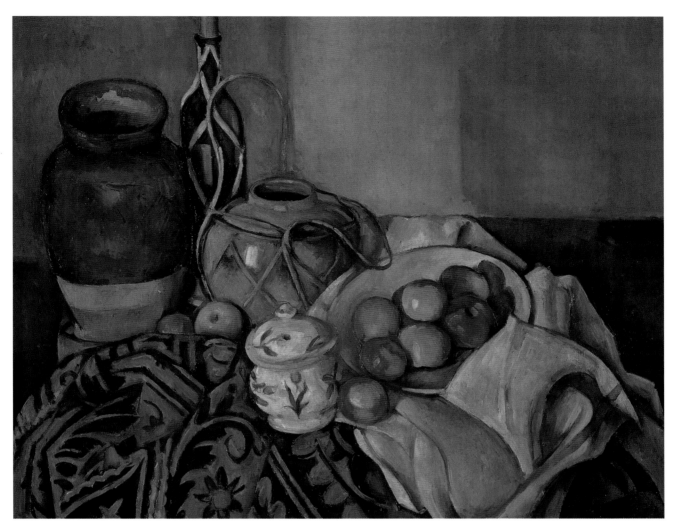

Still-life with Apples, 1893-1894, by Paul Cézanne. © Erich Lessing/Art Resource, New York.

Graphology notes on Paul Cézanne

The artist has a very, very far forward emotional slant to the right, and may openly exhibit intense likes and dislikes for anything, people included. Writer dislikes immediately in obvious ways, even to the point of rudeness.

To those this writer likes, the responsive behavior may be friendly and effusive.

Writer remains extremely enthusiastic and persistent despite snubs, attempts at discouragement and perhaps even ridicule and harsh insults. There is a strong strain of self reliance.

The writer loves to converse, and to tell tall tales, the taller the better, many with a pessimistic cast.

Intuition, the ability to analyze and to investigate are primary thinking patterns.

Much confusion is apparent, whereby the writer engages in so many actions that all actions become diffuse and scattered to some extent. Imagination is ample, but almost never achieves the hoped for level of creativity. This person is impatient to the point of disdain with details.

The writer is both generous and acquisitive, which would create debts of serious proportion.

Amedeo Modigliani
Letter to Ludwig Meidner in 1907

Mon cher ami.

Reclamez au plus
vite à "Arena"
mes peintures. et
expediez les encore
plus vite.

Imaginez vous
que j'ai, reçu
ce matin un
amateur. qui
m'a acheté les

dessins du Salon d'Au
tomne et quelques autres
croquis pour 150 frs.
Il a promis de me
protéger dans la suite
et m'a recommandé à
tes marchands.
Vous voyez la perte que

me procure de ne pas
avoir là mes tableaux
Dans ce moment ci
ils seraient assure
ment vendu.
Je vous supplie de
ne pas perdre un
seul instant pour
me les renvoyer.
Je vous serre cordia
lement les mains.
Modigliani

Monsieur –
Ludwig. Meidner –
100. Schillerstrasse.
Charlottenburg – Berlin
Allemagne.

Mon cher ami

Reclamez au plus vite à "Arena" mes peintures et expediez les encore plus vite. Imaginez vous j'ai reçu ce matin un amateur qui m'a acheté les dessins au Salon d'Automne et quelques autres croquis pour 150 fr. Il a promis de me proteger dans la suite et m'a recommandé à des marchands. Vous voyez la perte que me procure de ne pas avoir là mes tableaux. Dans ce moment qu'ils seraient assuremént vendu.

Je vous supplie de ne pas perdre un seul instant pour me les renvoyer.

Je vous serre cordialement les mains.

Modigliani

[*envelope*]
Monsieur
Ludwig Meidner
100. Schillerstrasse
Charlottenburg - Berlin
Allemagne

My dear friend,

Request my paintings back as fast as possible from "Arena" and ship them even faster. Just think, I had a visit this morning of a collector who bought the drawings that were at the Salon d'Automne, as well as some other sketches, for FF150. He promised he would look out for me as my patron in the future and will recommend me to art dealers. You can see the loss I am suffering from not having my pictures. At this moment they would surely be sold.

I beg you not to waste a single instant and to send them back to me.

I clasp your hands cordially,

Modigliani

[*envelope*]
Mr.
Ludwig Meidner
100. Schillerstrasse
Charlottenburg - Berlin
Germany

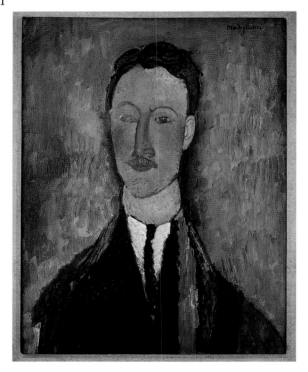

Self-portrait, by Amadeo Modigliani. © Giraudon/Art Resource, New York.

Amedeo Modigliani (1884-1920)

In this somewhat frantic letter sent to fellow artist Ludwig Meidner in Berlin just after the Salon d'Automne of 1907, Modigliani begs his friend who had taken several of his works to Germany to try to sell them, to return them as fast as possible. Modigliani is exultant over selling a group of drawings that had been at the Salon d'Automne, to collectors (this reference is to Paul Alexandre) for 150 francs—a fortune to the penniless painter. And better still, he feels that Alexandre has promised to become a continuing patron and to recommend him to other buyers. "You can see," he writes, "the loss I am suffering from not having my pictures."

Modigliani's tone reflects both the artistic excitement and desperate poverty of the life he led in Paris. After settling there in 1906, Modigliani had only fourteen intense years to create a body of work, before his life of squalor, addiction, and alcoholism resulted in his death. His major works were made between 1915 and 1919. No painter more clearly personified the bohemian "School of Paris" in the early twentieth century than the Italian expatriate artist. A familiar figure in Montparnasse, he would sell his brilliant drawings for almost nothing (or in exchange for a drink), and his portraits for a few francs. His one-man show, including a number of nudes, was shut down by Paris police. The lack of public response occasionally destroyed his ability to work. "I do at least three paintings a day in my head. What's the use of spoiling canvas when nobody will buy?" he remarked to a friend. Since Modigliani rarely sold a work, he literally lived as a vagabond. Thus he turned to anyone who could sell his paintings or offer an attic room in which he could stay for a short time and paint. Nonetheless, he continued to work, producing dozens of lyrical paintings, many of them portraits of notable artists and writers of his time.

His richly colored, elongated nudes and stylized portraits were elegantly linear, mask-like, and poetic. Rather than drawing on the various avant-garde movements of his time, he preferred long-necked Medieval images, and the purity of form of early Cycladic sculpture. But both his sensuous nudes and fascinatingly opaque portraits were quite thoroughly modern in their distortion and abstraction of the forms of nature. And his lyrically melancholy image of the characters and well-known figures of Paris suggest the bohemian environment in which he made these memorable paintings.

Among his many artistic friends and colleagues was the young German expressionist and graphic artist Ludwig Meidner. Like Modigliani, he had come to Paris to study art. The two spent many hours at the Parisian café "Lapin Agile" together. Meidner greatly admired his friend's intensity. "Never before," he said, "had I heard a painter speak of beauty with such fire." (Meidner's personal accounts of the downward spiral of Modigliani's bohemian lifestyle are revealing and pathetic.) It was when Meidner left Paris to return to Berlin, where he would join the "November Gruppe," that he took with him a group of Modigliani's works.

Despite his lack of financial success, Modigliani's work was accepted at several public exhibitions—the Salon d'automne in 1907, and the Salons des Indépendants of 1908 and 1910. In 1912 he sent a sculpture to the Salon d'Automne. Though these shows did little for his career, the first did bring him one client, the amateur artist and future doctor, Paul Alexandre. The artist's excitement over his sale was, in fact, well-placed, for Alexandre did take a continuing interest in him for several years. Modigliani painted five portraits of the doctor before 1910 and Alexandre was his major patron and enthusiastic collector. Of course, the doctor was increasingly worried about Modigliani's health and self-destructive path, but he did not oppose the painter's frequent use of hashish, feeling that it was "the food of genius." Once Alexandre went off to the First World War, the relationship ended; the doctor never saw the

artist again upon his return to Paris. But more than a dozen of Modigliani's finest paintings are still in the Alexandre family collection.

Modigliani died at the age of thirty-six. But as he told his friends time and again in his last years, he had wanted only a "brief but intense life."

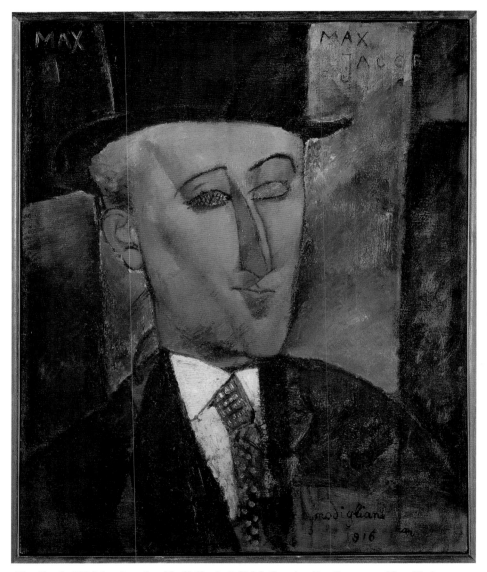

Max Jacob, 1916, by Amadeo Modigliani, © Erich Lessing/Art Resource, New York.

Graphology notes on Amadeo Modigliani
This artist is an extremely fast thinker with immediate comprehension, adding to this is a keen intuitive sense.

He is a dreamer by nature with very lofty goals. He has the determination and enthusiasm to see them through. He will be aggressive when pursuing objectives and is impatient to succeed. He is a get-to-it type of person who dislikes hesitancy and wasting even one second.

He is a loner by nature who is very self-reliant and would rather do things by himself than ask for help. His integrity is good.

Auguste Rodin
Letter to Charles Morice in 1910

[handwritten facsimile of the letter]

77 rue de Varenne

Mon cher Ami,

Dans ma pensée, le chapitre sur Beaugency que publie *Paris-Journal* ne lui était point destiné. Il aurait pu passer dans le cours de l'ouvrage, mais je ne l'ai point aimé comme premier article dans un journal où je ne dois que parler architecture.

Quant aux notes promises sur le style roman sur Reims et sur Soissons, je travaille à leur rédaction et dès que je le pourrai, je vous les enverrai.

Je remercie Madame Charles Morice des salutations affectueuses qu'elle m'envoie, et je lui offre en retour l'hommage de mes respects.

Avec tous mes voeux pour votre travail, je vous prie de bien agréer mon cher ami, mes souvenirs et mes bien chères amitiès.

Auguste Rodin

15 Juillet, 1910

———

77 rue de Varenne

My dear friend,

In my thinking the chapter on Beaugency that *Paris-Journal* is publishing was not meant to be there. It would have passed as part of a study of the work, but I didn't care for it at all as the first article in a journal where I am supposed to speak only of architecture.

As for notes I promised on the Roman style at Reims and Soissons, I'm editing them, and as soon as I can, I'll send them to you.

My thanks to Madame Charles Morice for the affectionate greetings she sends to me, and in return I send her my respects.

With all my wishes for your work, I'm sure you know that, you have my very warm friendship,

Auguste Rodin

15 July 1910

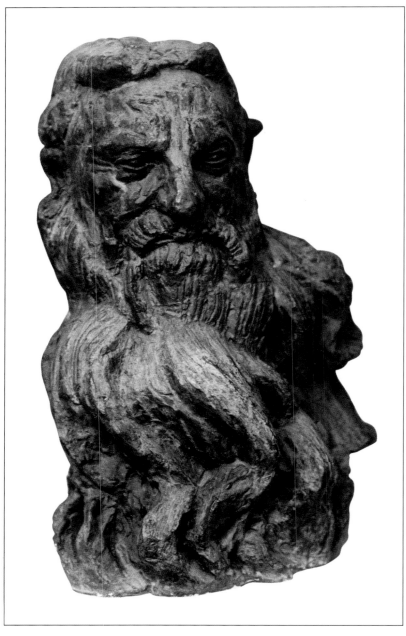

Bust of Rodin, bronze, 1910, by Antoine Bourdelle. © Sipa Press/Art Resource, New York.

Auguste Rodin (1840-1917)

Auguste Rodin, one of the world's greatest sculptors, was so inspired by medieval French cathedral architecture that he wrote a book about its "immortal beauty," discovering in his study of cathedrals the same "unadorned modeling of the planes" and "the genius of form" that he sought in his revolutionary sculpture. The "dear friend" to whom this letter is written is apparently Charles Morice, the writer and art critic who collaborated with him on his book about French architecture.

All of his life Rodin had been making sketches of, and musing, often quite poetically, about various noted architectural sites. While traveling through his beloved France he made elegant, detailed drawings of architecture (and of nature too), as well as taking copious notes about the architecture and the way of life of the people in each area. He described great cathedrals, like Notre Dame and Reims and Chartres, and smaller churches, like Beaugency. He included other great architectural sites, like the Louvre and Place de la Concorde, frequently describing himself as "dazzled" by their magnificence. In each of his artistic and poetic descriptions he focused on the interaction between art and nature, on the very essence of creativity.

Beginning in 1908 he and Morice began to put the literary and artistic material into book form. Morice described Rodin's enthusiasm for the project "like that of a prophet conducting his people to the promised land." And Morice was equally pleased, writing to the sculptor, "I cannot tell you the joy I find in this work." The two collaborated so closely that it is not known who actually wrote each section, though the drawings are certainly Rodin's.

In this letter from 1910, writing of their architecture project together, Rodin says he will be sending two chapters (on the cathedrals at Reims and Soissons) as soon as he can. But he objects to the inclusion of one of his chapters, on the medieval Loire village of Beaugency, in a magazine called *Paris-Journal*. The month before this letter was written, Morice had published an article called simply "Rodin" in the magazine.

Rodin disapproved of the choice of the Beaugency chapter, given the architectural focus of the article, for his description is hardly typical, nor indeed even architectural. While in his book he goes into architectural detail about such impressive cathedrals as Amiens and Notre Dame, he makes no such commentary about Beaugency. In writing of this rather obscure church he has little to say about architecture at all. Instead he describes the simple people entering its doors. "These folk," he writes, "are very gentle, completely estranged from the severe epoch in which their Romanesque Cathedral was born… They will gaze respectfully at the awesome perspectives and guess that Heaven is their goal." Suggesting his own artistic attitudes, he adds, "Because the Church is a work of art derived from nature, it is accessible to simple and true minds." Rodin tells Morice that such commentary was hardly appropriate for the first article in the journal, in which architecture was the focus.

In the same year that he began collaborating on the book with Morice, Rodin had moved to 77, rue de Varennes in Paris. His new home was in the Parc de Biron, a magical place to him. He rented the ground floor of a mansion with its own garden there; this grand house would eventually become the Rodin Museum. It was here that he met with Morice, as well as with numerous other artists and writers and clients. "The Cathedrals of France" was finally published in 1914; it is still in circulation in many languages. And it is still one of the major studies of French architecture, revealing many of Rodin's innermost thoughts about art, sculpture, and architecture, and their relationship to each other and to nature itself.

Corniche Renaissance, pen and ink, by Auguste Rodin. © Musée Rodin, Paris.
Photo - Jean de Calan.

Graphology notes on Auguste Rodin

This artist is a fast and comprehensive thinker. His intuitive ability is a strong combination with his other thinking patterns. He will think quickly on his feet and reach rapid decisions.

He is self-reliant and an independent thinker who reserves the right to make up his own mind. He can block out external stimuli when he concentrates, and this trait affects all other traits.

At times a feeling of pessimism sweeps over him and will affect all that he encounters. His stress level is light, so he gets through these periods of time easily and fast.

He enjoys communicating his ideas to others and he does this in a fluid manner.

His goals are high and ambitious, and his self starting skills are strong.

Pablo Picasso
Letter to André Salmon in 1917

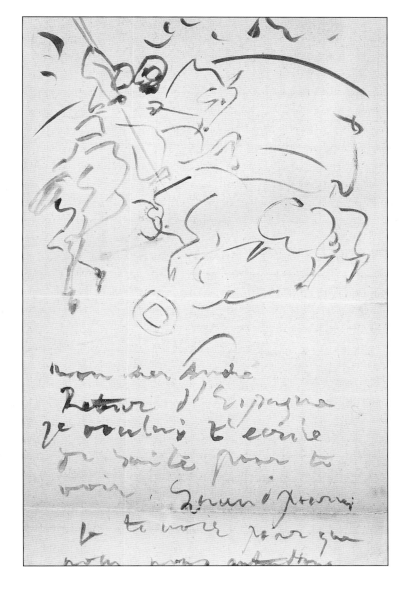

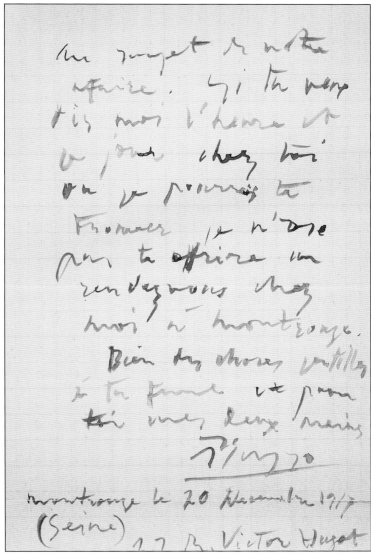

Mon cher André

Retour d'Espagne je voulais t'ecrire de suite pour te voir. Quand pourrai-je te voir pour que nous nous entendions au sujet de notre affaire. Si tu veux dis moi l'heure et le jour chez toi où je pourrai te trouver. Je n'ose pas t'offrir un rendezvous chez moi á Montrouge. Bien des choses gentilles á ta femme et pour toi mes deux mains.

Picasso

Montrouge le 20 novembre 1917

(Seine) 22 rue Victor Hugo

My dear André,

Back from Spain I write to you immediately, to see you. I want to meet with you so that we may talk about our project. If you wish let me know the time and the day when I can find you at home. I dare not suggest a time at my place in Montrouge. Many kind wishes to your wife, and both my hands clasp yours.

Picasso

Montrouge, November 20, 1917

(Seine) 22 rue Victor Hugo

Photograph of Françoise Gilot, Pablo Picasso, and Pierre Simon in Antibes

Pablo Picasso (1881-1973)

By the beginning of World War I, Picasso had already been recognized as a great innovator in the world of modern art, a founder of Cubism, a central figure in the French cultural world, a bon vivant, and a leading member of the avant-garde in Paris. His greatest friends in these days were a close-knit group of poets and artists including Surrealist poet Guillaume Apollinaire, writer Max Jacob, and poet and art critic André Salmon, to whom this letter is addressed. The little group was known as "La Bande à Picasso."

Salmon was a poet whose verse paralleled the works of the Cubist and Dadaist painters. He was also a respected art critic for the "Paris-Journal," whose efforts helping to elucidate and to present the aesthetic theories of the avant-garde included publishing a book called "Histoire anecdotique du cubisme." Picasso saw Salmon frequently, with and without the other members of "La Bande," in both social and artistic settings; he made several pictorial and sculptural images of the writer.

Salmon was present at many of the dramatic events in Picasso's life during the early decades of the century. It was Salmon who organized an exhibition called "L'Art Moderne en France" where Picasso's "Les Demoiselles d'Avignon" was shown in 1916. Salmon, too, accompanied Picasso to the Ethnographic Museum to view the tribal sculpture that influenced the painter's work. His reports and commentary are primary sources for the study of Picasso's life and oeuvre, despite his rather quirky memory and caustic observations, such as: "At first it (Cubism) seemed inoffensive mental juggling... Picasso laid the first stone (of Cubism), the first cube of the temple, which was not the most laudable thing he has done." Picasso in turn described Salmon's history of the movement as "revoltingly unjust" to him.

In 1917 Picasso decided to accompany the Ballets Russes to his native land, where performances were to be given in Madrid and Barcelona. Jean Cocteau had persuaded Picasso to work with Diaghilev and the Ballets Russes on a new Surrealist ballet called "Parade," which had a controversial opening in Paris. Already turning away from Cubism and pure abstraction at this point, Picasso found working with the dancers and the human body, as well as the large scale of the stage, invigorating. Between June and November he remained in Spain, painting some ten works—both naturalistic and Cubist—and receiving a homecoming celebration in Barcelona. He apparently visited the bullfights as well.

In November of 1917 he returned to the rue Victor Hugo in Montrouge, not too far from Montparnasse, and here he writes to Salmon to say he is back home in Paris. But his recent, and ongoing, association with the world of the ballet theater and the *haut monde* meant that his Parisian lifestyle would be changing, as would his style of painting. Though he soon would leave Cubism behind, his close association with Salmon, one of its theorists, continued for some years, but with less intimacy as time passed.

Known for writing very brief letters, sometimes with only one word in them, Picasso often allowed his drawings to replace words in his notes. (A a native of Spain, he was often a phonetic writer in French.) In this uncharacteristically longer note, he combined a delightful scene of a bullfight, one of so many of his images picturing this typically Spanish theme, along with a few lines in French to Salmon. This is certainly an invitation to meet a friend like no other!

Ministère de la Culture et de la Communication

Direction
des Musées de France

Musée Picasso
Palais de Tokyo
2, rue de la Manutention
75116 PARIS
TEL : 723 36 53 PARIS, le 15 Avril 1981

N°, 58

Chère Madame,

J'aurais voulu vous dire plus tôt l'excellent souvenir que je
garde de cette rencontre à New-York et vous remercier, ainsi que M. Simon
du chaleureux accueil que vous avez bien voulu me réserver. Je ne serais
jamais assez reconnaissant à André-Jean Libourel de m'avoir amené chez vous
et permis de voir Matisse et Dubuffet... ainsi que l'extraordinaire collec-
ction d'autographes rassemblée par M. Simon. Si ce n'est pas indiscret per-
mettez-moi de vous demander copie de la lettre de Picasso à Salmon ; elle
serait très utile pour les archives du musée Picasso . Je m'emploie à ras-
sembler le maximum de documents concernant Picasso et ses amis. Le musée
vient d'acquérir une lettre de Picasso à Salmon écrite pendant la Première
guerre. Je serai très heureux de vous la montrer lorsque vous viendrez à
Paris si nous avons la chance que celà soit avant les vacances.

J'ai, d'autre part, beaucoup apprécié l'intérêt de M. Caste comme
celui de votre mari pour les projets de constitution d'une collection d'oeu-
vres américaines à New-York, pour Paris. Je crois l'idée intéressante pour
tout le monde et qu'il serait fructueux de pouvoir en reparler lors d'une
prochaine rencontre. Enfin, je n'ai pas oublié votre proposition d'aller un
jour chez votre ami M. Hallers. Voilà beaucoup de projets en commun et je
m'en réjouis.

Je vous prie de croire, Chère Madame, en l'expression de mes res-
pectueux hommages et de partager avec M. Simon celle de mon souvenir le meil-
leur et *[manuscrit]* _

Dominique BOZO

Madame Jacqueline SIMON
988, Fifth Avenue
10021 NEW-YORK, N.Y.
 (U.S.A.)

Ministère de la Culture et de la Communication
 Direction
des Musées de France
Musée Picasso
Palais de Tokyo
2, rue de la Manutentionm
75116 PARIS
TEL. 723 36 53 PARIS, April 15, 1981

Dear Madame,
 I wanted to thank you sooner for the fine memory I have of that visit to New York and to thank you and Mr. Simon for your warm welcome. I can never be grateful enough to André-Jean Libourel to have introduced me to you and so gave me the privilege of visiting you and seeing your Matisses and your Dubuffet, and also the extraordinary collection of letters assembled by Mr. Simon. If I'm not too indiscrete, I'd like to ask for a copy of the letter of Picasso to Salmon; it would be very useful for the archives of the Picasso Museum. I keep trying to assemble the maximum of documents about Picasso and his friends. The museum has just acquired a letter from Picasso to Salmon written during the first World War. I'll be happy to show it to you when you're in Paris, if we're lucky enough to see you before the holidays.
 Additionally, I very much appreciated Mr. Caste's interest as much as your husband's, in showing, in Paris, a group of American paintings in private homes in New York. I find the idea interesting for all concerned, and it will be useful to continue the discussion when next we meet. And finally, I haven't forgotten to visit your friend, Mr. Halbers. So there we have several prospects in common, and I'm happy about that.
 I send you, dear Madame, my respectful regards, and to share with Mr. Simon my best wishes.
 Dominique BOZO
Madame Jacqueline SIMON

Graphology notes on Pablo Picasso
This artist has a variable slant in his writing. It goes in all directions. That is what his emotional range is all about. It is difficult to know how he will respond in situations. Many moods swings.
He seems to be set in his own ways and thinks independently of others. He is direct to the point of being blunt in his communications. He is extremely impatient with those who are slower than he is and will employ sarcasm.
He is very stubborn even when he may know that he is wrong in his views.
He is extremely acquisitive, wanting to own or possess. This may be in the form of possessions as well as knowledge.
He works quickly and is adept with his hands.

Emile-Antoine Bourdelle
Letter to Doctor Roy in 1917

12 de mars, 1917 Ant. B., 6 Avenue du Maine
 Cher Docteur Roy
 Pour nous avoir apporté comme disent les modèles Italiens quelqu'un représentant la maison Jansen (ou Jansen lui même) Madame Bourdelle et moi nous vous remercions.
 Jansen ou le représentant que ma femme a dirigé dans le labyrinthe des bronzes, a paru s'intéresser aux oeuvres, et nous croyons qu'il tâchera de nous amener des gens (de gout!!!) galetteux et acheteurs.
 Cela est excellent.
 Plus excellente encore est ma santé—qui change chaque année, à l'encontre de la pente coutumière, semble remonter d'un cran très nettement accroché. Je garde de votre apport triple, de votre science, de l'art avec lequel vous l'appliquez, et de coeur qui rayonne de votre dévouement et de votre personne, une impression rare: celle non pas que j'ai été malade, mais que j'étais entré dans une sorte d'oasis morale, sortant de la rosserie de l'époque actuelle. Je me suis trouvé, grace à vous, dans un temps tout de dévouement, dans cet air si respirable et bienfaisant qu'apportent l'esprit parlant à voix de coeur.

Pour Madame Roy qui a eu la bonté de venir avec vous nous voir, voulez vous bien lui dire combien nous en sommes touchés, et voulez vous bien lui présenter enfin l'amité de Madame Bourdelle et mes hommages, notre pensé que nous sentons vers elle et vers vous. Non comme les giboulées boudeuses du mois présent mais bien comme son soleil de naissance.

De tout coeur à vous deux, Antoine Bourdelle

———————

12 March, 1917. Ant. B., 6 Avenue du Maine

Dear Dr. Roy,

Madame Bourdelle and I both thank you to have brought us, as the Italians say, someone representing Jansen (or Jansen himself).

Jansen, or the representative whom my wife guided through the labyrinth of the bronzes, seemed to be interested in the work, and we think he'll try to bring us people who are interested (people of taste!), both rich and buyers.

That's wonderful!

Even more wonderful, if possible, is my health which, each year, against the expected trend, seems to get better, with a stubborn force. I think so much of your triple support; your science and the skill with which you apply it, and your heart which reveals your devotion, and your actual person, which adds a rare presence: I feel not that I was ill, but that I had entered into a moral oasis. Leaving the nastiness of our times, I found myself, thanks to you, in a moment of caring in that marvelous atmosphere that does so much good, bringing a sense of the heart itself speaking.

For Madame Roy, who had the kindness to come with you to see us, please tell her how touched we are, as we send her the friendship of Madame Bourdelle and my respect, and the thoughts we have for both of you. Not like the unpleasant showers of this month, but like the dawning of the sun.

All my heart-felt wishes to you two. Antoine Bourdelle

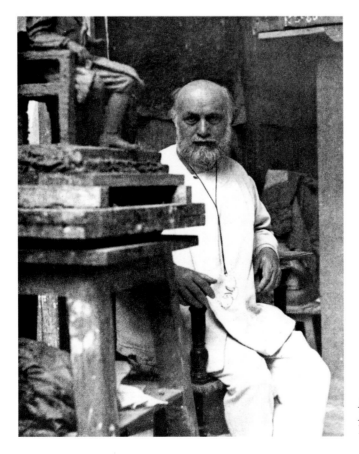

Photograph of Antoine Bourdelle. © Art Resource, New York.

Emile-Antoine Bourdelle (1861-1929)

In 1917 Emile-Antoine Bourdelle was the premier sculptor in France, and was known throughout the world for his grand monuments. His major works were large, dramatic, and emotional—and judging by this letter to his doctor and friend, his prose was equally grand. In fact, this letter is written in an expressive, dramatic style not unrelated to Bourdelle's sculptural accomplishments. The artist employs romantic, expressionistic images ("the dawning of the sun"..."the heart itself speaking"... "a moral oasis..."), instead of the formal, more conventional turn of phrase generally associated with a thank-you letter.

Bourdelle had been Rodin's pupil and marble cutter for fifteen years before leaving the master sculptor. In later years he described himself first as Rodin's "disciple," then eventually as an "antidisciple," (and finally he took credit for a great number of Rodin's accomplishments). In fact, Bourdelle became a major figure in the beginnings of modernism in his own right. Turning away from Rodin's naturalism and traditional musculature toward a more expressionistic style, and eventually toward an almost architectural way of seeing the human figure, he brought a form of expressionism to sculpture, as well as providing the groundwork for Cubism. Bronze was his chosen medium. Both his great monuments and smaller works (including many portraits— Tolstoy, Beethoven, Daumier, Carpeaux, and Rodin himself) are known for their freely expressed forms and dramatic impact.

The critic Waldemar George summed up Bourdelle's importance: "Initiated into the art of sculptural manufacture, he then used every effort to abolish it and, instead of modeling, so often risky, to substitute construction by means of planes. The simple play of surfaces juxtaposed to one another took the place of depth for him....he was the successor of stone carvers of the twelfth century and the predecessor of ...the Cubists."

His fame led him to charge huge amounts for his commissions, and his influence on monument makers and public taste spread widely from Europe to America in the first decades of the twentieth century.

Bourdelle's lifestyle was appropriately grand. He occupied some twenty studios in a building on the Impasse du Maine in Paris. His great monumental commissions occupied some studios, while his smaller bronzes were kept in others. It was to this setting that the famous interior decorator Jansen (or his representative) had come to look for bronzes to purchase for the designing of fashionable Parisian homes. In this letter, the sculptor thanks Dr. Roy for arranging Jansen's visit.

The most sought-after decorator in the early part of the century, Jansen was known for his snobbishness and his wealthy clientele. A Jansen interior was described by one critic as décor "with pounds of bronze with a bit of wood underneath...(with) marble valued only by cubic content...since neither bronze nor marble could be put on the ceiling, it was covered with tapestries worked in gold." The artist and his wife, of course, coveted the interest of this buyer of "pounds of bronzes" for decorative use in the interiors of "people with taste, both rich and buyers."

Bourdelle, who had the ability to translate powerful feelings into three-dimensional form, is able to convey something of the same emotional energy into a brief letter of appreciation.

Herakles, by Antoine Bourdelle. © Erich Lessing/Art Resource, New York.

Graphology notes on Emile-Antoine Bourdelle

At the time this sample was written the artist may have been ill. The handwriting is shaky and shows signs of depression and psychic distress.

There are signs of dubious integrity, including overwriting, excessive crossing out, secrecy and self-deception loops on many a's and o's.

The writer is a daydreamer with visions that are higher than he [or perhaps any mortal] can achieve.

The writer, like so many here, is argumentative.

There are clear signs of remarkable manual dexterity and attention to details.

Writer is intuitive, investigative and analytical.

There are many delta d's. Literature and music may play a major role in this artist's life.

This writer enjoys material wealth and this may be the prime motivation to take on lofty goals.

Albert Marquet
Letter to la Princesse Marguerite de Bamano in 1920

2 Décembre

Madame,

Ce sera avec le plus grand plaisir que je recevrai votre visite, malheureusement je ne pourrai guère vous montrer de peinture, tout ce que j'ai fait récemment se trouve exposé chez Druet. Si vous voulez bien quand même venir me voir soyez assez aimable pour me prévenir afin que je sois chez moi.

Avec tous mes remerciements pour votre aimable lettre recevez, Madame, l'assurance de mes meilleurs sentiments.

Marquet

19. quai St Michel

Madame la Princesse Marguerite d. Bamano
Villa Romaine
Avenue Douglas Haig
Versailles

2 décembre
Madame,

Ce sera avec le plus grand plaisir que je recevrai votre visite, malheureusement je ne pourrai guère vous montrer de peinture, tout ce que j'ai fait recemment se trouve exposé chez Druet. Si vous voulez bien quand même venir me voir soyez assez aimable pour me prévenir, afin que je sois chez moi.

Avec tous mes remerceiments pour votre aimable lettre recevez, Madame, l'assurance de mes meilleurs sentiments.

Marquet
19, quai St. Michel

—————

2 December
Madame,

It will be with the greatest pleasure that I'll welcome your visit. Unfortunately, I won't be able to show you much of my work. All that I've done recently is on exhibit at Druet. If you'd like to come anyway, do be kind enough to let me know, so I can be home.

With thanks so much for your pleasant letter, I send my very best wishes.

Marquet
19, quai St. Michel

[*envelope*]
Madame la Princesse Marguerite de Bamano
 Villa Romaine
 Avenue Douglas Haig
Seine-et-Oise, Versailles

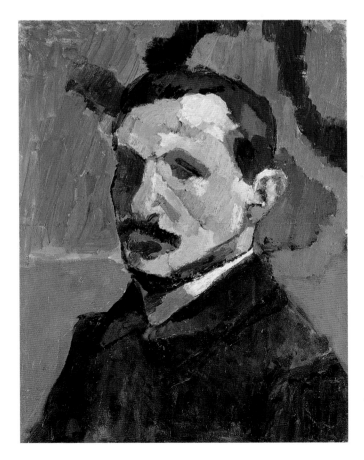

Portrait of Albert Marquet, 1905, by Henri Matisse. © Nasjonal Galleriet, Oslo, Norway.

Albert Marquet (1875-1947)

In this brief, very polite note to a prospective buyer of his paintings, Albert Marquet reveals the difficult situation in which so many artists find themselves. If he sells a painting directly to a buyer and charges no commission, the dealer will not be happy and may decide to terminate their relationship. It is surely unlikely that the artist had nothing to show at his studio, but more than likely that the gallery that handled his work would be displeased. Thus, Marquet suggests obliquely that Madame visit the Druet Gallery, if indeed she wants to see his work, or come to visit him "anyway", if not.

A close associate of Matisse, who was his early protector and lifelong friend, Marquet began (and has been identified ever since) as a Fauvist. He did exhibit with Matisse and the Fauves as a young man, and his highly-colored, dynamic landscapes of the first decade of the twentieth century are still his most admired works. But he confided in 1905 that his exhibiting with the Fauves was due more to chance than to theory. After a painting trip to Morocco with Matisse, he turned away from the bright tones of the Fauves toward a more naturalistic style, which he would maintain for the rest of his life.

As Matisse and his colleagues went on to explore abstract uses of color and design, Marquet devoted himself to delicate, sober painting of beach scenes and cityscapes in various seasons and weather conditions. He moved away from the dramatic color he had used during the Fauvist period toward studies in muted tones. He has been described as a "master of gray," recording snowy and dusky views, many painted from his high windows above the streets of Paris. Although a spiritual successor to the Impressionists, Marquet favored cityscapes to country views, even including billboards and other signs of the "new Paris." In the years following his exhibitions with the Fauves, he isolated himself from art movements and politics, travelling widely and working alone. His explorations of line and light, delicate rendering, and his illusionistic impressions led Matisse to call him—in reference to the great Japanese printmaker—"our own Hokusai."

As a young man, Marquet was so poor that he often could not afford to buy paints. By the turn of the century, however, his connections with the Fauves made him better known. He participated in the Salon des Indépendants in 1901 and the Salon d'Automne in 1903 and his 'Fauvist' canvasses began to sell. The Gallery Druet took him on.

Eugène Druet was an enterprising dealer, who had first worked as an artist's photographer. It was his method, known as the "Druet Process," that enabled painters to record large and handsome photographs of their works. (Among his clients, whom he served as both photographer and dealer, was Matisse.) Druet was aware of the latest styles in art, offering shows to the Post-Impressionists and then to the Fauves, though his gallery struggled financially for years. As their fame and fortune grew, many artists left Druet for more successful galleries, but Madame Druet was still showing painters at the Parisian gallery in the rue Royale in the second decade of the twentieth century.

Marquet, who had first met Eugène Druet in 1901, had his first one-man show at Druet's in 1903. (This undated note indicates that Druet had an exclusive contract with Marquet.) By 1909 the artist had a notable reputation that rested on the works he had done in a very brief period of his life. Collectors avidly bought his early work. A Russian collector purchased nine of his paintings at once, as well as thirty-seven Matisses, but for the next thirty years Marquet painted in his own simple and direct way, recording what he saw from his windows.

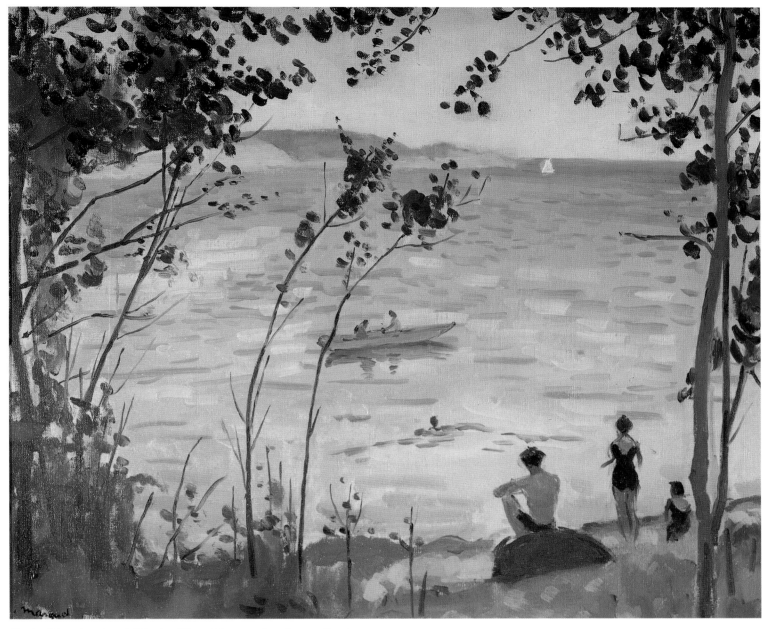

Bassin d'Arcachon, late 1920s, by Albert Marquet. © private collection

Graphology notes on Albert Marquet

This artist has intense powers of concentration. He can exclude any outside stimuli when he is working. All traits are intensified by the ability to focus.

He is a logical and investigative thinker with the capacity to weigh and analyze his findings.

His goals are high and ambitious. He can take the initiative when a new opportunity presents itself, but his drive to accomplish his goals fades rapidly as does his enthusiasm for his own work.

He is resilient when facing problems and pressures, with the ability to move on quickly.

He is indecisive with the fear of making a final commitment. He tends to yield to the decision-making of others. He is narrow-minded, preferring to stay with the tried and true rather than taking risks.

Paul Klee
Postcard to Dr. Lichtenstein in 1921

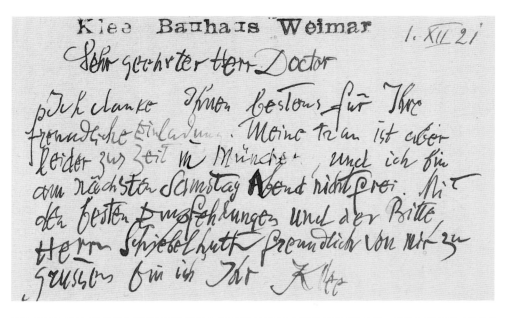

Klee Bauhaus Weimar
1/12/21
 Sehr geehrter Herr Doctor
 Ich danke Ihnen bestens für Ihre freundliche Einladung. Meine Frau ist aber leider zur Zeit in München und ich bin am nächsten Samstag Abend nicht frei. Mit dem besten Empfehlungen und der Bitte, Herrn Schiebelhuth freundlich von mir grüssen bin ich Ihr Klee.

(postkarte)
Herrn Dr. Lichtenstein
 (verlag Erich Lichtenstein)
 Weimar
Junkerstrasse 45

————

Klee Bauhaus Weimar
1/12/21
 Much honored Doctor,
 I thank you very warmly for the kind invitation. But unfortunately, my wife is in Munich at that time and I am not free next Saturday evening. With best regards, and with friendly greetings also to Mr. Schiebelhuth, I remain Your Klee.

[*postcard*]
Dr. Lichtenstein
 (Erich Lichtenstein Publishers)
 Weimar
Junkerstrasse 45

Self Portrait, line drawing, 1911, by Paul Klee. © Art Resource, New York.

Paul Klee (1879-1940)

In December of 1921, when Paul Klee sent this brief note in his polite, old-world style and inimitable hand, he had been in Weimar only a short time. Late in 1920 he had received a telegram from Walter Gropius inviting him to join the teaching staff of the Bauhaus, the influential art school in Weimar. Klee arrived in January and would teach there until the school closed in 1924, rejoining the faculty when the Bauhaus reopened in Dessau in 1926.

The Bauhaus and Weimar itself in the early 1920s provided an ideal environment for the intellectual and prolific artist. At the school, in the company of Gropius, Kandinsky, Feininger, and Schlemmer he had all the artistic freedom he could wish, and he was able to test his theories as he had set them down in his "Creative Credo." The school's cultural milieu was one of rationalism; Klee wanted to "transpose the impulses of the irrational into a logical frame of reference," and he did some of his most fascinating paintings and drawings at the Bauhaus. As an artist he was already very well known in Europe and widely admired; in 1921 alone he had his works exhibited in Cologne, Vienna, Hanover, Frankfurt, and Munich. His first American show was only three years away. He collaborated on books and joined in group exhibitions, wrote articles for journals, and contributed lithographs and drawings for publications.

Not only did he belong to a tight-knit artistic circle at the Bauhaus itself, but he also corresponded with and visited numerous artistic and intellectual figures of his time. In this note he expresses his regrets that he cannot accept an invitation to the home of Erich Lichtenstein, a literary historian and occasional publisher of elegant art books in Weimar, as well as a contributor to the literary supplement of the "Heidelberger Zeitung." (The envelope is addressed to Lichtenstein at his publishing house.)

While the letter itself is short and precise in its expression, it is the handwriting that particularly captures our attention. It is very much in the Klee drawing style, suggesting his many pen and ink works with their intuitive rhythmic hand, decorative curlicues, distortions, and even words and sentences—and occasional hieroglyphics. With his minute observation and miraculous imagery, Klee created tiny masterpieces picturing times and places of the imagination. In Klee's drawings "dots, dashes, masonry, fish-scale patterns, etcetera, express events or accompany them," wrote one critic. Symbols and signs bear messages and implications.

"Art does not imitate the visible, it makes visible," wrote Klee. The rhythmic movement of symbols, letters, numbers, filigrees, and other abstract shapes allow the artist to create a cosmic world that is nonetheless formally structured. It is Klee's inimitable, symbolic lines that make his drawing, and this note, seem so finely related.

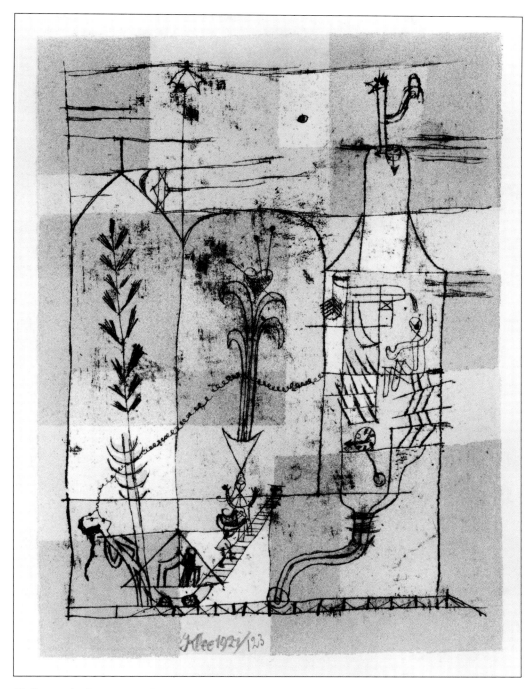

Hoffmanneske Szene, 1921, lithograph, by Paul Klee. © Art Resource, New York.

Graphology notes on Paul Klee

This artist has so many ideas and projects brewing that he tends to get scattered and confusion sets in.

He thinks fast and shows zest for all that involves him. He is investigative and easily gets his own information first hand.

He expresses himself fluidly and well, but his confusion can be an inhibiting factor.

He is a daydreamer with very lofty goals. Fortunately, his drive can achieve his high expectations.

He has much flair and wonderful color appreciation.

André Derain
Letter to André Salmon in 1921

Angneri, 3 aout'

Mon cher Salmon

On peut ajouter ce petit post-scriptum à l'article que je t'ai donné, cela d'autant plus que tout qui veut est rigoureusement authentique.

Depuis l'envoi de cette lettre, il m'est arrivé une singulière aventure. Visitant par hasard le Musée de Lyon, j'eus la stupeur admirative de trouver voisinant avec 2 très beaux Renoir un triptique de Monsieur Blanche répresantant, je vous donne en mille, "La panne d'automobile."

Sur la toile, de gauche, intitulée "Côté des hommes," des messieurs en casquette de voyage discutant sur le motif de panne, on aperçoit un capote.

Dans l'autre côté, côté de droite, intitulé "Côté des femmes," des femmes se poudrent, elles ont des voiles de toutes couleurs.

Au milieu, une créature plantureuse s'appuit sur un table de salon "Le tout offert par l'auteur."

Je comprends que lorsque' un peintre a eu l'honneur d'exécuter de pareils morceaux, il ait le loisir de discuter, la conscience tranquille, les oeuvres des maitres et des rapins.

Le travail de cette couleur "Cambronne" (cet qualificatif est de M. Blanche lui-même, et c'est à dessin je l'emploie, écrit, je ne pourrais jamais inventer de pareilles choses) justifie vraiment la longeur des articles de *Cómedia*. Une dame tres pressée, voyant écrit "Côté des femmes" voulait en ma présence ouvrir le

tableau, disant que c'était très délicat de masquer les indications de cette sorte avec une tel tact, mais le gardien s'interposa la rudoya, et finalement la mit à la porte, en lui disant, "non, mais pour quoi prenez-vous les tableaux de Jacques Blanche?"

Bien à toi, poignée de main et Bonjour à ta dame. A. Derain

Angneri, August 3

My dear Salmon,

This short post-scriptum could be added to the article I gave you, all the more so since everything in it is rigorously authentic.

Since I mailed the letter, I had an odd adventure: visiting by chance the Musée de Lyon, I was stunned to find right next to two very beautiful Renoirs, a triptych by Mr. Blanche representing, you'll never guess, "The car breakdown." On the left side of the canvas, titled "men's side," gentlemen wearing caps discuss the cause of the break, and on the right, titled "women's side," women powder their noses under multicolored veils.

In the center, a buxom creature leans against the table in a living room. "The whole thing courtesy of the author."

I understand that when an artist has had the honor to produce such pieces, he may feel at ease to discuss, with a clear conscience, the works of masters and amateurs alike.

The invention of this color "à la Cambronne" (the term is by Mr. Blanche himself, and I use it here purposefully. I could never come up with such things) truly justifies the length of the articles in *Comédia*. A woman rushing by, when she saw written "women's side," tried to open the picture right under my very eyes, saying that it was quite delicate to indicate directions in such a tactful way. But the guard got involved, talked to her rudely, and finally threw her out, telling her, "But what do you think Jacques Blanche's paintings are, anyway?"

Truly yours. A handshake and regards to your lady. A. Derain

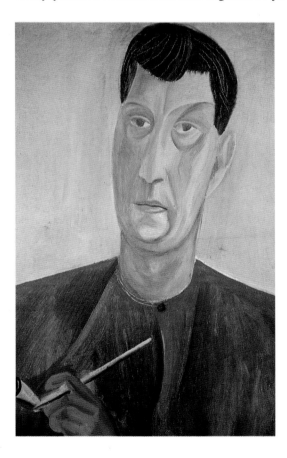

Self Portrait, 1913-1914, by Andre Derain. © Giraudon/Art Resource, New York.

André Derain (1880-1954)

In this humorous, anecdotal letter to his friend, André Salmon, André Derain sends off a satirical story about a colleague, a 'society' painter and eminent art critic named Jacques-Emile Blanche. Derain is best known for his brilliant Fauvist period, but by the time this note was written in the early 1920s, he was no longer painting in a modern style. He disliked both abstract art and the kind of fashionable portraiture and society scenes for which Blanche was well known.

Although Derain was at the center of new French art movements as a young man, he turned increasingly towards historical and realistic painting after World War I. His own later work "on the margins of modern art," as Salmon wrote, makes reference to Italian Renaissance painting and other historical still life: "healthy, like bits of the Last Supper," said Salmon. Derain's acerbic opinions and attacks on other artists and movements were expressed in articles by him and about him. "Do you like cinnamon?" asked Derain. "If you do, it can be sprinkled all over the painting for you, little dabs for those of you who like Impressionist cinnamon, little lines for those who like Cubist cinnamon."

André Salmon, a prominent figure in Parisian cultural circles, was a poet and a friend of Picasso and Derain, as well as a publisher or editor of various books and magazines on art. He wrote many articles on Derain, beginning in 1912, and quoted Derain's views in a variety of journals. At the time of this letter, Salmon was publishing, among numerous other projects, a review called "Signaux de Belgique et de France." It was to this review that Derain contributed a satirical article attacking Blanche in 1921; it was called, with tongue-in-cheek, "Hommage à Jacques-Emile Blanche, peintre splendide et critique admirable."

Derain had been infuriated by Blanche's recent article daring to suggest the role Derain should play for the good of French painting. Blanche had also commented that Derain would develop into a great "decorateur," perhaps simply suggesting large-scale works, but it was a remark to which the painter not unexpectedly took exception. In his article Derain envisages Blanche being tipped out of a boat into a lake by the Dadaist painter Picabia. But before its publication in September he finds he has another anecdote to add and he sends it off to Salmon.

During a recent visit to an exhibition in Lyon he has come upon a Blanche triptych, picturing the breakdown of a car. Its juxtaposition to two "beautiful Renoirs" and its cartoonish subject matter itself already offend Derain. His acid comment that Blanche can "feel at ease to discuss, with a clear conscience, the works of masters and amateurs alike," suggests how Derain feels about a critic/painter who "has the honor to produce such pieces." The reference to General Cambronne's famous remark at Waterloo when he refused to surrender to the British, (merde!) and the mistake by the lady seeking a restroom right through Blanche's painting, adds a further touch of satire to Derain's letter.

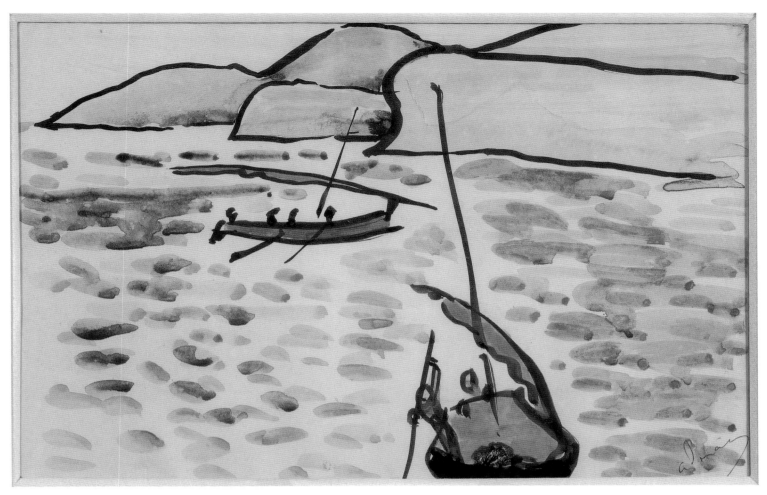

Small Boats, Summer, aquarelle, by André Derain. © private collection.

Juan Gris
Letter to Léonce Rosenberg in 1918

Beaulieu 9-8-18

Lettre No _____ 189 _____

Reçu le _____ 9/8/18 _____

Répondu le _____

Mon cher ami.

Je suis tres content d'avoir par votre lettre des nouvelles de vos projets toujours si courageux.

La vertu du sacrifice est en tout et doit toujours exister dans les moments necessaires. Sans cela on ne pourrait pas arriver a faire de la bonne peinture ni rien de bien dans la vie. Pas moyen d'eviter vous lui ("l'infernale commodité de la brosse" comme disait Delacroix.

Je suis disposé a vous envoyer les choses finies lorsque vous me le direz. J'essayerai de le faire par colis postal par le chemin de fer.

Ici le temps n'est pas non plus tres beau, il pleut constamment mais je ne me rends pas bien compte car je ne sort presque pas et tout presque toute la journée au chevalet.

J'espere que vous allez tout a fait bien du mal de gorge dont vous avez souffert dernierement. Il faut que vous soyez joliment fatigué pour souhaiter vous lever a midi pendant quinze jours. Vous ne pourriez pas le faire car vous êtes trop actif pour cela. C'est comme moi quand je decide me reposer et ne rien faire pendant quelques jours. Je m'embête tellement que malgré moi je me trouve au travail sans m'en apercevoir.

Presentez S.V.P. mes hommages a Madame Rosenberg et avec les salutations de Josette recevez l'amitié de votre

Juan Gris

Beaulieu 8-8-18

Mon cher ami.

Je suis très content d'avoir par votre lettre des nouvelles des vos projets toujours si courageux. La vertu du sacrifice est en tout et doit toujours exister dans les moments necesaires. Sans cela on ne pourrait pas arriver a faire de la bonne peinture ni rien de bien dans la vie. Pas moyen d'éviter sans lui "l'infernale commodité de la brosse" comme dirait Delacroix.

Je suis disposé à vous envoyer les choses finies lorsque vous me le direz. J'essayerai de le faire par colis postal par le chemin de fer. Ici le temps n'est pas non plus très beau, il pleut constamment mais je ne me rends pas bien compte car je ne sort presque pas etant presque toute le journée au chevalet.

J'espère que vous allez tout a fait bien du mal de gorge dont vous avez souffert dernierement. Il faut que vous soyez rudement fatigue pour souhaiter vous lever a midi pendant quinze jours. Vous ne pourriez pas le faire car vous etes trop actif pour cela. C'est comme moi quand je decide de me reposer et ne rien faire pendant quelques jours. Je m'embete tellement que malgré moi je me trouve au travail sans m'en apercevoir.

Presentez s.v.p. mes hommages a Madame Rosenberg et avec les salutations de Josette recevez l'amitié de votre

 Juan Gris

[*The original note lacks a majority of accented letters.*]

Beaulieu 8-8-18

My dear friend,

I am very happy to get, in your letter, some news of your projects, ever so courageous.

The virtue of sacrifice is in everything and must always exist in necessary moments. Without it, we would not be able to produce good art nor anything else of value in life. Without it, there is no avoiding "the infernal lure of the brush," as Delacroix said.

I am willing to send you finished pieces when you tell me. I shall try to do so by rail parcel post. The weather is not very good here either; it rains constantly, but I am not really aware of it because I barely go out, spending the better part of the day at my easel.

I hope you are fully recovered from the sore throat you had lately. You must be really tired to wish to sleep till noon for two weeks. You could not do that because you are too active. It's like when I decide to rest and to do nothing for a few days, I get so bored that in spite of myself I get back to work without noticing it.

Please give my regards to Mrs. Rosenberg, and, with Josette's salutations, I send the friendship of your

 Juan Gris

27-8-22
Mon cher Man Ray
 Est-ce à Miss Kate Burr que vous envoyé une photo de moi? Cette dame
qui est une amie de Mlle Stein demande mon portrait pour une etude sur moi
en Amerique. Si ce n'est pas a elle que vous avez envoyé ma photo vous seriez
bien aimable de m'en donner une epreuve pour que je la lui expedie.
 Soyez assez gentil mon cher Man Ray pour me répondre tout de suite car
cette dame a l'air pressé de l'avoir.
 Bonjour à Mlle Kiki et bien votre
 Juan Gris
8, rue de la Mairie
Boulogne sur Seine
Seine

[The original note lacks more than is usual of accented letters.]

———

27-8-22

My dear Man Ray,

 Was it to Miss Kate Burr that you sent a picture of me? This lady, who is a friend of Miss Stein's, asked for my portrait for a study on me in the United States. If you did not send her my picture, please give me a copy that I may send her.

 Kindly answer right away, my dear Man Ray, because the lady seems to be in a rush to have it.

 Regards to Miss Kiki, and yours truly

 Juan Gris

8, rue de la Mairie

Boulogne sur Seine

Seine

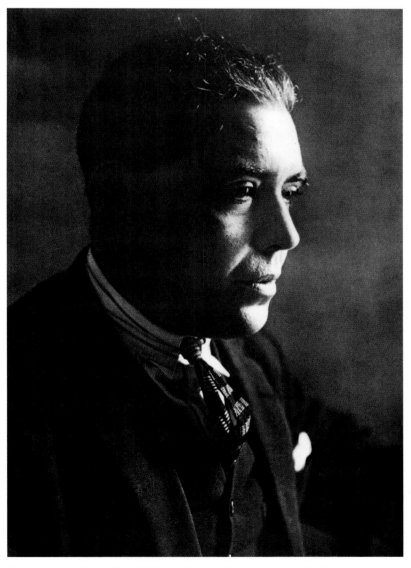

Photoportrait of Juan Gris, 1926, by Georges Duthuit. © AKG, Paris.

Juan Gris (1887-1927)

The first letter, dated August, 1918, is written to the collector and dealer Léonce Rosenberg. It mentions that the artist will send canvasses by rail parcel post. In the previous years Rosenberg had purchased works directly from Gris, and had in 1916 begun to buy all of his paintings. In November following this letter, Gris signed a contract with Rosenberg for three years.

In 1922, when the letter to Man Ray was written, Juan Gris was already acclaimed as a great Cubist painter and was living in Boulogne, outside of Paris, where a steady stream of artists, poets, critics, and musicians came to see him. Among this circle was Man Ray, an American painter and photographer who had helped found the Dada movement in New York during the first World War. He arrived in Paris in 1921 and on his first day met with the poets and artists who originated Surrealism. Ray had taken up photography to support himself, and he began by photographing the paintings of his friends, but moved on to doing unusually fine photography portraits—a career that assured him a livelihood. He continued to work in his own chosen field, however, becoming a leading Surrealist, making experimental films, and inventing "rayography," a combination of painting and photography.

Among his portrait sitters was Juan Gris. Ray photographed the artist in 1922, and it is this picture that Gris wants Man Ray to send to an American friend of Gertrude Stein. Miss Kate Burr was doing a study of Gris. In fact, the famous portrait became the definitive photograph of Gris, appearing in numerous exhibition catalogs and books. Gertrude Stein included the Man Ray portrait, along with seventeen of Gris' paintings in an article in "The Little Review" in 1924-25. Mademoiselle Kiki, to whom Gris sent regards, was at that time the mistress and favorite model of Man Ray. Kiki, known and adored by that special group of artists, is herself a legend.

Gris had come to Paris from Spain at the age of nineteen; he arrived at Picasso's studio, the Bateau-Lavoir, in 1906, just before Cubism. (Picasso would paint "Les Demoiselles d'Avignon in 1907.) Gris soon became fully immersed in the avant-garde, living and working among such leading figures in Parisian cultural circles as Picasso, Matisse, Marquet, Apollinaire, and Braque, as well as Gertrude Stein, whose writings did much to further the careers of the Cubists and whose salon was a center of artistic activity. Gris exhibited at the Salon des Indépendants in 1912, and was soon taken on by the important dealer Henry Kahnweiler. During the following decade he became a well-known figure in the art world, and the spokesperson for the style of analytical Cubism. Gertrude Stein was intrigued by Gris and his work; years later she wrote about him in "The Life and Death of Juan Gris, " and both Appollinaire and Maurice Raynal, among many others, wrote books about him.

Gris is sometimes considered the true classicist among the Cubists. It was Gris who pushed Cubism's intellectual discipline the furthest, and who brought about a decisive transformation of the relationships between the object and reality. Gris, who became known as an Analytic Cubist, began with tightly woven geometric elements of the painting, and allowed certain forms to take the shape of objects, rather than beginning with the shapes themselves: sharp angles became table-tops and cylinders became bottles. "I begin," he wrote, "by organizing my picture; then I characterize my objects...I work with the elements of the mind; with the aid of the imagination, I try to make concrete what is abstract." Yet Gris was a poet with color and form; his paintings are lyrical and expressive compositions of both color and pattern.

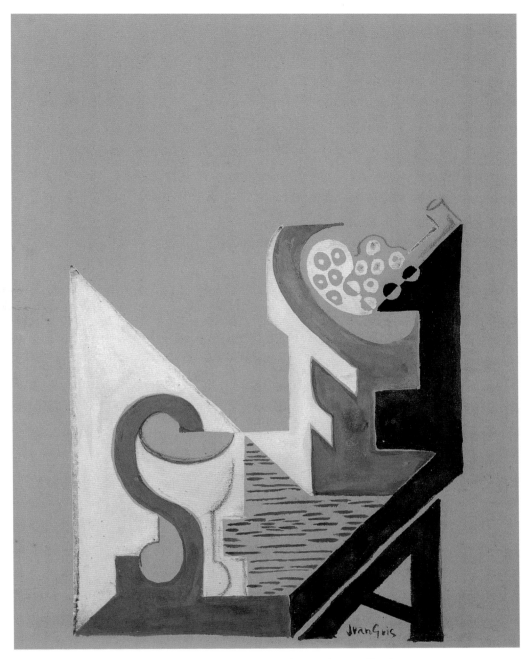

SFA (Salon Français d'Aviation), gouache, by Juan Gris. © private collection.

Othon Friesz
Letter to Léon Pédron in 1924

2 décembre 24 Toulon

Mon cher Pédron

Nos lettres se sont croisées; j'avais repondu par anticipation à la fameuse polémique entamée par ce vieux C... Est il possible qu'il existe encore le type de pareil sot—pareil borné?

Comme je l'écrivais, ca me rajeunit avec les mêmes à Havre il y a une vingtaine année dans la *Journal du Havre*, par le denommé—le Canteloup—décédé.

Bien sur quelques discussions méprisantes mais adroitement menées comme vous savez le conduire ne peuvent que faire une réclame intense à notre art à l'Art. C'est ainsi que fut acquis le resultat de la première affaire Canteloup. Tout le monde ignorait qu'il y eu un imbecile en art au *Petit Havre*, maintenant tout le monde le sait.

J'ai montré les deux corrigés à Monsieur Latil et autres amis compétants. Il n'en ont fait aucun cas même vague, trouvant cela au dessous de toute polémique possible.

C'est un C...a dit Latil. A votre place je lui dirais de quel droit osez-vous parler peinture? Car il n'y a en effet aucun argument possible avec de pareil ignares et écrivains impuissants.

Si ma réponse parait, elle n'est même pas pour lui mais pour tenter dans le debat d'éclaircir cette pauvre foule moutonnière qui sait rien non plus, mais

marque quelque fois quelque bonne volonté à écouter et à reçevoir la révélation de Beau.

Quant à la majorité de l'art, elle est suffisamment notoire déjà et s'accroit toujours (gagne la foule) pour être écrasante à cet cretin—ce primaire.

Avec de tels raisonnments en art, qu'est-ce que doit être joli ses directives politiques!

Pauvre *Petit Havre* dans quelles mains es-tu tombé? Herrenschmidt en congé, le Garzbé en congé!

Au moins Cantaloup avait l'excuse de ne pas être sûr à cause de nos 20 ans, mais cet idiot qui a l'avantage de pouvoir juger sur l'évolution d'un peinture croit peut-être que je débute, ce qui confirme son ignarre.

Je ne connais pas les valeurs des tableaux qui m'accompagnaient, mais après les noms ce n'était pas plus que pour moi de cette manière qu'il eut fallu les engueuler, si toutefois il en avait eu quelque droits. J'éspère que notre sympathique 'Barbe Assyrienne' va n'en faire qu'une bouchée de ce C...là, car il faut respecter sa volonté de ne parler que par initiale, ce qui n'est pas très adroit pour lui.

Je vais vous dire, disait notre bon maître Alphonse Allais au professeur d'Honfleur qui ne comprenait pas son humour, et pourquoi lui n'était pas devenu aussi célèbre!

Eh bien! Eh bien eh bien, et eh bien?

Eh bien, c'est parce que vous êtes un Conge!!!!!

On ne peut pas lui écrire tout ça à ce monsieur, qui lui est si grossièrement malpoli. Il criait à l'assassin, et il dirait qu'on l'insulte et pourtant c'est bien ainsi que tous ceux à qui je ferais voir le corriges, le baptiseront. C'est beaucoup d'honneur lui faire que l'en faire le sujet principal de cette lettre, mais entre nous il faut bien rigoler.

Il y a des choses périodiques, les attaques des Anglais, les suppurations périodiques d'un Conge et le vie continue. Ainsi soit-il—

Mais causons un peu de nous. Andrée va beaucoup mieux et se remet tout à fait. J'espère que l'amélioration continue quant à vos affaires, entrainant plus de sérénité pour votre santé surmenée. C'est toujours ce qui m'inquiète dans votre vie d'affaires si enquiquinante.

Bonjour amicale au brave Georges et la bise à Colette, personne qui compte serieusement maintenant.

[*en marge*]

Si vous jugez utile de répondre à ces attaques stupides et d'applatir le perroquet par les articles de ses éminents et plus valable confrères de la grande presse parisienne c'est facile. Je vous communiquerai ses récents corrigés et en plus, les plus anciens.

[*en marge*]
notre bonjour affectueux à tous, Yvonne, Lalia, et Jean. A vous, amitiés de tous et la main cordiale de votre ami
Othon Friesz
Mosel
28 rue de la Pécherie

————

December 2, 24 Toulon

My dear Pédron,

Our letters crossed. I had responded in anticipation to the famous controversy started by that old C... Is it possible that there still exist such fools, such narrow-minded types?

I felt younger as I wrote it, the same attacks as some twenty years ago in the *Journal du Havre*, by someone named Cantaloup—dead now. Of course some contemptuous but adroitly phrased comments that you know how to do can only result in intense publicity for the sake of art. That's how we resolved the first Cantaloup incident. No one knew that a fool wrote for the *Petit Havre*. Now everyone knows.

I showed both clippings to Latil and other competent friends. They paid not even vague attention to it, considering it unworthy of any possible controversy. He is an idiot, Latil said. If I were you I would ask him, how dare you talk about art? Because there is indeed no point in arguing with such ignoramuses and impotent scribblers.

If my response is published, it won't be to his benefit. It's really an attempt to enlarge the debate, for the poor sheep-like masses that know nothing either but show at times the good will to hear and receive a revelation of beauty.

As for art, it is famous enough already and it grows ceaselessly (and spreads to the masses) to be crushing to this cretin, this primate.

With such reasoning in the arts, his political guidelines must be a pretty sight; poor Petit Havre, into what hands did you fall?

Herrenschmidt gone, le Garzbé, gone!

At least Cantaloup had the excuse of not being sure because we were all 20, but this idiot, who is privileged to be able to gauge a painter's evolution, perhaps thinks that I'm a beginner, which confirms his ignorance. I do not know the value of the paintings that accompanied me, but based on the names, it was not the right way to criticize them, anymore than me, if he had any right at all to do so. I hope that our friendly "Assyrian beard" makes short work out of this C. We must honor his wish to speak through his initials only, which is not very clever of him.

Let me tell you what our dear master Alphonse Allais used to say to the headmaster at Honfleur who did not understand his humor, nor known why he had not become a celebrity—

"Well, well, well, well? and well?

Well, it's because you are a fool!!!!!"

We can't write to him all of this even if he is so crudely impolite—he would cry foul play—he would say that he is being insulted and yet that is exactly what all of those to whom I would show the clippings will do.

We show him too much honor by making him the subject of this letter—but we need to have a good laugh.

There are recurrent things—The British recurrent attacks—the recurrent writings of fools...and life continues. So it goes.

But let's talk a bit about us. Andrée is much better and is almost fully recovered. I hope your business continues to improve, leading to more serenity for your overstressed health. I've always worried about that, your taxing business activities.

Friendly hello to good old Georges—a kiss to Colette—a person who matters seriously now.

[right margin]

If you think it useful to respond to those stupid attacks and to crush the parrot with articles by his eminent and much more competent colleagues from the great Paris press, it's easy; I will send you the recent clippings as well as the older ones.

[left margin]
Our warm regards to all. Yvonne, Lalia, and Jean. Greetings from all, and to you, the cordial handshake of your friend.
Othon Friesz
Mosel
28 rue de la Pécherie

[There is a delightful double meaning in "the old C," as Friesz implies to his friend when he writes that C. prefers to use only his initial, "not too clever of him." C., and especially with a few dots after it, means only one word in French—con—generally said or written as "vieux con." At its most polite, the translation in use is: jerk, idiot, moron. Poor C., not the best initial for him in the employ of his sarcastic adversary.
J.A.S]

Photograph of Othon Friesz in his Studio, 1943. © Collection Viollet

Othon Friesz (1879-1949)

Infuriated by the art reviews written by an obscure critic in a daily paper in Le Havre, the painter Othon Friesz debates the age-old question: is it better to give the offensive review more attention by publicly attacking it? Friesz writes in 1924 to his friend and patron Leon Pédron of his outrage at the critic, who only wants to be identified by his initials—he is described by Friesz as "that old C." "Is it possible that there still exist such fools?" asks the painter. But criticizing the review will only "advertise" it, and he "will cry foul play!"

Friesz, a native of Le Havre, is particularly sensitive to the comments of the home town critic because twenty years before the same thing happened, when a now dead critic named le Cantaloup also attacked his painting in the *Journal du Havre*. Friesz, who as a young man in the first decade of the century, was a promising Fauvist painter and a colleague of Derain, Vlaminck, and the youthful Braque. Along with the other Fauves he explored the dynamism of brilliant color and free expression in landscape painting. He became a life-long friend of Dufy, with whom he shared a studio. It was to Dufy that he wrote that he was seeking "to give art a shake and turn the old principles on their heads." But the local critic didn't care for his revolutionary notions about painting and twenty years later Friesz is still furious about Cantaloup's review.

Now, two decades have passed and Friesz says that perhaps the earlier writer had some excuse when they were all twenty years old, but "this idiot!…does he think I am a beginner?" Friesz, in fact, at this point in his life had turned away from the modern art movements that once enticed him, and was painting in a more traditional manner, though retaining his mastery of color. He thought of himself, as he told the dealer René Gimpel some time later, as "having renewed the art of painting."

Returning again and again to his outrage at the hostile review, Friesz debates sending a scathing reply. He feels he is speaking on behalf of other artists included in the show as well, though he doesn't know who they are or the value of their paintings. But he resents the criticism on their behalf too. He has showed the offending review to several friends, who recommend ignoring it, as unworthy of reply. On the other hand, his friend Latil suggests that Friesz write and ask him "how dare he talk about art?" If Friesz does respond and his reply is published, it "could crush this ape," as well as "enlightening the masses," but would they care? Friesz also proposes a humorous attack. His amusing drawing shows a great bearded critic skewering a small, limp "C" on a fork. Finally, however, the beleaguered artist concludes that there is "no use arguing with such an ignoramus."

But behind the pleasantries of the letter is a deeper question, relegated to the margin. Will Pédron consider writing a rebuttal on his behalf? Friesz will send him the clippings, and suggests that "the parrot could be crushed" by his "much more competent colleagues writing in the Paris press." Having laid out all of the options to his friend and patron—whom he hardly wishes to offend—the painter is left to his uncertainty and aggravation.

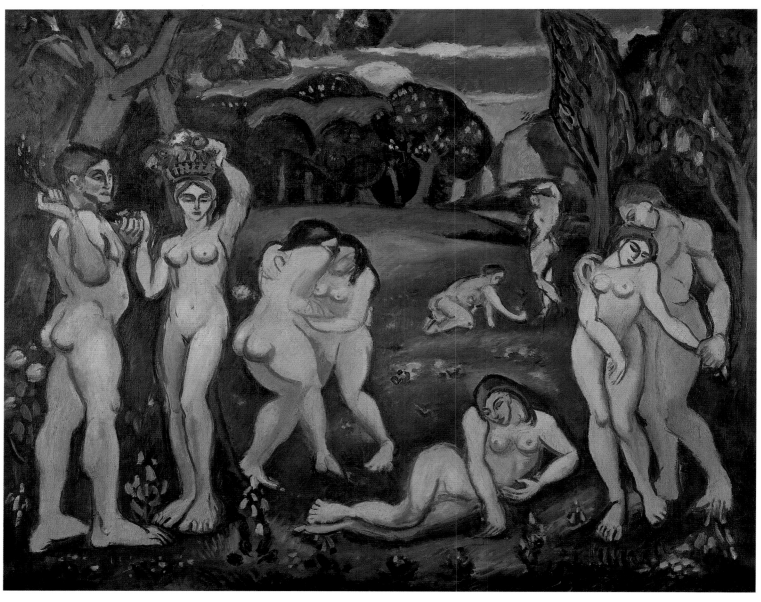

Spring, 1908, by Othon Friesz. © Giraudon/Art Resource, New York

Francis Picabia
Letter to a dealer in 1928

Samedi

Mon cher ami,

Je vous ai fait expédier hier 4 tableaux en petite vitesse prévenez moi de leur arrivée. Vous avez du reçevoir une lettre de Mlle. Guiness vous disant qu'elle est d'accord pour faire une exposition dans votre galerie en janvier ou février à votre convenance.

J'ai bien reçu votre lettre du 27 avril. Suis complètement d'accord pour tout, mais pour le paragraphe 4 je vous signale qu'il ne peut porter que sur les tableaux postérieurs à notre entente. Vous comprendez que j'ai chez moi quelques oeuvres qui datent de plus de dix ans et que je ne puis vous faire intervenir dans leur vente éventuelle. Je suis certain qu'il était superflu de vous dire cela mais en affaire il faut toujours être le plus clair possible.

Nous avons un temps magnifique, quand venez vous en profiter?

Mes mains amies dans les votres—

Francis Picabia

———

Saturday

My dear friend,

Yesterday I sent you 4 paintings express. Let me know they've arrived. You must have received a letter from Miss Guiness, telling you she's in agreement to do an exhibition in your gallery in January or February, at your convenience.

I've received your letter of April 27. I'm completely in agreement, but for paragraph 4, I want to remind you that it can't affect the paintings finished before our agreement. You understand that I have at home some works that are more than ten years old, and I can't allow you to be involved in their eventual sale. I'm sure that it's superfluous to tell you that, but in business one should be as clear as possible.

The weather's wonderful—when will you come to take advantage of it?

My friendly hands in yours—

Francis Picabia

Photoportrait of Francis Picabia. © H. Roger-Viollet, Paris

Francis Picabia (1879-1953)

In the summer of 1928 Francis Picabia, already a successful avant-garde artist, was living in a rented chateau in Cannes with an entourage of family and friends, including many illustrious artists and writers. Though he worked regularly in his studio beginning at 5 a.m. each day, he had time and energy for a life style of parties, yachting, fast cars, and high jinx, "abandoning himself to chance," as his wife put it. He was also involved in a complex domestic situation with two or perhaps three women, all of whom were at Cannes too.

Into this heady atmosphere came a young woman named Meraud Guiness, the daughter of Sir Benjamin Guiness who lived in a nearby chateau (which he would eventually sell to Picasso). The twenty-four year old Meraud had seen Picabia's "dream fantasies" at a Cannes gallery, and she approached the artist for lessons. Not long after moving to a nearby cottage and beginning to study with him, she fell in love with the famous and debonair artist.

Picabia was then at the height of his career—both as artist and writer and as '*agent provocateur*' of the art world. Already a founder of two major movements of modernism—Dadaism and Surrealism—he was a complex figure who delighted in defying the status quo. Few traveled so freely through the many movements of modern art as Picabia did, and his contributions in the formation of these art movements involved both word and image, as well as collaborations with other art forms, including dance, movies and periodicals. A sometime friend and colleague of the major artistic and literary figures of his generation (Max Ernst, Apollinaire, Gertrude Stein, Marcel Duchamp, André Breton, among others), Picabia was at the center of a constantly changing world of the avant-garde. Picabia had the liberty to explore his myriad intellectual interests in art and his times, and his playfulness was part of an ironic wit.

During these years he picked up and abandoned both ideas and friendships, changing his directions and his allegiances, and striving endlessly for the new, the free, the original, and the personal. In the summer of 1928 he was working on "transparencies," paintings with multiple impressions; he described them as spaces where he might express "the resemblance of my interior desires...where all my instincts might have a free course."

Yearly one-man shows in Paris and exhibitions around the world gave Picabia access to various dealers and galleries. As this letter suggests, despite his often playful and iconoclastic attitude towards his art, his business sense was very down to earth. "In business one should be as clear as possible." Written to one of his many dealers, this letter refers both to the details of his own contract and to Meraud Guiness. He apparently helped her arrange an exhibition of her own works, for in December of 1928, following the summer in Cannes, she had her own show at the Van Leer Gallery in Paris, where Picabia himself had exhibited the previous year. Picabia contributed the preface and a drawing of his disciple for the catalogue. By 1931 Meraud Guiness had married, and the Picabia entourage stayed with the young couple for a brief time in Paris.

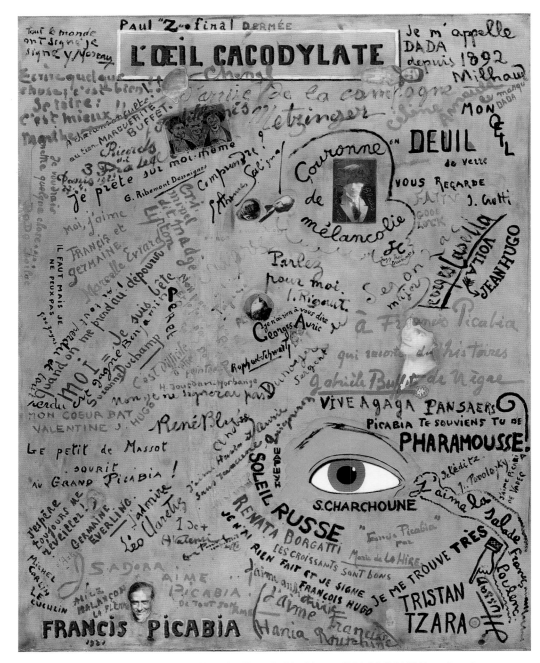

L'oeil Cacodylate, oil on cloth and collage by Francis Picabia. © CNAC/MNAM/Reunion des Musées Nationaux/Art Resource, New York.

Graphology notes on Francis Picabia

This artist moves quickly and has a high energy level. He will show emotion readily in most situations and can be sympathetic to the needs of others. He can also show impatience and irritability to those who don't move as quickly as he does.

His strong intuition will give him a head start in understanding others. Most of his decisions are based on his instincts.

He is open to new ideas but will be very sensitive to any criticism that isn't constructive.

He can express himself fluently and is able to change from one way of thinking to another. He enjoys talking and communicating his thoughts but his listening skills leave a lot to be desired.

Henri Lebasque
Letter to Albert-Lucien Dubuisson

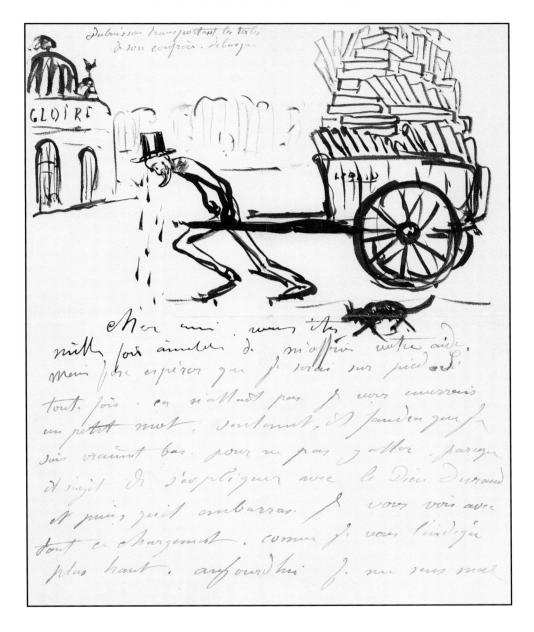

fichu. et je vais garder la chambre
pour tout de bon afin de faire bien
mijoter. ce cochou de petit rhume
qui mine de rien sans me faire trop
souffrir. m'a complètement demolit.
en procedant ainsi je m'ennuirai
davantage ; mais me guérirai plutôt
encore merci de votre gentil
mot et à tous amitiés

croyez bien que j'aurais toute
confiance. en vous. la belzique
est encore loin.

H Lebasque

P.S. Mange vous si Mme Bon
et si ami.

[*reference to drawing*]
Dubuisson transportant les toiles de son confrère Lebasque.

Cher ami. Vous êtes mille fois aimable de m'offrir votre aide. Mais j'ose espèrer que je serai sur pied. Si toutefois ça n'allait pas, je vous enverrais un petit mot. Surtout, il faudra que je sois vraiment bas pour ne pas y aller parce qu'il s'agit de s'expliquer avec le Dieu Durand et puis, quel embarras. Je vous vois avec tout ce chargement, comme je vous l'indique plus haut. Aujourd'hui je me sens mal fichu et je vais garder la chambre pour tout de bon afin de faire bien mijoter ce cochon de petit rhume qui mine de rien sans me faire trop souffrir, m'a complètement démoli. En procèdant ainsi je m'ennuirai davantage, mais me guerrirai plus tôt. Encore merci de votre gentil mot et à tous amitiés. Croyez bien que j'aurai toute confiance en vous. La belgique est encore loin.
H. Lebasque

along the margin of the letter]
P.S. Savez-vous si Mr. Beau est à St. Amer?

[*reference to drawing*]
Dubuisson transporting the paintings of his friend and colleague Lebasque.

Dear friend, You're agreeable a thousand times over to offer your help. But I dare to hope that I'll be better. If ever I'm not, I'll send you a note. In fact, I must be really not well at all, because I have to explain all that to god Durand, and what an embarrassment. I visualize you with all that stuff, as you can see by my drawing above. Today I feel really awful, so I'm just going to stay in my room once and for all, and let this damn cold simmer. It's really nothing, and without making me suffer too much has completely done me in.

Staying home, I'll be completely bored, but I'll be cured sooner. Again, thanks for your kind note and all your friendship.

Believe me, I'll have complete confidence in you—Belgium is still far off—
H. Lebasque

[*along the margin of the letter*]
P.S. Do you know if Mr. Beau is at St. Amer?

Henri Lebasque (1865-1937)

Though the writer of this letter, and the friend to whom it is addressed, are today seen as somewhat obscure figures from the art world of the past, both were active painters in their day. Only recently has Lebasque been 'discovered' by museums and dealers; his work was given a retrospective show in San Francisco, and today the Fauve-like landscapes and "faceless portraits" he made after World War I are interesting to both scholars and collectors.

Henri Lebasque, who made the delightful drawings on both pages of this letter to his friend, painter Albert-Lucien Dubuisson (1850-1937), was not merely a follower of artistic trends. He began as a Post-Impressionist and visited with Pissarro. He exhibited at the Salons of 1893 and 1896, becoming a lifelong member of the exhibition's governing body. He was known for his landscapes of the French countryside, particularly of the Midi where he settled, and for his portraits and interiors.

As a neighbor of Bonnard in the south of France, he met the young Fauves and modernists, including Matisse, Dufy, and Rouault. But although he exhibited at the Salon d'automne with the Fauves, he never considered himself a member of their group. He was, however, influenced by the new emphasis on color and free expression, and he left his post-Impressionist style for more brilliant color and lyrical design. For more than thirty years his primary subjects were members of his family and the interiors and gardens of his surroundings not far from Nice. His watercolors were particularly charming and successful. He also became known for his pictorial decorations, and he received commissions for theatrical designs, including one for the Théâtre des Champs Elysées in Paris, and for the décor of a transatlantic steamer.

After World War I, Lebasque created an unusually somber body of work. His portraits without faces of mysteriously anonymous people reflected both the national post-war mood and the modernist emphasis on the abstract. By 1937 he was so well regarded that he was honored with an exhibition at the Exposition des Maîtres de l'Art Indépendant at the Petit Palais in Paris.

In this undated letter Lebasque belies the complaining tone of his letter with his witty and charming drawings. Written to his colleague, Dubuisson, (a fellow painter and contributor to the Salon des Artistes), he expresses his thanks and laments that he is too sick with a cold to go out. But in the delightful drawing at the top of the page he depicts his friend in a top hat, exhaustedly transporting Lebasque's paintings in an over-loaded wheelbarrow, on his way to a building marked "Gloire." In his drawing on the second page, he draws a lugubrious scene of himself in bed, covered by pillows, and surrounded by cobwebs and an equally morose dog. In the tradition of illustrated letters, this one provides a glimpse of both the personality and the artistry of the painter.

Graphology notes on Henri Lebasque

This artist can be very emotional, being ruled by his heart and not his head.

He doesn't let things bother him and will rarely hold a grudge. He enjoys getting his own information first hand and has good research and analytical skills. He uses his intuition to accelerate his decision making process.

His goals are set very high, yet they are practical and set within his own realm of potential achievement.

His approach to work is simple and uncomplicated. He likes to get to the bare essentials without hesitancy. He pays close attention to details and has good manual dexterity.

He is tactful, listens well, yet is a loner by nature.

Georges Rouault
Letter to Simon Bussy, undated

Toute la famille n'est libre qu'en Juillet Aout
Septembre —
Je mène une vie oiseuse depuis mon retour
adieu les paysages
et la lumière
la rue des cheminées m'aveugle —
On va démolir chez moi encore une seconde
fois — Tous les ans chantier de démolitions
et jamais on n'en sortira de l'avis
même de l'architecte —

Soleil et la lumière de la Grèce en
ferme ma paupière endort mes harpieuses négations
 tamper en tamplumere

 croient y voir clair

 et elles parlent très bien entre elles
 de la lumière de l'Hellade
Sur la Rivera j'ai reporté aux Collettes la
chaise longue de Renoir prêtée par la famille —
C'est peut être à Londres que nous nous
verrons dans le brouillard
 le franc retabli
 la grève universelle décrétée
 sinon aurons les bras croisés

le genre humain s'en f p —————— bien
avec raison peut être —
 Je le quitte sur cette consolante pensée
 G Rouault

Monsieur Simon Bussy
"La Souco"
Roquebrune
Cap Martin
Alpes Maritimes

Mon cher Bussy,

Oui, J'ai été chez toi. J'ai vu le toit de l'atelier de l'auto au passage mais on m'a dit que tu étais à Londres pour toute la saison—Je ne sais, j'aurai peut-être du m'adresser à tes remplaçants. J'ai eu craint d'être indiscret. Quand on m'a dit que c'était les Rudyard Kipling cela m'a fait beaucoup plus d'effet que si on m'avait nommé Premier—je t'assure—ou certains de ses hommes collaborateurs distingués. Tu dois avoir prochainement le numéro de l'art et les artistes—que j'ai prié la Revue de t'adresser directement—évidèmment je n'ai pas de mépris pour les hommes politiques. Je trouve leur métier horrible et pour expliquer ma pensée et désirs, je serai plus heureux d'avoir écrit le livre de La Jungle que de la plus générale discussion parlementaire. Nous aurions beaucoup à causer mon vieux.

Le rouleau compresseur du temps sur tous, menus faits ou importants, passe rapidement. Antennes de nos yeux s'éclairent ou se ferment froissés du spectacle désavantageux pour notre coeur adipeux.

Malheureux! Tu va voir une page de *Sucères* sur moi. Il devait presenter simplement en quelques lignes mes petits souvenirs—voici ce qui est arrivé. Je croyais qu'il ne parlerait que de G Moreau aussi tu vois d'ici la g——— de certains.

Oui nous aurions beaucoup à causer—surtout ce que tu me dis des lettres et autres choses aussi que je ne peux vous dire ici comme dit la vieille chanson désueté.

Qu'arriverait-il si je vivais à Monte Carle? Je parle pour dans un avenir encore lointain? Garde cela pour toi—surtout.

Ai-je des contributions à payer comme en France si mon domicile est etabli à Monaco?

La Turbie m'a bien plu—et ton coin—aussi. Et à Monaco il y a une ruine pour moi—mais c'est encore le paysage si divers qui l'emporte pour moi.

Toi qui es depuis si longtemps là renseigne moi à fond. Impossible de parler dans une lettre. Si août et juillet n'étaient si durs j'irai avec tous les miens pousser une pointe c'est le seul moment où ils sont libres l'ainée vient de passer son bachot—cela ne me rajeunit point. Car je ne me deciderai que si ma femme et les enfants peuvent venir—et voir sur place.

[right side of page, in margin]

J'avais envoyé un mot à Andrée au sens de ce que je dis sur l'autre versant de cette feuille.

Je suis venu seul—mais il y a toutes sortes de questions matérielles et autres qui m'échappent—j'ai trop le nez dans ma peinture! Fait-il vraiment si chaud à La Turbie au mois d'août—oui je pense!

Encore un systeme D—pour me voir me renseigner ou m'éclairer en me gardant rigoureusement le secret de notre conspiration car cela aurait pour moi en ce moment des reprecussions facheuses—plus tard ce sera different.

Ou arrange toi à me voir un peu à l'aise si tu viens à Paris. Crois à ma vieille amitie—-par relation on m'avait dit qu'il y avait des gens qui étaient heureux de laisser leur propriete à la garde de quelqu'un, moi cela m'est égal mais encore ces bonnes gens ignorent ce qu'ils ont à faire—tous mes enfants sont grands. Ils sont raisonnable et prennent soin comme ma femme pour le bien d'autres. Mais qu'en fait on ne les connaissents pas. Toute la famille n'est libre qu'en Juillet, Août, Septembre—Je mène une vie d'oiseuse depuis mon retour

adieu les paysages

et la lumiere

la fume des cheminées m'aveugle

On va demolir chez moi encore une seconde fois. Tous les ans chantier, de demolition et jamais on en n'sortira, de l'avis même de l'architecte.

Soleil et lumière de la Grêce en rêve ferme mes paupières, envois mes hargneuses negociations.

taupes et taupières
croient y voir clair
misere
et elles parlent très bien entre elles
de la lumière de l'Hellade.

Ton ami Raveru—J'ai rapporté aux Collettes la chaise longue de Renoir prêtée par la famille. C'est peut-être à Londres que nous nous verrons dans le brouillard le franc retabli la grève universelle dècrétée. Si nous avions les bras croisés.

Le genre humain s'en f— bien avec raison, peut-être
Je te quitte sur cette consolante pensée
G rouault

[*margin on last page, written sideways*]

Bien entendu j'ergote quand je parle pratiquement—Ne pas trop tenir compte à la lettre de ce que je dis là, je ne me vois pas gardant une propriété—tout cela est un peu ridicule—mais j'ai tant d'idées en tête qu'il ne faut en tenir compte sinon que les grandes lignes.

My dear Bussy,

Yes, I went to your place, I saw the studio's roof from the car, driving by, but I was told that you were in London for the whole season. I don't know, perhaps I should have spoken to your replacements, I feared being indiscreet. I was told they are the Rudyard Kiplings, which had a greater effect on me than if I had been made Premier—I promise you—or one of his distinguished collaborators.

You should have the issue on art and artists soon, which I asked the review to send to you directly. Of course I do not feel disdain for politicians. I think their profession is horrible, and to explain my thoughts on the matter I would be happier to have written "The Jungle Book" than that of the most general parliamentary statement. We would have had a lot to talk about, old man.

The steamroller of time passes rapidly over all small things and important ones.

Antennae of our eyes light up or shut off shaken by a spectacle detrimental to our poor, fat heart.

Unfortunate one! You will see a page of *Le Sucères* on me. They were to feature my recollections simply in a few lines. Here is what happened; I thought that he would only talk about G. Moreau, so you can imagine the expression on some peoples' faces.

Yes, we would have had a lot to talk about, especially everything you say about the letters and other things. And something else as well that I cannot tell you here, as the song goes.

What would happen if I lived in Monte Carlo? I mean, in the still distant future? Keep this to yourself, please. Would I have to pay taxes as in France if I move my residence to Monaco? I liked La Turbie a lot—and your area too. And in Monaco there is a ruin for me—but still it is the diversity of landscape that matters most to me. Tell me all about it, since you have been there for so long.

Impossible to chat in a letter. If August and July were not so hard I would make the trip with my family, it's the only time when they are free. The oldest just passed the baccalaureat; it does not make me feel any younger.

Because I will only make up my mind if my wife and the children can come and see the place.

I can come alone—but there are all sorts of material questions and others that escape me—I am too much into my painting! Is it really all that hot at La Turbie in August—yes, I think it must be!

Again the system D, [*this is French slang for arranging things without trouble, legal or bureaucratic or other*] to extricate myself so that I may get informed or enlightened while keeping our conspiracy strictly a secret because this could have negative repercussions for me. It will be different later.

Or make arrangements so that you may see me in a more secluded manner when you come to Paris. Trust in my old friendship—through relations I heard that there were people who were happy to let someone watch over their property. I don't really care but still these nice people don't realise what they have to do—all my children are grown, and well behaved—they're careful, as my wife is, of other people's things, but actually, we don't know them.

[*right margin, sideways*]

I sent a note to Andrée along the lines of what I'm saying on the back of this sheet.

The whole family is free only in July, August, September. I have been leading a trivial existence since I'm back.

> Farewell landscape and light
> the smoke of chimneys blinds me—

There will be demolition here for a second time. Demolition work every year and we'll never be done according to the architect himself.

Sun and light from Greece force my eyes to shut, and chase my negative thoughts.

> Moles in their mole holes
> think they can clearly see
> misère
> and speak quite well among themselves
> of the light in Hellas

Your friend Raveru. I brought back to Les Collettes Renoir's lounge chair lent by the family. Perhaps we shall see each other in London, in the fog: The franc restored, and a universal strike decreed

If our arms were crossed mankind wouldn't give a damn and with reason, perhaps.

I leave you now with this consoling thought.

G. Rouault

[*margin, sideways*]

Of course, I babble when I talk about practical matters. Do not take too literally anything I say here, I cannot see myself responsible for the care of an estate—this is all a bit ridiculous—but I have so much going on in my mind that you shouldn't think about it at all, except for main themes.

[*envelope*]

Mr. Simon Bussy
"La Source"
Roquebrune
Cap Martin
Alpes Maritimes

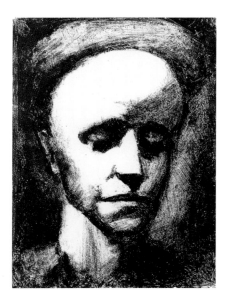

Self Portrait II, 1926, lithograph, by Georges Rouault. © Art Resource, New York.

Georges Rouault (1871-1958)

When Georges Rouault entered the Ecole Nationale des Beaux-Arts in 1891, among his teachers there was the Symbolist painter Gustave Moreau, a greatly beloved professor who took a particular interest in each of the young artists. His influence and his friendship were wide and long lasting, and his students formed a kind of fraternity that lasted for much of their lives. "I thought we would only talk about G. Moreau," writes Rouault, speaking of an article he thinks Bussy will read.

Among the students in the class were Henri Matisse and Simon Bussy. Though Bussy was not to have a brilliant career as an artist himself, he continued to paint and remained a life long friend of both Matisse and Rouault. He appears as the subject of a Matisse painting, a "small interior" in which he is shown sketching, and many of his letters to and from Matisse have survived. Bussy settled in the south of France, not far from Nice, in an area popular with artists and writers, among them Matisse himself. While on a trip to London, Bussy apparently let his home to the Rudyard Kiplings, whose *Jungle Book* Rouault so admired. Knowing the Kiplings were there "had a greater effect on me than if I had been made Premier," writes Rouault.

This letter is written to Bussy after Rouault's return to Paris from a trip to the south of France. He had driven by Bussy's studio in Cap Martin on the French Riviera and even considered settling there, regretted leaving the blinding sun and light of Greece, dreamed of Monte Carlo (and perhaps its lack of taxes). But it was "the diversity of the landscape that matters most to me," he writes.

The inchoate manner of expression of this letter is most certainly in contrast to the consistency of his paintings. His hope of finding "warm, sunny places," his concerns over taxes, caretakers for estates, apartment demolition, and getting older are balanced by delightful references to "antennas in our eyes," "Moles in their holes," and Renoir's lounge chair. ("Collettes" was the name of the property which Renoir owned, and where he painted a majority of his canvasses.) In fact, like so many great artists, the worldly cares and the art world's internecine battles may fill their thoughts, but, as Rouault adds, "There are all sorts of material questions and others that escape me. I am too much into my painting!"

Georges Rouault has a distinctive place in early modern art. An expressionist and a highly emotional artist at a time of strong interest in abstraction and formalism, as well as a devout Catholic in an increasingly secular society,

Rouault developed his own distinctive personal style and iconography. His apprenticeship to a stained-glassmaker as a youth introduced him to the deep translucent tones and heavy black outlines of medieval glassmaking that were to lead to his signature as a painter. His subject matter, from bleak and somber landscapes to images of Christ, clowns, judges, and prostitutes, emphasized his deep piety and dismay at the miseries of society. Working in a rich palette of jewel-like tones with vigorous black contours, Rouault used radiant color and simplified forms to express his darkest views, and ultimately, his humanity.

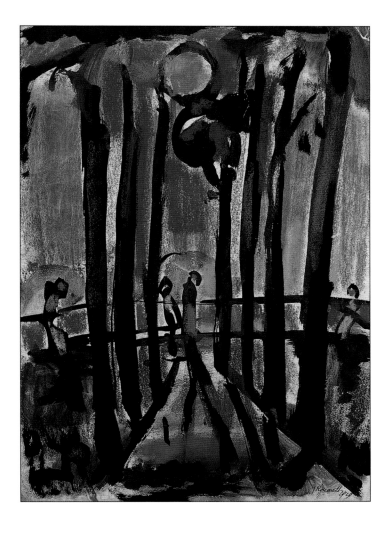

Sunny Alleyway, 1929, by Georges Rouault. © Visual Arts Library/Art Resource, New York.

Graphology notes on Georges Rouault

This artist is very open and has an alert and curious mind.

He has the capacity to reach decisions with assuredness and usually holds on tightly to his values and ideals.

He has so many ideas brewing at one time that his mind tends to get scattered without accomplishing all that comes through his imagination.

He is not always frank within himself. He tends to rationalize away unpleasant realities.

He is not always straightforward with others.

His goals are high, and he has the drive and initiative to accomplish them.

He works extremely well with his hands.

He enjoys communicating with others but could improve his listening skills.

Chaim Soutine
Letter to Emile Lejeune in 1932

Lundi
Cher Lejeune,
 Je regrette de ne pas pouvoir venir ce soir et vous voir. Je doit aller voir ce soir un grand combat de boxe. Demain mardi à 7 1/2 je serai sans faute chez vous. Votre, Soutine

[*envelope*]
Monsieur Lejeune
38 rue des Mathurins
Paris

[*return address*]
 Soutine
 26 Avenue d'Orleans
[*Postmarked 1936, Feb. 15*]

————

 Monday
Dear Lejeune,
 I am sorry not to be able to come this evening to see you. I must go this evening to see a great boxing match. Tomorrow, at 7:30 I will be without fail at your house. Yours, Soutine

[envelope]
Mr. Lejeune
38 rue des Mathurins
Paris

[return address]
Soutine
26 Avenue d'Orleans
[Postmarked 1936, Feb. 15]

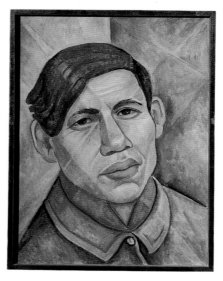

Portrait of Chaim Soutine,
circa 1916-1917, by Maria
Marevna. © Erich Lessing/
Art Resource, New York.

Chaim Soutine (1894-1943)

"Don't worry," said Modigliani on his deathbed, "in Soutine I am leaving you a man of genius." The expressionist Soutine, today indeed regarded as a painter of genius and a precursor of abstract expressionism, was a fellow artist and ex-patriot in Paris. Soutine was highly eccentric and extraordinarily gifted, turning his own personal anguish into self-expression through thick paint and writhing forms. He worked in a frenzy (once dislocating his own thumb) and he frequently destroyed his own work, slashing it to pieces. Though surrounded in Paris by new movements in avant-garde art, he had little interest in Cubism and other formal schools; he remained true to his own vision, producing hundreds of canvasses in his convulsive, unchanging style of self-expression.

Despite his alienation from the current styles and movements of modernism, this poor émigré from a shtetl in Lithuania nonetheless found a haven in the French art world. He associated in Montparnasse with many of the great artists of his era, including Picasso, Chagall and Modigliani, as well as with his good friend Emile Lejeune, a relatively unknown traditional painter from Switzerland.

It is to Lejeune that this note was sent in 1932. Soutine met the Swiss painter at the Café de la Rotonde not long after his arrival in Paris in 1913. Despite his own traditional style of painting, Lejeune was receptive to modern art, leasing a studio to an avant-garde group called "Lyre et Palette." Young painters and composers, including the influential group known as "Les Six," exhibited and performed there. Lejeune took a liking to the penniless artist's work and purchased several of his paintings, providing some of the first sales Soutine experienced as an artist.

After the first World War Lejeune continued to interest himself in Soutine, commissioning (in 1921) a series of four or five paintings of praying men. In 1922-23 Lejeune posed for a portrait by Soutine. When Lejeune moved to Cagnes on the Mediterranean coast, Soutine visited him there many times, producing dozens of paintings, including landscapes of the area. Lejeune bought a number of the artist's works; he soon had a large collection. By the mid - 1920s a market had developed for Soutine following an enormous purchase of between 50 and 100 canvasses by the American collector Dr. Albert Barnes. Lejeune sold part of his collection to the dealer Paul Guillaume, who knew that Soutine's work was particularly popular among collectors in the United States. Soutine soon found himself a successful painter with patrons and sales; his canvasses sold almost as quickly as he painted them. In 1927 the dealer

René Gimpel noted that Soutine was "a star rising in the firmament of modern painting…his oils, which a year ago couldn't find a buyer, are sold these days in the ten thousand bracket."

With his newfound financial stability in the late 1920s and 30s, Soutine divided his time between Paris and the South of France, though chronic ill health and his own tormented nature gave him little peace. But he was a great fan of both boxing and wrestling. In this brief note to Lejeune, who was also spending time in Paris, Soutine says he is unable to make an appointment because of "a great boxing match." But he assures one of his oldest and closest friends, and earliest and most faithful patrons, that he will meet him without fail the day after.

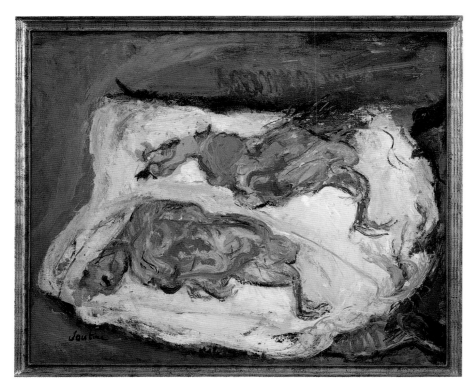

Two Chickens on a White Cloth, circa 1924-1925, by Chaim Soutine. © Erich Lessing/Art Resource, New York

Graphology notes in Chaim Soutine

This artist appears to be in a state of depression. There may also be a neurological problem as evidenced by the problem he has in forming letters. Because of this he seems to feel very pessimistic.

He is a fast and comprehensive thinker with good analytical skills.

His goals are set very high, and at times he would be considered a daydreamer.

He is not very organized and can show great impatience with details.

His capacity to reach decisions is weak and he tends to yield to the decisions made by others.

At times he will be open and receptive, and at other times he closes off, which makes him less flexible and not as productive.

Marc Chagall
Letter to Emile Tériade in 1933

le 28/8/33 Amphion
Cher Tériade

Mes compliments de la campagne, où votre enquête m'a surpris. Je joins ma réponse. S'il n'y a pas de fautes, ne la retouchez pas, s'il vous plait, surtout ne la racourcissez pas.

Je profite l'occasion de vous dire, (mais cela vous—Minotaure—intéresse-t-il?) que la Kunsthalle de Bâle organize au mois de novembre une grande exposition de Chagall. Elle fait des efforts pour réunir mes principales toiles de 1907-1933, en les faisant venir de tous les coins du monde.

Où êtes-vous? Je suis empoisonné par les voitures, mais consolé par le lac et les montagnes.

Votre Chagall

———

28/8/33 Amphion
Dear Tériade,

Greetings from the country, where your inquiry surprised me. I'm enclosing my response. If there are no errors, please don't edit it, and especially, please don't shorten it.

I'm profiting from the moment to tell you (but does this—"Minotaure"—interest you?), that the Kunsthalle in Bâle is organizing a big exhibition of Chagall in November. They're making an effort to reunite the major paintings of 1907-1933, bringing them together from all over the world.

Where are you? I'm poisoned by the cars, but consoled by the lake and the mountains.

Yours Chagall

Letter to Emile Tériade in 1933

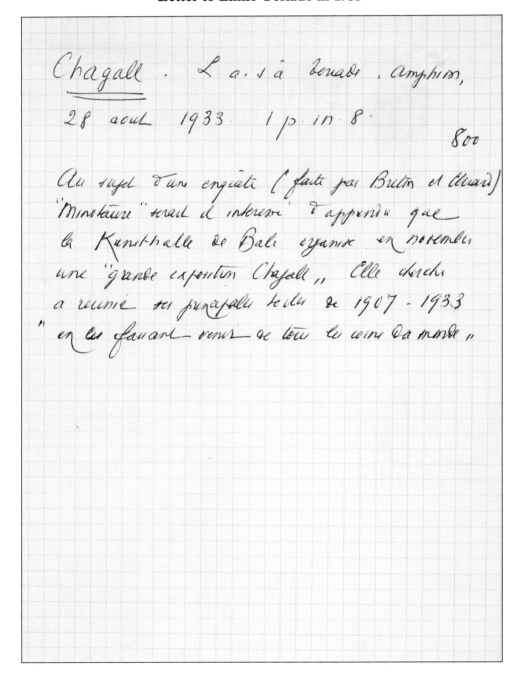

Chagall L.A.S. à Tériade. Amphion,
28 août 1933 1 p in 8 800

Au sujet d'une enquête (faite par Breton et Eluard) *Minotaure* serait-il intéressé d'apprendre que la Kunsthalle de Bâle organize en novembre une "grande exposition Chagall." Elle cherche à reunir ses principales toiles de 1907-1933 "en les faisant venir de tous les coins du monde."

Chagall L.A.S. to Tériade. Amphion,
28 August 1933 1 p in 8 800

Concerning the inquiry (done by Breton and Eluard), would *Minotaure* be interested to know that the Kunsthalle in Bâle is organizing a "large exhibition of Chagall" in November? The Kunsthalle is working to reunite the most important canvases of 1907-1933 "having the come from every corner of the world."

[*The above note is perhaps included with the first or sent immediately afterward, intended by Chagall for Tériade to pass on to someone at* Minotaure.]

Postcard to M. et Mde. Gustave Coquiot

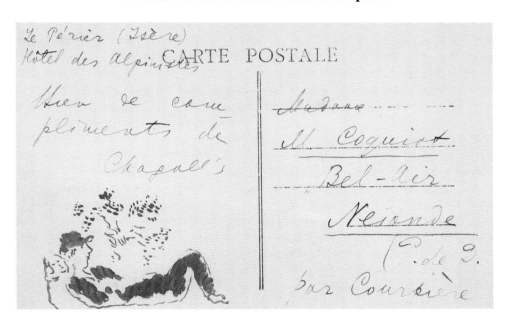

Le Périer (Isère)Carte Postale
Madame Coquiot, M. Coquiot
 Bel-Air
 Neionde
 (P. de D.)
Par Coupière

From Périer (Isère)Carte Postale
Mrs. Coquiot, Mr. Coquiot
 Bel-Air
 Neionde

 (P. de D.)
Through Coupière

Hôtel des Alpinistes
 Bien de compliments des Chagall

Hôtel des Alpinistes
 Best wishes from the Chagalls

Postcard to Mde. Gustave Coquiot

Madame	Madame
Coquiot	Coquiot
52, rue de Moscou	52, rue de Moscou
Paris	Paris
Nos meilleurs souvenirs	Our best wishes,
Les Chagalls	The Chagalls
Hôtel du Mont-Blanc	Hôtel du Mont-Blanc

Self Portrait, 1959-1968, by Marc Chagall. © Scala/ Art Resource, New York.

Marc Chagall (1887-1985)

These notes, and the two characteristically illustrated postcards by the twentieth century master Marc Chagall, bring us a taste of the artist's whimsicality and the burgeoning of his career. By 1933 he was already one of the world's most noted artists, the creator of a unique world of imagination, enchantment, and pathos, as well as a seminal modernist. In this year he was being given a retrospective in the Kunsthalle in Basel (while his paintings were being publicly burned by the Nazis in Germany).

Here he writes to his good friend, the critic and publisher, Emile Tériade, from Amphion, a resort near Evian on Lake Geneva. Chagall and Tériade had become close friends after the critic had written a glowing review of the artist's work. A major supporter of the avant-garde, Emile Tériade (who had been born Efastratios Elefheriades in Greece) was a central figure in French modernism. He and the foresighted dealer and connoisseur Ambroise Vollard had forged close relationships with the painters and poets of the new art movements, producing both journals and illustrated books with such notable artists as Matisse, Miró, Léger, and Picasso, as well as Chagall. Their contributions are among the treasures of their time.

In 1933 Tériade, with his colleague Albert Skira, launched a new periodical called "Minotaure" that was to become a major voice for Surrealism. (The first issues were devoted to Miró's work.) Chagall's whimsical and poetic style led many Surrealists to claim him as one of their own. André Breton said years later that with Chagall, "the metaphor made its triumphant entry into modern painting," but Chagall was never an orthodox Surrealist. Nevertheless, the artist has answered a request from Tériade in reference to *Minotaure*. He sends Tériade a piece "not to be edited or cut" for inclusion in the new journal.

The artist's friendship with Tériade would last for decades, and would include publication of magnificent books and series of lithographs. Among the most acclaimed was Chagall's illustrated Old Testament. Commissioned in the 1920s by Ambroise Vollard, Chagall finally completed the 105 etchings years later, and in 1957 Emile Tériade published the illustrated Bible. The painter's second wife described the lifelong friendship between the two men: "Tériade had a true insight into the artist's nature…His warmth and understanding for Chagall were such that it was one of his happiest relationships."

The Coquiots, to whom the two postcards bring greetings from the traveling Chagalls, were the art critic Gustave Coquiot and his wife. The cards, with their charming drawings, elicit a curious and unexplained tale. Between 1912 and 1914 Chagall lived and worked in a run-down studio building in Paris called "La Ruche." It was during this exciting period in France that the Russian Chagall joined the Parisian avant-garde. Among the many artists and writers with whom he became close friends was the poet Blaise Cendrars.

In 1914 Chagall returned to Russia, and, trapped there by war and politics, he did not get back to France until 1922. On his return he found all of the paintings he had left at "La Ruche" had vanished. Some had been used by the concierge to cover her chicken and rabbit coops, but others had been documented as originals by his good friend Cendrars and sold to Gustave Coquiot. Cendrars claimed to have believed Chagall lost in the war. To add to Chagall's distress, a Paris auction of thirty-two of the same works, the property of a mysterious "Madame X," followed, but the artist received no money. He never spoke again to Cendrars until the poet lay dying almost forty years later. In 1926 M. Coquiot reviewed a Chagall show, and he and Madame Coquiot apparently remained good enough friends to merit an occasional postcard with a delightful drawing.

Meeting of Ruth and Boaz, lithograph, by Marc Chagall. ©
Réunion des Musées Nationaux/Art Resource, New York.

Graphology notes on Marc Chagall

The downward slope of the artist's handwriting indicates a relentless sense of depression that is occasionally supplanted with less dark moods.

Stress level is very light, and his resilience helps the writer get through depressed, pessimistic periods without hurting himself.

When this sample was written, his goals are set well within reach, his drive is moderate and his determination to see his goals to completion is weak. [At other times, perhaps, these indications were less strong.]

Needle pointed n's and m's indicate an exceptionally fast thinker.

There is a clear flourish of humor which, along with resilience and self reliance helps this writer through.

Joan Miró
Letter to Emile Tériade in 1934

Pasajo crédito 4

Barcelone, le 3 janvier 1934

Mon cher Tériade; je viens de recevoir le numéro du *Minotaure*. Il est vraiment splendide! Je vous félicite sincèrement et vous prie de féliciter Skira en mon nom pour votre belle réussite.

J'espère que vous pourrez trouver ici quelques souscripteurs. Il faudrait que vous n'oubliez pas d'expédier quelques examplaires en dépôt à

 Adlan

 Paseo de Gracia 99

 Barcelone

Je crois que Sert est déjà venu vous visiter à ce sujet. C'est des gens intéréssants qui feraient de leur mieux pour faire connaitre votre revue et pour qu'elle soit répandue.

A part cela, quoi de nouveau?

Je travaille beaucoup et reviendrai à Paris au début de Février avec des choses récentes que je considère comme très importantes et significatives dans ma production. Je me ferai un grand plaisir de vous les montrer.

Avec mes meilleurs voeux pour le nouvel an, à vous, à Skira, et à la revue, je vous serre cordialement la main,

Miró

Pasajo crédito 4

Barcelona, January 3, 1934

My dear Tériade. I just received the issue of *Minotaure*. It is truly gorgeous! I sincerely congratulate you and ask that you please convey my congratulations to Skira for such a beautiful achievement.

I hope you will be able to find subscribers here. You should not forget to send a few copies to

Adlan

Paseo de Gracia 99

Barcelona

I believe that Sert came to see you already about this. They are interesting people who would do their best to make your review better known and widely distributed.

Aside from that, what's new?

I am working very hard and will be back in Paris at the beginning of February with recent things that I think are very important, and significant in my work. I will be very happy to show them to you.

With my best wishes for the new year to you, Skira, and to the review, I shake your hand cordially.

Miró

Self Portrait, 1919, by Joan Miró. © Giraudon/Art Resource, New York.

Joan Miró (1893-1983)

This letter by Joan Miró to the publisher and supporter of avant-garde art, Emile Tériade, was typical of the close relationship among artists, writers and publishers in the vibrant creative years between the two world wars. Painters and writers worked closely in many of the new art movements, sharing aesthetic ideas and seeking common ground. Many of the leading painters—in addition to exhibiting their works—involved themselves in the production of illustrated books and periodicals. (Among them were Picasso, Léger, Chagall, and Matisse.) These publications became an integral part of the introduction and development of new aesthetics—as well as providing a showcase for the works of various painters and poets. Several individuals guided these extraordinary books and magazines to publication; the most important of them were Albert Skira and Emile Tériade. They not only knew the leading artists of their day, but were highly knowledgeable about art, and were prepared to present both avant-garde works and ideas to the public in intellectual and stylish form. Joan Miró was among the artists in the 1930s who were actively involved in such publications.

Considered by many to be the finest painter associated with Surrealism, Joan Miró created a brilliant pictorial world that used a unique language of symbols, visual signs, and anthropomorphic forms. A native of Barcelona, he had an individual view of the world that was expressed in transforming images, though he did not see his art as abstract, but grounded in reality. His works seemed joyful, vivid, spontaneous responses to the world around him. By the 1930s he was well known in France—and in the art world at large for paintings, collages, and objects. He returned to Barcelona from his years in France in 1932, but he kept in close touch with the Paris art scene.

A year after Miró left France, Albert Skira and Emile Tériade launched a review called *Minotaure*, which became the leading voice of the Surrealist movement. Tériade was the artistic editor and Skira the managing editor. They gave Miró great attention in the new periodical, honoring him in No. 1-4 with an "Hommage à Miró" of 58 pages. This review became the first systematic study of Miró's work up to 1933. He was then at the height of his success and public recognition. The periodical included texts by many well-known art critics, prefaces to his exhibition catalogues, and reproductions of his paintings, including his most recent experimental compositions. (And the next year, *Minotaure* No. 7 carried a cover by Miró.)

Along with the many reviews and reproductions, the issue devoted to Miró included explanations of the Surrealist outlook and the following commentary by the artist: "It's never easy for me to talk about my painting since it is always born in a state of hallucination induced by some kind of shock, objective or subjective, for which I am not personally responsible in the least…I try my hardest to achieve the maximum of clarity, power and plastic aggressiveness; a physical sensation to begin with, followed up by an impact on the psyche."

In this letter from Barcelona, dated 1934, Miró had just received the issue of *Minotaure* dedicated to him. Emile Tériade, in addition to editing *Minotaure*, had been associated with *Cahiers d'Art* and published a periodical in Paris called *Verve*. Tériade's extraordinary series of "Livres d'artistes" was illustrated by well-known painters. He was a friend and publisher of Henri Matisse, with whom he made exquisite books.

Miró was apparently delighted with the issue of *Minotaure*, congratulating Skira and Tériade. It is amusing to note that Miró, pleased with Tériade's enthusiasm for his work, is looking for subscribers to the review. He asked if his compatriot, painter José Maria Sert (whose mural can be seen at Rockefeller Center in New York), has not already suggested Adlan, a group in Barcelona that might be helpful in creating interest for the review in Spain. Despite having only recently returned to Catalonia, Miró is already planning another trip to Paris, "with recent things that I think are important and significant in my work."

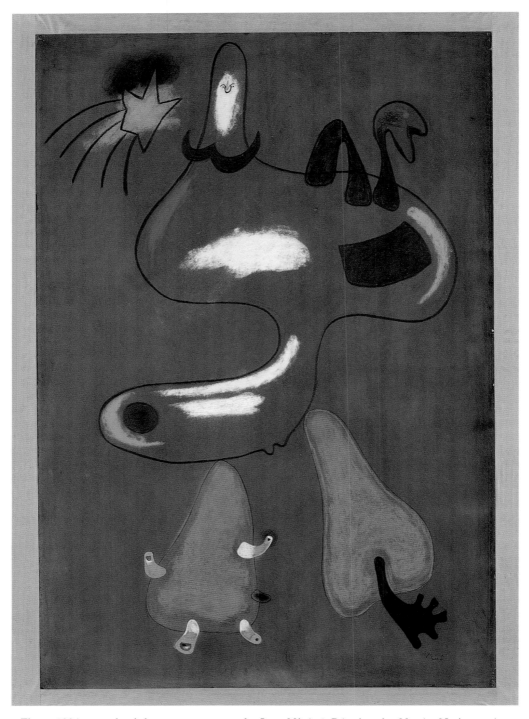

Figure, 1934, gouache, ink, crayon on paper, by Joan Miró. © Réunion des Musées Nationaux/ Art Resource, New York.

Graphology notes on Joan Miró

This artist experiences many highs and lows. His emotional structure is sometimes incoherent. When the letter was written he appeared to be in a depressed state.

His stress level is moderate to heavy. He is strongly impacted by problems and pressures, and his personality is profoundly affected. Confusion sets in, and he shows a tendency to display a temper based in fear. Those close to him feel the effects of his stress greatly.

He is open to new ideas and, with his considerable imagination, he likes to change the ordinary into something particular and relevant.

Marie Laurencin
Letter to an unknown recipient, in 1936

7 rue Alphonse Daudet
Champrosay par Draveil
(Seine-et-Oise)

Mes Oiseaux—
Vite de vos nouvelles—la lettre Breton dans N.R.F. On peut appeler ça Basse Bretonnerie.
C'est tout juste s'ils ne sont pas fies du suicide de René. Alors ici très calme—chaleur et même beauté—on lave—on nettoie—la cervelle aussi—
Le chant du coq. Un gendarme parle entre Delacroix et moi—paroles d'or.
J'ai retrouvé une revue des poètes Elizabetains. Ça c'était quelque chose—poison—épée—révolte des femmes contre l'homme—Enfin je vous envoie des baisers et des tendresses.
Je vous aime
Votre
Marie
Jamais René n'eût été enterré à l'église—les idiots. (Suicide)

———————

7 rue Alphonse Daudet
Champrosay par Draveil
(Seine-et-Oise)

My birds,
Send news quickly. Enclosed, Breton's letter in the N.R.F. One might call that 'Basse Brétonnerie.' [*This is a play on words, "low Brittany" in this case is derisory, not geographic.*]

It's questionable whether they're not proud of René's suicide. Here it's calm—warm—even beautiful.

One washes, one cleans, the brain as well. A rooster crows, a gendarme chats about Delacroix and me—words of gold.

I found a review of Elizabethan poets. That's really something! Poison—sword—revolt of the women against man—

Finally I send kisses and tenderness
I love you
Yours
 Marie

René should never have been buried at the church—the idiots! (Suicide)

Letter to M. et Mde. Marcel Jouhandeau in 1938

nous reçoit avec plaisir —
Tout est d'un vert solide — sagace même
— Normandie —
et dans ce calme j'ai peint une
petite nature morte à base de citron d'une extrêm
purete
qui j'espere désaltérera celui qui
l'aimera —
Autrement tricot — une invention
de chaussons pour le lit —
d'un vert tendre
Avoir les pieds revêtus d'herbe
pour habiter Paris — Je vous montrerai cela —

Votre Marie
Vous embrasse —

Les Italiens en mettent un coup —

Domaine Des Buards
 Hotel-Pension
 Le plus beau Site de la Station
 Cure d'air et de repos
 Tessé-la-Madeleine, le 3 septembre 1938

Mes Oiseaux—
Je suis en Normandie depuis les premièrs jours d'Août—
D'abord séjour dans le château Belle au Bois Dormant. J'ai même fait une peinture, maison rose Louis XIII et grands tilleuls. Résultat rose et vert.
Il y avait là de fameux chiens. Bouviers des Flandres et naturellement la vieille reine Dinah.
Les bombances que nous avons faites dans la cuisine à nous tous!
Une grande cuisine. La femme du jardinier faisait un café au lait brûlant À 7 heures du matin je descendais.
Tout se passait comme dans un rêve à la Gérard de Nerval—un souvenir fait sur mesure pour votre Marie.
Içi cure. Un peu d'enchantement subsiste.
Un ruisseau coule et une vieille laveuse à laquelle nous portons des sucreries nous reçoit avec plaisir.
Tout est d'un vert solide—sagace même—Normandie.

et dans ce calme j'ai peint une petite nature morte à base de citron d'une extrême pureté qui j'éspère désaltèrera celui qui l'aimera.

Autrement tricot—une invention de chaussons pour le lit—d'un vert tendre.

Avoir les pieds revêtus d'herbe pour habiter Paris—je vous montrerai cela.

Votre Marie Vous embrasse

Les Italiens en mettent un coup!

Domaine des Buards
Hotel-Pension
The most beautiful spot in the Station
Cure of air and rest
 Tessé-la-Madeleine, September 3, 1938

My birds,

I'm in Normandy since the beginning of August. First a stay at the castle, Sleeping Beauty. I've even made a painting of this rose colored Louis XIII chateau and the lime trees. Result, rosy pink and green.

There were two splendid dogs there: Bouvier des Flandes and naturally the old queen Dinah.

The feasting we did in the kitchen, all of us!

A huge kitchen. The gardener's wife making a steaming *café au lait*, and at 7 A.M. I came downstairs.

Everything went by as in a dream, style Gérard Nevral—an experience made to order for your Marie.

Here, the cure—some enchantment still remains. A stream runs outside and there's an old washerwoman to whom we bring sweets and she greets us with pleasure.

Everything is a solid green—sage even—Normandy. And in this calm environment I painted a little still life with an extremely pure lemon yellow base, which I hope will quench the thirst of the one who likes it.

Otherwise, knitting. My creation—socks for bed, in a tender green. To have feet dressed up with the color of an herb, to enjoy in Paris—I'll show you that.

Yours, Marie I send kisses.

The Italians have really done something!

Photoportrait of Marie Laurencin, 1908. © Snark/Art Resource, New York.

188

Marie Laurencin (1885-1957)

In these two letters Marie Laurencin reveals a nature simultaneously charming and urbane, sophisticated and youthful. Her descriptions and breathless sentences reflect her style as a painter. Her quick artistic eye, her alternately sentimental and sharp commentary, and above all, her exceptional warmth permeate these letters. The letters are usually addressed to "mes oiseaux" (my birds). They frequently end with exclamations of tenderness. Laurencin's acquaintance with artists and writers was a large one, ranging from Apollinaire's circle to the Surrealists, though her own style of painting, the instinctive, delicate, decorative pictures of doe-eyed women and oblique portraits of her friends, remained constant throughout her life.

Written from different settings, these letters convey a sense of her personal life in mid-career. She owned a delightful country house in Champrosay, Seine-et-Oise outside of Paris, she went for 'cures' to a variety of resorts, and she kept in close touch with her friends, as well as with the art world. In each wide-ranging letter, delicately scripted and decorated with scrolls, she sends a little of her own personality, her ideas, her reflections on people, scenery, books.

In the letter written in 1936 from her home in Champrosay her remarks come so quickly that they are divided with dashes.

She takes up the subject of a Surrealist artist she knew named René Crevel, whose falling out with his colleague and friend André Breton over politics and art was thought to have precipitated his suicide. A label on his wrist when his body was found specifically mentioned cremation, and knowing Crevel's deep distrust of religion, Laurencin notes with outrage that "les idiots" have buried him at a church. Her reflections in this letter range from reading the Elizabethan poets to talking about Delacroix with a policeman, to how, despite the tragedy, life goes on in the calm and beauty of Champrosay.

It was a Catholic friend of Crevel's, a painter named Marcel Jouhandeau, who published an article claiming that Breton had caused Crevel's death by allowing Crevel "to believe in him too much." And it is to Jouhandeau and his wife that Laurencin writes, two years later from Normandy. She is staying at a hotel-pension (a former chateau.) Her letter describes her life there as "a dream in the style of Gerard de Nerval," the 19th century French writer. There are giant dogs, wonderful food, friends—she is writing this letter from her next stop, which is in Tessé-la-Madeleine where she is taking a 'cure.' Still, the memory lingers, and the enchantment is there too, her sense of fun, joy in passing moments, and her poetic, painterly view of life around her. She has painted a small still life using a pure lemon color "of extreme purity" which she hopes will "quench the thirst of those who like it."

Laurencin's letters reveal, too, another of the central facets of her personality: her interest in others. As her dear friend, the dealer René Gimpel wrote, "She is adored in her village of Champrosay, where... she performs acts of kindness for everybody...the sight of misery troubles her dreams...she has many friends and is devoted to them ... since she muses aloud, they know her intimate thoughts." Her letters too could be described as "musing aloud."

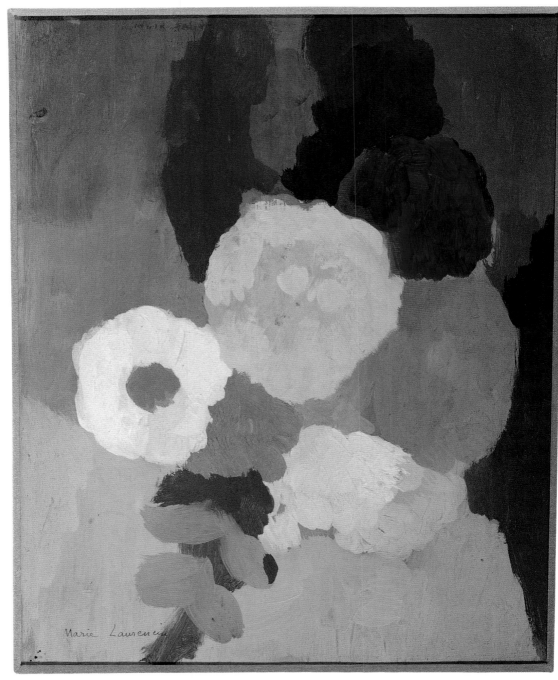

Pastel Flowers, aquarelle, by Marie Laurencin. © private collection.

Raoul Dufy
Letter to Etienne-Jean Bignou in 1937

THE PLAZA

FIFTH AVENUE AT 59ᵗʰ STREET

NEW YORK

29 septembre 1937

Mon Cher Bignou

notre tournée Carnegie est
terminée. Je suis allé ce matin
à la Bignou Gallery. Très bien
belle oui, beaucoup de Dufy,
Bonne Gallerie. J'ai eu votre
lettre et le mot de Barnes
tout cela m'a fait plaisir, ainsi
qu'un télégramme de cette femme
tout va bien. Ce n'était pas
possible de mêler ma visite
à Barnes avec celle du Musée
de Philadelphie car tout cela
se fait sous les auspices de
~~Barnes~~ Carnegie Institute et
vous savez qu'on ne peut pas,
concilier les 2 choses. J'avais
donc décidé de revenir à Phila
delphie

2

quand je serais dégagé de mes
devoirs envers Carnegie; ce sera
fait tantôt. Je m'installe
à l'hôtel Pierre au 36ᵉ étage
j'ai eu ma chambre, je pourrai
aquareller à mon aise, la
vue est superbe ainsi que celle
de votre bureau. Mon séjour
jusqu'au départ du Queen Mary
le 6 Octobre est absolument
aux frais du Carnegie, ils te tête
j'offris mon séjour à l'hôtel Pierre
donc tout va bien. Je ferai
pour cela un petit cadeau
à S Gaudens pas pour cela absolument
mais personnellement quand car c'est un homme charmant
Notre tournée a été une chose
très extraordinaire en ce sens
qu'en 8 jours nous avons vu
Pittsburgh, Mount Vernon, Washington
Philadelphie, Baltimore, en passant,
et New York un peu. Dans chacune

29 septembre, 1937

Mon cher Bignou

Notre tournée Carnegie est terminée. Je suis allé ce matin à la Bignou galerie. Très bien belle vue, beaucoup de Dufy, bonne galerie. J'ai eu votre lettre et la note de Barnes tout cela m'a fait plaisir, aussi qu'un telegramme de ma femme. Tout va bien. Ce n'était pas possible de mêler une visite à Barnes avec celle du Musée de Philadelphie car tout cela se fait sous les auspices de Carnegie Insititute et vous savez qu'on ne peut pas concilier les deux choses. J'avais donc decidé de revenir à Philadelphie quand je serai degagé de mes devoirs envers Carnegie; ce sera fait tantot. Je m'installe à l'hôtel Pierre au 36ème étage. J'ai vu ma chambre, je pourrai aquareller à mon aise, la vue est superbe ainsi que celle de votre bureau. Mon séjour jusqu'au depart du Queen Mary le 6 octobre est absolument aux frais du Carnegie Institute y compris mon séjour à l'hôtel Pierre donc tout va bien. Je ferai pour cela un petit cadeau à St. Gaudens, pas pour cela absolument, mais personellement, car c'est un homme charmant.

Notre tournée a été une chose très extraordinaire en ce sens qu'en 8 jours nous avons vu Pittsburgh, Mont Vernon, Washington, Philadelphie, Baltimore, en passant, et New York un peu. Dans chacune de ces places nous avons visité musées ou collections privées reçus et invités lunch ou dinners par les personnes les plus importantes soit par leur argent ou pour un autre prestige et qu'en plus nous avons discuté 2 jours pour l'attribution des Prix Carnegie. Je pense qu'on sera satisfait à Paris de l'attribution du prix. Je ne peux pas vous dire le nom, ou plutot je vous le dis c'est Braque mais il doit être tenu secret jusqu'au 14 octobre ouverture de l'esposition et c'est une chose très sérieuse, ne le dites pas surtout à Rosenberg mais je vous le dis à vous d'une manière strictement privée

au cas où vous pourriez en tirer un avantage quelconque. Je vais demain à l'Hotel Pierre, j'ai une chambre au 36e étage. Mardi je vais passer la journée sur un remorqueur du port. Pour Empire State, j'ai diné avec l'architecte ce soir et je pourrai travailler la haut quand je reviendrai.

Et il faut revenir par ou j'aurais dû commencer ma lettre: que je suis complètement mordu par New York et que toute la vie américaine m'enchante. Je dois reprendre le Queen Mary le 6 octobre qui est je crois un mercredi ici et en Europe, pour arriver le 11 à Cherbourg. Ensuite j'irai pécher des châteaux, et vous, des brochets en Touraine. Mon vieux Bignon, une bonne poignée de mains, mes souvenirs à votre femme et à lundi 11 octobre.

Votre
Raoul Dufy

[*in the border*]
Je serai chez Barnes Samedi et Dimanche prochains.

September 29, 1937
My dear Bignou,

Our Carnegie tour is over. This morning I went to the Bignou Gallery. Very good, beautiful view, lots of Dufys. A good gallery. I received your letter and the note from Barnes. All of that made me happy, as well as a telegram from my wife. All is well. It was not possible to include my visit to Barnes with that of the Philadelphia museum because the whole thing is happening under the auspices of the Carnegie Institute and you know one can't combine those two things. So I decided to go back to Philadelphia when I am free of obligations to Carnegie, which will be soon. I am moving to the Hotel Pierre on the 36th floor. I saw my room. I'll be able to do my watercolors in comfort. The view is gorgeous and so is the view from your office. My stay until the Queen Mary leaves on October 6th is fully at the expense of the Carnegie Institute, including while I am at the Hotel Pierre. So everything is well. I'll have a small gift of gratitude for St. Gaudens, not completely for all of this, but personally, because he is a charming man.

Our tour was extraordinary in the sense that in eight days we saw Pittsburgh, Mount Vernon, Washington, Philadelphia, Baltimore in passing, and a little bit of New York. In each of these places we visited museums or private collections, received and were invited for lunch or dinner by the most important people, either because of their money or because of some other prestigious reason, and in addition we talked for two days about who should get the Carnegie Awards. I think they'll be satisfied in Paris with the award recipient. I cannot tell you the name, or rather, let me tell you. It's Braque, but it should be kept secret until October 14th, the day the show opens. It's a very serious thing, so above all do not tell Rosenberg, but I am telling you strictly privately in case it may profit you in some way. Tomorrow I go to the Hotel Pierre, I have a room on the 36th floor. On Tuesday I'll spend the day on a harbor tugboat. As for the Empire State *[building]*, I had dinner with the architect tonight and I'll be able to work up there when I come back.

I must go back to where I should have begun this letter: I am completely smitten with New York and everything about the way of life enchants me. I return on the Queen Mary on October 6th, which, I think, is a Wednesday here and in Europe, and will arrive in Cherbourg on the 11th. Then I'll go fishing castles, and you, pikes in Touraine. Dear old Bignou, a good handshake, regards to your wife, and see you on Monday October 11th.

Yours,
Raoul Dufy

[*in the border*]
I'll be at Barnes next Saturday and Sunday.

(Haute Garonne) Aspet, 4 Mars, 1944
 Mon cher Georges,
 J'ai reçu il y a quelques jours seulement ta lettre du 14 janvier.

 J'ai du me deplacer ces derniers jours, c'est pourquoi je suis en retard pour te repondre. Ta lettre m'afflige beaucoup. Ta situation est réellement la conséquence d'une injustice née au désordre des temps actuels et il faut l'envisager au point de vue immédiat, car pour l'avenir il est sûr que le pays n'aura pas assez des services de tous les siens pour vivre et reconstruire. Ce que je peux faire à l'instant c'est d'abord de te demander de me dire franchement si un peu d'argent peut te servir. Ensuite je te demanderai si tu as vu ton ancien patron, Julien Cain? Tes connaissances de l'espagnol et du portugais pourraient te servir si les relations avec ces pays étaient normales, ce qui n'est pas le cas du moment. Je vais aller la semaine prochaine à Perpignan où la langue espagnole est en usage et je verrai si je peux te donner une indication. Ensuite, il y a la peinture où on vend beaucoup. As-tu à montrer dessins, peintures, aquarelles et as-tu essayé d'en tirer parti. il faudrait le faire avec assurance et sans timidité. Commences de le faire, et de mon côté, je te donnerai bientot une addresse, mais si tu pouvais, fais le sans m'attendre pour commencer. Je vais voir quelque chose de mon côté pour la partie commerciale, décoration théâtrale. Je connais Laverdet. Je vais te donner un mot pour lui mais je n'ai pas son addresse ici. Je vais te la faire envoyer par Robert à qui j'écris ce soir. Il n'est pas possible que tu doive te trouver d'une façon si angoissante le problème de ton avenir car tu as beaucoup de ressources. Alors ne te laisses pas t'attrister par ce mauvais

présent. Je te fais donc à ton addresse un mot pour le decorateur Laverdet. Je reste ici jusqu'au 12 de ce mois, ensuite, Villa Slam à Vence, Alpes Maritimes. Je serai heureux de te donner un coup de main. A bientot et crois à ma vieille amitié de ton

 Raoul Dufy

[*in the border*]

Je n'ai pas de nouvelles de Friesz. Donnes lui mon meilleur souvenir et à toute la famille ainsi qu'à Anita.

(Haute Garonne) Aspet, March 4th, 1944

 My dear Georges,

 I received your letter of January 14th only a few days ago. I had to go away recently; which is why I am late in replying to you. Your letter pained me greatly: your predicament is actually the result of an injustice due to the confusion of these times and you must look at it from an immediate viewpoint, for, as far as the future is concerned, it is certain that our country will not have enough to aid all its people, to live, and to rebuild. What I can do for the moment is first of all to ask you to tell me frankly if a little money could be of use to you. Then I must ask you if you have seen your former boss, Julian Cain. Your knowledge of Spanish and Portuguese could be valuable to you if relations with their countries were normal, which is not the case at the present time. Next week, I am going to go to Perpignan where Spanish is used, and I shall see if I can give you a lead. Then, there is painting. A lot is being sold. Have you any drawings, paintings, or watercolors and have you tried to make use of them? You must do so with assurance and without timidity. Begin to do so on your own, and I—for my part—will soon give you an address, but if you could begin without waiting for me, do so. I shall look into something at my end for the commercial part—stage designing. I know Laverdet. I am going to give you a note for him, but I don't have his address here. I will have it sent to you by Robert, to whom I am writing this evening. It's just awful that you should have to face the problem of your future is such an anguished way, because you have so many resources. So don't let yourself be saddened by the unfortunate present. I shall have a note for the designer Laverdet brought to your address. I am staying here until the 12th of this month, then Villa Slam at Vence, Alpes Maritimes. I would be happy to help you. See you soon, and believe in my long-standing friendship for you.

 Raoul Dufy

[*in the border*]

I don't have any news of Friesz. Remember me to him and to all his family; as well as to Anita.

Self Portrait, aquarelle, by Raoul Dufy. © Giraudon/Art Resource, New York.

Raoul Dufy (1877-1953)

Two letters written by Raoul Dufy illustrate clearly the many dimensions of this ebullient, worldly character, who was, as well, a thoughtful and caring friend. The first letter was written in 1937, on a triumphant voyage to America; the second, dated just after the war, commiserates with a fellow artist caught in the turmoil of the times.

The same effervescence that we recognize in Raoul Dufy's painting characterizes the first letter. Written to his dealer, Etienne-Jean Bignou, from New York in 1937, Dufy's impressions of his visit, like his paintings, are airy, bright, enthusiastic. These same qualities are often used to describe the artist's views of brilliant blue seaside resorts, delicate green parks, ebullient concerts and festivities—all the scenes he enjoyed picturing. Dufy has been described as "a painter of joy—the joy both of seeing and creating." With his bright, light-filled and intense color harmonies and his calligraphic, rhythmic lines, Dufy recorded an attractive, fashionable world that he imbued with a sensuous charm and elegance.

Yet he was a prolific and wide-ranging artist. In fact, Dufy followed a long line of French painters who interested themselves in the decorative arts, as well as in painting. He made murals, tapestries, fabric designs, book illustrations, screens, and pottery, in addition to hundreds of oil and watercolor paintings. All of his work was characteristically witty, energetic, and fresh, bearing his unmistakable style. "When you have succeeded in something or other," he said, "quickly turn your back on it and enter on a new adventure."

By the late 1930s he was widely recognized, a successful artist receiving numerous commissions (among them murals for the Palais d'Electricité at the World's Fair in Paris, the Palais de Chaillot, and the Paris Zoo), as well as the attention of museums in both France and abroad. He was invited to foreign countries where his paintings were shown, was a juror of international art shows, and found his paintings purchased by noted collectors, such as Dr. Albert Barnes. Dufy notes in this letter that he has recently heard from Barnes, who has just bought two of his works for his collection in Merion, Pennsylvania. His own dealer and good friend, Etienne-Jean Bignou, has shown his paintings in Paris, (at his gallery on the rue de la Boetie), and in the Bignou Galleries of London and New York

And 1937, when this letter was written to Bignou, was a typically busy and satisfactory year for Dufy. The artist has sailed for America because he has been invited to serve as a member of the jury for the prestigious Carnegie Prize in Pittsburgh, and because Bignou has opened a show of his work in his 57th Street gallery in New York. Dufy has spent two days deliberating on the jury, which had finally chosen Georges Braque for the top award. But, as he warns Bignou, "above all, don't tell Rosenberg…I am telling you strictly in private, in case it may profit you in some way." He obviously enjoyed the tour, led by the director of the Carnegie, Homer Saint-Gaudens ("a charming man" for whom he will buy a "little gift"), and its social aspects, during which the artist was "received and invited for lunch or dinner by the most important people." He has been taken on a week-long trip to visit museums and private collections.

He will sail home on the *Queen Mary* to Cherbourg, filled with enthusiasm for all he has seen and done in America, revealing the same joy that we sense in his paintings.

In the second letter, sent to a friend and fellow artist, Dufy reveals a more tender and caring attitude. The war has ended, but Dufy is concerned with the "confusion of the times," blaming the post-war turmoil for his friend's want of artistic success. Dufy praises his friend, tells him not to give up hope and offers an introduction to a designer named Laverdet. He recommends his friend contact a previous employer, Julian Cain, the head librarian of the National Library and a hero of the Resistance, and he suggests the penniless artist try to

put together a collection of his work to sell. And he graciously offers financial assistance. This is a thoughtfully worded and exceptionally generous letter from one artist to another.

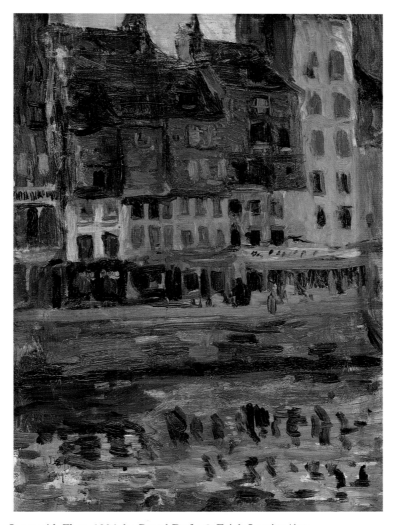

Street with Flags, 1906, by Raoul Dufy. © Erich Lessing/Art Resource, New York.

Graphology notes on Raoul Dufy

The writer has a stylish, rhythmic handwriting that overall flows with an attractive balance of emotions and controls.

This mind is in the top five percent of fast thinkers. without the help of intuition, and is essentially analytical. The time between acquisition of information and the formation of an insight or conclusion is astonishingly quick.

Writer is decisive, organized in an individual fashion, persistent in the quest of high practical goals, which may seem excessively high to some.

Although there are indications of leadership aptitude, there are signs the writer can be dishonest with others, at times; this trait may impede the pursuit of goals.

Imagination exists but sometimes ideas are snuffed before reaching reality. There is a tendency toward abstract notions, including science, mathematics and philosophy.

There is an unexplained muddiness in the handwriting that may indicate an addiction and/or a sign of deceptiveness.

A strong streak of aggressiveness, daring and adventurousness.

Much secrecy about himself.

Henri Matisse
Letter to François Campaux

199

Vence 15 avril 46
Cher Monsieur Campaux

J'ai trouvé ce que vous désirez pour l'étude d'avoué—où j'ai passé quelques années un peu à l'étouffe, n'ayant d'autre désir que de peindre. Avant d'aller à l'étude vers 9h, plutot après 9 heures, j'allais au cours de dessin du palais Fondation Quentin de La Tour destiné aux dessinateurs en rideaux qui avait lieu dans les ensembles du Palais de Fervaques de 7h à 8 heures du matin. Je déjeunais à midi au plus vite et j'allais peindre encore 1 h avant de rentrer à l'étude de M. Derieu, Place du Marché Couvert. Après la journée d'étude avoué (6 heures du soir) je retournais au plus vite à ma chambre pour y peindre jusqu'à la nuit—encore une bonne heure de peinture. Mais ceci l'été seulement, c'était possible.

Ne pourriez-vous pas photographier une porte du style de celle que j'indique au dos de cette feuille. D'abord ouverte montrant son tambour fermé par une porte dont le panneau supérieur, en verre dépoli à fleurs gravées porterait: ETU comme une indication coupée par la porte d'entrée pas complètement ouverte

ETU
M. DER
AVO

Ensuite la porte refermée montrerait la plaque de cuivre dans son panneaux supérieur.

ETUDE
de
M. DERIEU
AVOUE

Voilà de que je trouve de tout à fait expressif. une porte ouverte ainsi, et tout son mystère. Faire un dessin est impossible. Ça ferait très mal. Vous savez combien je suis interessé à votre travail, croyez-vous que je regarderais un dessin si je le croyais bien placé. Croyez moi cher Monsieur Campaux j'ai absolument raison.

Dans l'espoir que vous me comprendrez je vous serre cordialement la main.
H Matisse

[*envelope front*]
AVION
 Monsieur Campaux
 Cie Gle Cinématographique
 3, rue Clément-Marot
 Paris

Vence April 15, 1946
Dear Mr. Campaux,

I found what you want for the attorney's office—where I spent a few somewhat stifling years, wishing for nothing other than painting. Before going to the office at about 9 a.m., or rather after 9, I would go to a drawing class at the Fondation Quentin de La Tour which was given in the Palace of Fervaques from 7 to 8 a.m. I would have a quick lunch and I would go and paint for about an hour before going back to Mr. Derieu's office, attorney-at-law on the Place du Marché Couvert. After office hours (6 p.m.), I would go back as fast as I could to my room to paint until it got dark—another solid hour of painting. But this was possible during the summer only.

Could you photograph a door of the kind I indicate on the verso of this sheet, first open and showing its tambour shut by a door, where the upper panel, in flower engraved frosted glass, would say:

LAW OFF
Mr. DER
LAWR

the wording cut off by a partially open door. Then with the door shut, showing the copper plaque in an upper panel

LAW OFFICE

Of

Mr. DERIEU

That's what I find to be most vivid. An open door like this one with all its mystery is impossible to draw. It would not be good. You know how interested I am in your work. Believe me, I would consider a drawing if I thought it were well placed. Trust me, Mr. Campaux, I am absolutely right.

In the hope that you understand me, I shake your hand cordially. H Matisse

[envelope front]
AIR MAIL

Mr. Campaux
Gle Cinématographique Company
3, Clément- Marot Road
Paris

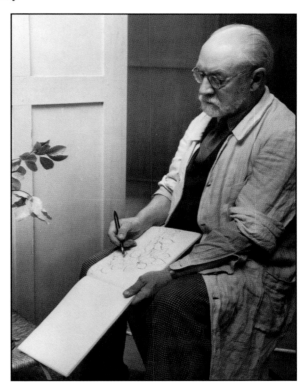

Photoportrait of Henri Matisse, by Brassai.
© private collection.

Henri Matisse (1869-1954)

In 1946 when this letter was written, Henri Matisse was one of the two or three most famous artists in the world. Many of Matisse's most beautiful paintings throughout his career were interiors, featuring open doors and windows looking out, for these architectural shapes had special significance in his art— formally, pictorially, and psychologically. In fact, he made several paintings consisting entirely of these mysterious forms, including "The French Window at Coullioure" and "The Open Door." Not surprisingly, this letter concerns doors, and one door Matisse remembered particularly well from his youth.

When the artist was approached by a documentary film maker, François Campaux, who wanted to make a short film about him, he agreed. (The finished product, called "Henri Matisse," was a 16 mm. black and white film of 22 minutes showing the artist drawing in slow motion, and working at his easel on a painting in fifteen stages of development. The film had a text by Jean Cassou and was directed by Andre Leveille, and was made in Paris and at Matisse's home in Vence, in the south of France.)

Matisse sent Campaux the biographical material he needed, and as illustrated here, in his letter of April 1946 to Campaux, with its quick sketches and telling descriptions, is a personal revelation. He describes his days and hours as a law clerk, and his continuous efforts to find painting time. And here we find the image of a particular door with an "upper panel of flower-engraved tambour glass," and the suggestion of its significance in the artist's future paintings.

Matisse, after completing law school in 1888, went to work at twenty, as a clerk in a law office in St. Quentin in the north of France. For a "few stifling years" he remembers "wishing for nothing other than painting," and finding only hours here and there to paint, early in the morning, during the lunch hour, and before the light faded in the (summer) evening. He wants the film maker to recreate and photograph the two-paneled door of the law office with the lawyer's name on a copper plaque upon it, but "the wording cut off by a partially open front door, and then with the door shut..." The symbol of his hours away from his art, this door open and closed, was an image that had lasted in his memory. "That's what I find most vivid," he writes Campaux. "An open door like this one with all its mystery. It is impossible to draw it. It would not be good."

In fact, Matisse left St. Quentin and his career in law for Paris in either 1890 or early 1891, and (equipped with 350 francs to last for two years of study), began life as a full-time student of painting. Within a very short time this "greatest colorist of our time" had become an extraordinarily gifted innovator in the art world of the early twentieth century, his paintings, drawings and illustrated books always joyfully received. Despite bouts of ill health, his was a life filled with good art, good friends, and public recognition. Freed from the constraints of naturalism, he responded to the outside world with strong imaginative color, graceful forms, and a combination of geometric and sinuous lines on a flat picture surface; the results were brilliant, expressive syntheses of the recognizable and the abstract. "The whole arrangement of my pictures is expressive," he wrote in 1908. "The place occupied by figures or objects, the empty spaces around them, the proportions, everything plays a part...What I dream of is an art of balance, of purity and serenity devoid of troubling or depressing subject matter." This personal view of art remained his throughout his life.

Correspondence from Alain le Marc'Hadour to Pierre F. Simon

ALAIN LE MARC'HADOUR
AVOUÉ
15, rue Jean Jaurès
SAINT-QUENTIN

Monsieur Pierre F. SIMON
52 Wall Street
New York N.Y. 10005

Cher Monsieur,
J'ai reçu votre courrier du 28 Mars 1972, qui m'a fort intéressé.
Henri MATISSE fut effectivement clerc pendant quelques années, en

l'Etude de Maître DERIEU, qui habitait alors, 54 Rue du Gouvernement à SAINT QUENTIN.

Son successeur, fut Maître PERIN, qui transferra l'Etude, 15 Rue des Patriotes.

Il eut pour successeur Maître MARCHANDIER, qui était son gendre, puis Maître COMTE.

L'Etude est toujours 15 Rue des Patriotes.

Mon confrère, Maître Louis FORMEAUX, avec lequel vous pouvez-vous mettre en rapport, est toujours en possession d'un important carton de MATISSE, dans lequel se trouvent des dessins, et des autographes de ce dernier (probablement des projects d'actes de procédure).

MATISSE, bien que né au CATEAU (Nord) était originaire de BOHAN (chef lieu de Canton de l'arrondissement de SAINT QUENTIN).

L'école de dessin de LA TOUR à laquelle MATISSE fait allusion, dans l'une de ses lettres, existe toujours.

Les cours ont lieu, maintenant dans un bâtiment neuf construit après la guerre 1914 1918.

Heureux d'être entré en rapport avec vous au sujet de cette affaire,

Je vous pris d'agréer, Cher Monsieur, l'expression de mes sentiments dévoués.

Saint-Quentin, March 29, 1972

Mr. Pierre F. Simon
52 Wall Street
New York, NY 10005

Dear Sir,

I received your letter dated March 28, 1972, which interested me a great deal.

Henri MATISSE indeed clerked for a few years in the law office of Mr. DERIEU, who resided at the time at 54 rue du Gouvernement, in SAINT-QUENTIN.

Mr. PERIN, his successor, moved the office to 15, rue des Patriotes.

Mr. Marchandier, who was his son-in-law, succeeded him, then Mr. COMTE.

The office is still 15 rue des Patriotes.

My colleague, Mr. Louis FORMEAUX, with whom you could get in touch, still holds an important carton of Matisse's, in which there are drawings, and autographs (probably drafts of procedural acts).

Although he was born at CATEAU (Nord), MATISSE was from BOHAN (county seat for the the district of SAINT-QUENTIN).

The LA TOUR drawing school MATISSE alluded to in one of his letters still exists.

Classes are given now in a new building erected after the war of 1914-1918.

I am happy I got in touch with you in reference to this story, and I trust you will believe, dear Sir, in my cordial regards.

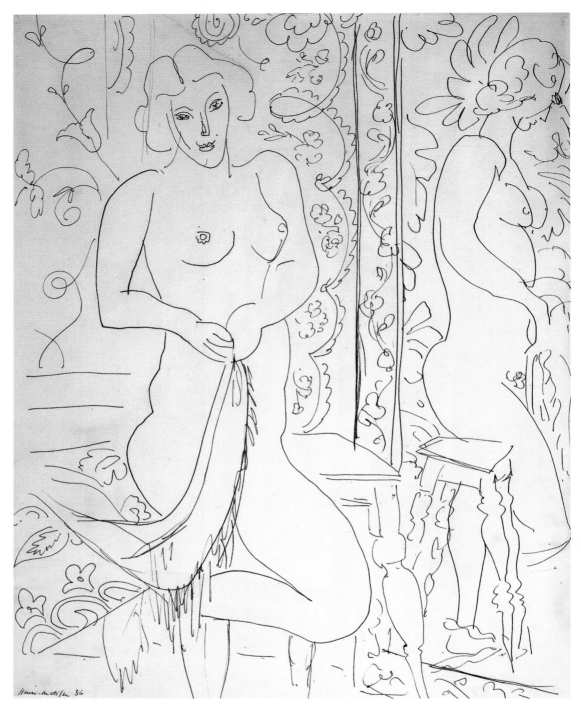

Femme demi-nue, Réfléchie dans la glace, 1932, by Henri Matisse. © private collection.

Graphology notes on Henri Matisse

This artist rebounds very quickly from any stressful situations he may encounter.

His goals are set high and at times in the daydreaming realm. His self-starting ability is very strong, and his follow-through is moderate.

He is not always open and tolerant to new ideas and opinions

He can be aggressive when pursuing his objectives. There is some argumentativeness within his personality, and that is usually to save face. He dislikes working with details and can be very impatient and irritable if faced with too many.

He can talk as well as listen, can use tact when necessary, and is very sincere in his communications.

Georges Braque
Letter to Daniel Wallard in 1946

20.2.46

Mon cher Wallard voici
deux photos. J'espère qu'elles
vous satisferont. J'ai été
heureux de savoir que vous
remettiez au travail. Nous allons
repartir ensemble car moi
depuis une quinzaine j'ai
repris mes brosses.

et je ne doute que vous ne
trouviez là la même joie
que moi. J'ai lu votre
bon article des "Problèmes
de la Peinture —
Au travail mon cher
Wallard.

Bien à vous.

G Braque.

20.2.46

Mon cher Wallard Voici deux photos. J'espère qu'elles vous satisferont. J'ai été heureux de savoir que vous remettiez au travail. Nous allons repartir ensemble car moi depuis une quinzaine j'ai repris mes brosses et je ne doute que vous trouviez la même joie que moi. J'ai lu votre bon article des "Problèmes de la Peinture—

Au travail mon cher Wallard.

Bien a vous

G Braque

2-20-46

My dear Wallard Here are two photographs. I hope you'll be satisfied with them. I was happy to hear that you are getting back to work. We'll get back on track together, because I have been back at my brushes for the past couple of weeks and I have no doubt that you will experience the same joy I have. I read your fine article, "Problems of Painting."

To work, my dear Wallard.

Truly yours,

G. Braque

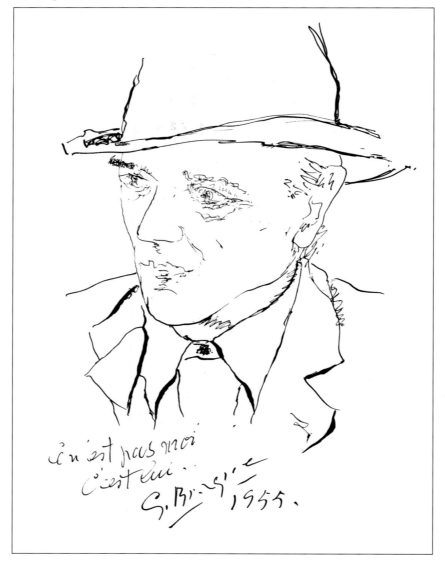

Self-sketch, line drawing, 1955, by Georges Braque. © Collection Viollet, Paris.

Georges Braque (1882-1963)

By 1946, when this letter was sent to a French writer on art and poetry named Daniel Wallard, Georges Braque had become one of the great elders of modern French painting. He had exhibited all over Europe and America—in the preceding year alone in Amsterdam, New York, Zurich, and Paris—and he would soon win the Grand International Prize for Painting at the Venice Biennale. Dozens of books and articles were written about him, explaining and analyzing his art; he was seen both as a founding father of modernism, and as a classicist to whom form, line, and color, were still important.

He was the subject of numerous studies. Among the many articles that tried to make sense of the rapidly changing world of modernist painting in mid-century was one called "Problèmes de la Peinture" by Daniel Wallard (1913-1983). Wallard, who also corresponded with the painter Jean Fautrier in the 1940s, was the author of a book on the Surrealist writer, Louis Aragon. He had sent Braque a copy of his article and a request for photographs.

Braque's answer was helpful and pleasant, but he rarely approved of the many explanations of his art, telling an interviewer that "Critics should help people see for themselves; they should never try to define things, or impose their own explanations, though I admit that if—as nearly always happens—a critic's explanations serve to increase the general obscurity that's all to the good..." Braque preferred to let his art speak for itself, though he did produce a number of brief, enigmatic statements that were more epigrams than explanations, such as "One must not imitate what one wants to create."

As a major figure in the evolution of modern painting and, with his colleague Pablo Picasso a founder of Cubism, Braque sought an art that would reveal the objective truth of reality. After a brief foray into Fauvism, he began to search for a way to show the depth and volume of objects in space. He also interested himself in the treatment of a picture's surface and texture. His serene, almost classical approach to radical ideas made him one of the most complex and extraordinary of modernists. He dominated the early phases of Cubism with his analytical, balanced ideas of space and form, and the harmony between the object and the space it occupies. He believed that perspective was a "bad trick," making it impossible for an artist to convey a full experience of space, since it "forces the objects in a picture to disappear away from the beholder instead of bringing them within his reach, as painting should."

Long after the Cubist movement had ended, he continued to interest himself in issues of space and form. After World War I he turned toward a freer style, painting nudes, landscapes, and still life. Light became a paramount issue, as did expressive line. By 1946, he had synthesized the spatial and formal aspects of Cubism with a classically lyrical style. And he had become known as one of the great masters of twentieth century French painting.

In this letter Braque politely sends off two photographs and thanks Wallard for his "fine article." But what is particularly revealing about this brief note is the joy the artist takes in his work. Braque, who had been seriously ill in the past year, was excited to have been able to return to his painting, and in this brief letter the major interest is his joy in working again.

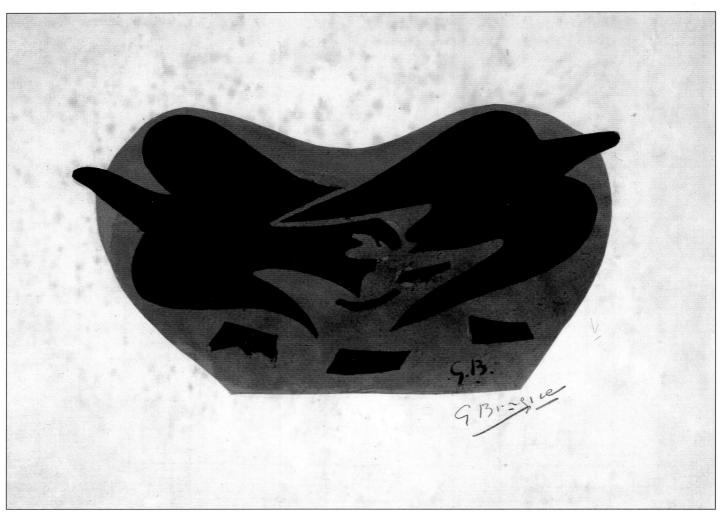

Bird, collage and gouache on paper, by Georges Braque. © private collection.

Max Ernst
Letter to Joë Bousquet

Sedona le 15 juillet
Mon bien cher Joë

Nous partirons dans une semaine. Nous arriverons en France après le 15 août. Que devient notre livre? Je n'ai reçu aucun mot de la part de l'éditeur.

Je serais heureux de savoir si les 18 dessins que j'avais confié à Lefèbvre-Foinet sont arrivés. Tu pourras m'écrire à l'adresse suivante: à bord de l' "Oregon" Compagnie Transatlantique partant de New-Orleans le 27 juillet.

Mille choses à faire, donc, amitiés aux amis de Carcassonne et je t'embrasse.

Max

—————

Sedona July 15th

My dearest Joë,

We are leaving in a week. We will arrive in France after the 15th of August. What has become of our book? I have not received anything from the editor.

I would be happy to know if the 18 drawings I sent to Lefèbvre-Foinet have arrived. You could write to me at the following address: on board the Oregon (Compagnie Transatlantique), leaving from New Orleans on the 27th of July.

Thousands of things to do, so, best to all our friends in Carcasonne, and I embrace you.

Max

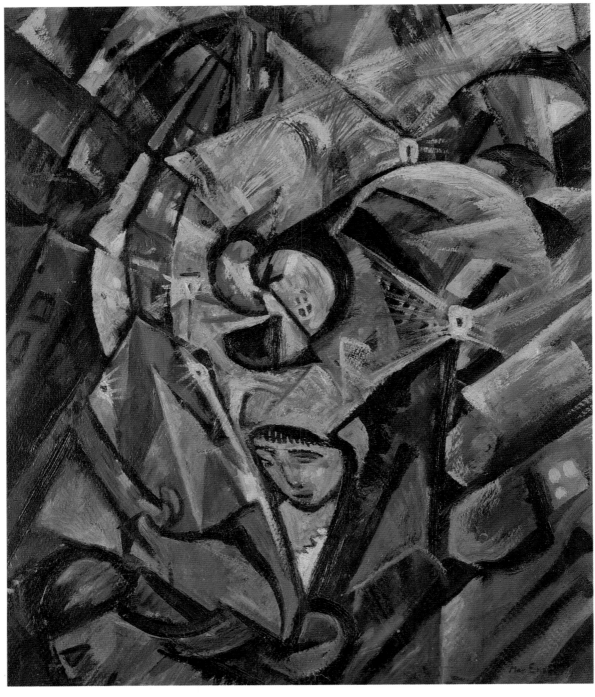

Self Portrait, 1911-12, by Max Ernst. © Erich Lessing/Art Resource, New York.

Max Ernst (1891-1976)

Max Ernst, a Surrealist whose art was characterized by horrific visions and visual puns, is straightforward and quite businesslike in this letter to his life-long friend and fellow Surrealist, Joë Bousquet (1897-1950). His concerns here are with galleries and publications. By 1949, when he sent this letter to announce his arrival in France from the United States, he was well known and much admired, and his art was being shown in major venues both in Europe and America.

Ernst, who was born in Germany and moved to France in 1922, was one of the central figures, both as a theorist and painter, in the development of Dadaism and Surrealism. The artist experienced the horrors of war (he served in the German artillery in World War I and was captured by the Nazis in France in World War II). His paintings reflect an illusory, unreasoning world of violence and destruction, made all the more terrifying by his extremely realistic style. His involvement in the manifestos and publications of the movement brought him into frequent contact with Joë Bousquet, a Surrealist poet and novelist, and fellow signer of the 1929 manifesto, who commented on Ernst's role in the evolution of Surrealism: "For many years he had borne the terrible burden of walking ahead of his generation."

In 1941, rescued from the Gestapo, along with several other prominent artists, with the help of Peggy Guggenheim (whom he married and soon divorced), Ernst arrived in America in the midst of World War II. Within two years he had met an American painter named Dorothea Tanning, and had made his first trip to Sedona, Arizona, far from the terrors of war. He and Tanner married in 1946 and settled in Sedona, where they built a house. His career, and hers as well, prospered, as did those of many expatriate artists in the United States. During his years in Arizona he produced a series of paintings, drawings, and collages to accompany the poetry of Paul Eluard, a volume by and about him called "At Eye Level/Paramyths," and a number of other works, including sculpture. Nonetheless, cut off from the intellectual and artistic ferment in Europe, Ernst wanted to go back, and to meet up with his Surrealist colleagues Arp, Eluard, Tzara, and Bousquet, among others. Ernst missed the experience of being the member of a group. "Art," he said, "is not produced by one artist but by several. It is to a great degree a product of their exchange of ideas with one another." He made several trips, before resettling permanently in France in 1953.

His first return was in 1949; he sailed with Dorothea from New Orleans to Antwerp aboard the "Oregon", to which he directs his friend Bousquet to write. He had not been forgotten in Europe. In this letter from Sedona he asks Bousquet to inquire about the eighteen drawings he had sent for exhibition by René Lefèbvre-Foinet (an art dealer and friend of his colleague Man Ray).

He worries about "our book." He had turned to Bousquet to write the preface to an exhibition catalog when he was offered a retrospective at the Paris Galerie René Drouin. The show was to take place in the fall of 1950. Bousquet did indeed write the preface and Ernst, who had returned to Sedona after several months, made his second trip to Europe for the opening of the show. The paintings he showed were all done in Arizona.

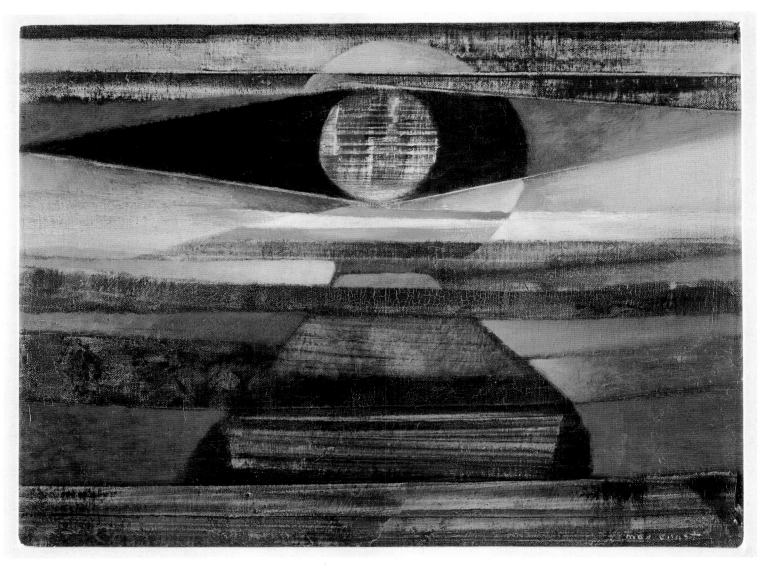

Sun, by Max Ernst. © Scala/Art Resource, New York.

212

Fernand Léger
Receipt to Léonce Rosenberg in 1918

Recu de Monsieur Léonce Rosenberg Editeur d'Art 19 rue de la Beaune la somme de <u>cinq cents francs</u> à valoir sur un achat <u>total de trois milles deux cents soixante dix francs</u>—
Paris le 16 octobre 1918
 F Léger
86 rue Notre Dame Des Champs

1. Nombre de Toiles cédées—10

2.

Calibre	Prix	Titre
50	700F	Les Acrobates dans le cirque.
6	200F	Esquisse des Acrobates dans le cirque
15	400F	Les usines.
25	500F	Les Acrobates
30	500F	Le Cirque
6	200F	Esquisse du cirque

[*verso*]

Calibre	Prix	Titre
6	200F	La perforeuse.
6	200F	Contraste de forme
4	100F	Le clown
4	100F	Le 14 juillet à Vernon

Dessins et Aquarelles

35 cm	70F	Dessins pour les Acrobates
35 cm	100F	Aquarelle pour le clown

Les oeuvres ont été terminées octobre 1918

Received from Mr. Léonce Rosenberg, art publisher 9 rue de la Beaune, the sum of <u>five hundred francs</u> as deposit for a total purchase of <u>three thousand two hundred seventy francs</u>—

Paris, October 16, 1918

F. Léger

86 rue Notre Dame Des Champs

1. Number of paintings sold—10
2.

Size	Price	Title
50	700F	Acrobats at the circus.
6	200F	Sketch of acrobats at the circus
15	400F	Factories.
25	500F	Acrobats
30	500F	The circus
6	200F	Sketch of the circus

[*verso*]

Size	Price	Title
6	200F	The hole puncher
6	200F	Contrasts of form
4	100F	The clown
4	100F	July 14 in Vernon

Drawings and Watercolors

35 cm	70F	Drawing for the acrobats
35 cm	100F	Watercolor for the clown

The works were complete in October, 1918.

[*One franc in 1918 would be the equivalent of 3.30 Euros in 2003.*]

Argentin Vendredi 27
Mon cher Rosenberg
J'ai votre lettre du 25—très curieux le petit tableau en question, et curieux aussi de voir cela. Ce noble méridional aurait-il besoin d'un peu de fraicheur? Sans fausse modestie j'en ai à lui revendre et je crois entre nous qu'il en a besoin.

Cet homme de 38 ans est un vieillard. De cela j'en suis sûr. La question du renouvellement se pose pour lui d'une façon très serieuse. C'est le cas de tous les artistes dont l'armature est surtout faite de charme—la courbe est courte, le bon gros volume, les bonnes grosses valeurs, je sais bien c'est un peu vulgaire, cela manque peut-être d'extrême originalité!

Mais que voulez vous, depuis que le monde est monde même les plus raffinés de ces messieurs n'ont pu éviter de se mettre à table deux fois par jour… comme tout le monde! Un tableau a des necessites lui aussi et impérieuses…

Le volume, c'est son cas de force majeure.

Bien à vous et dans quelques jours—F Léger

[left margin]
Tres curieux de voir les Derains. Et cette reforme?

———

Argentin Vendredi 27

My dear Rosenberg,

I have your letter of the 25th. Very odd, the small painting in question, and odd, too, to see that. Would that noble Southerner need a bit of fresh air? Without false modesty, I could sell him some and I believe, between the two of us, that he could use it.

At 38 that man is old, I am sure of it. He is facing the serious issue of renewal, which is typical of all artists whose reputation is essentially based on charm. The trajectory is short; good old volume, good old values. I know it's a bit vulgar, perhaps it even lacks originality! Volume in his case is the most important element.

But what do you want, ever since the beginning of times even the most refined of gentlemen have not been able to avoid sitting down for their two meals a day like the rest of the world! A painting has its own needs, and it is imperious…volume is his strength.

Truly yours, see you in a few days. F Léger

[*left margin*]
Very curious to see the Derains. And the reform?

Letter to Roger Christe in 1955

2.

indépendante de l'ordre architectural —
Tout le monde s'arrêtera, regardera ce
tableau et perdera de vue l'ensemble
réalisé par l'architecte — Voilà à mon
sens l'erreur qui doit être évitée —
qu'elle soit, Vitrail, Céramique, Mosaïque
Fresque, le problème reste le même —
Volonté d'unité avant tout .

En ce qui concerne mes rapports avec le Père
Couturier ils furent toujours d'ordre
Amical et absolument compréhensif dans
l'ordre plastique — Il fut un des premiers
à comprendre la valeur de la couleur libre
dans mes projets —
Il me fut d'un très bon conseil dans le choix
de "objets" évocateurs pour la Façade d'Assy
et pour "le drame du Christ" à Audincourt

Il comprit parfaitement, ce qui était tout
de même assez délicat, que l devait considérer
mes collaborations à des ensembles religieux
du même ordre c'est-à-dire de la même réalisation
que celles ayant eu lieu ou dans l'avenir pour
toutes collaborations publique, hôpital -
maisons collectives, centre d'aviation par exemple.
Je sais que cette position prête à critique
mais elle est comme cela —
Je me souviens avoir fait un certain scandale
en Sorbonne à Paris il y a une dizaine d'années
en émettant des idées très particulier sur le
comportement des grands artisans du Moyen Age

Je termine en pensant que je vous donne des
documents qui peuvent vous servir pour
votre projet si les documents n'arrivent
pas trop tard —
Cordialement
Fleger

Monsieur Roger Christe
Coulaurie
Suisse

217

18 juin 55

Cher Monsieur Christe

Bien recu votre lettre et papiers concernant projet. Je suis très en retard à répondre ayant eu un accident qui m'a immobilisé pendant 3 semaines. Cela va mieux et je puis envisager votre demande: voici ce que je puis vous écrire concernant mes travaux à Courfaivre.

D'abord l'emplacement des "lumières" dans cette église permettent plus de fantaisie que mon travail a Audincourt. De là j'ai envisagé d'essayer d'appliquer un procédé, que l'on trouve dans certains tableaux de chevalet et projets architecturaux—c'est à dire "la couleur en dehors du dessin" qui permet dans au sujet un evocation par objets, une liberté entièrement nouvelle—un dessin conçu très classique (comme c'est le cas à Courfaivre) "se libere" et devient "plus plastique" par le fait qu'un ordre de couleur absolument libre s'ajoute à ce dessin.

Je suis très satisfait du résultat dans l'ordination des vitraux de votre Eglise—

La situation actuelle dans la production artistique picturale est très évoluée en ce moment vers un art très libre "dit ABSTRAIT." Pour moi je tiens pour très valable cette évolution surtout concernant ma collaboration avec des positions architecturales. —Les architectes eux-mêmes inclinent beaucoup vers une collaboration libre... La raison est celle-ci—

Si, dans un ensemble architectural très voulu, très étudié par rapport à une construction très nouvelle et moderne, si dans cet ensemble vous imposerez sur les murs des tableaux représentatifs genre tableau de chevalet à sujet vous détruisez l'ensemble architectural—ce tableau devient une valeur indépendente de l'ordre architectural—Tout le monde s'arretera, regardera ce tableau et perdra de vue l'ensemble réalisé par l'architecte—

Voilà à mon avis l'erreur qui doit être évitée. Que cela soit, Vitrail, Céramique, Mosaïque, Fresque, le problême reste le même—volonté d'unité avant tout.

En ce qui concerne mes rapports avec le Père Couturier, ils furent toujours d'ordre amical et absolument compréhensif dans l'ordre plastique—Il fut un des premièrs à comprendre les valeurs de la couleur libre dans mes projets—

Il me fut d'un très bon conseil dans le choix des "objets" évocateurs pour la Façade d'Assy et pour "le drame du Christ" à Audincourt. Il comprit parfaitement, ce qui était tout de même assez délicat, qu'il devait considérer ma collaboration a des ensembles religieux du même ordre c'est à dire de la même réalisation que celles ayant eu lieu ou dans l'avenir pour tout collaboration publique, hôpital—maisons collective, centre d'aviation par example. Je sais que cette position prête à critique mais elle est comme cela—

Je me souviens avoir fait un certain scandale en Sorbonne a Paris îl y a une dizaine d'années en émettant des idees très particuliere sur le comportement des grands artisans du Moyen Age.

Je termine en pensant que je vous donne des documents qui peuvent vous servir pour votre projet si les documents n'arrivent pas trop tard—

Cordialement

F Léger

[envelope]

Monsieur Roger Christe
Courfaivre
Suisse

June 18, 1955

Dear Mr. Christe,

I've received your letter and the papers concerning the project. I'm very late in responding, having had an accident which immobilized me for three weeks. I'm better now, and I can think about your request.

Here's what I can write to you about my work at Courfaivre. First, the placing of the stained glass lighting in this church allows me more fantasy than my work at Audincourt. Based on that, I envisaged using a process which one finds in certain easel paintings and architectural projects—that is to say 'color,' beyond the drawing, which allows a freedom that is completely new to the painting of a subject, or even an evocation of objects—an absolutely classically conceived design (which is the case at Courfaivre) is liberated and becomes more decorative, since an absolutely free order of color is added to the design. I'm very satisfied with the ordination of the windows in your church.

The current situation in the production of paintings is evolving now to a very free expression of art labeled "ABSTRACT." For myself, I consider this a most worthy evolution, particularly concerning my collaboration in architectural situations. Architects themselves are very much inclined to a free collaboration. The reason is this: if, in an architectural ensemble that is very deliberate and very studied in terms of new and modern construction, you impose on the walls representational easel paintings, you destroy the architectural ensemble. The painting becomes a value independent of the architectural order—everyone will stop to look at the painting, and will lose the global view of the design of the architect.

That, to my mind, is the error which must be avoided, whether the issue is stained glass windows, ceramics, mosaic, fresco—the problem is the same—a desire for unity, above all.

As far as my relations with Father Couturier, they were always agreeable and absolutely clear about the art. He was one of the first to understand the value of 'liberated color' in my projects.

He was very helpful on the choice of evocative objects for the façade of Assy, and for "the drama of Christ" at Audincourt. He understood perfectly something that was, after all, rather delicate—that he should consider my collaboration in these religious constructions as exactly the same application as those having taken place for all public collaborations, hospitals, public housing, a center for aviation, for example. I know this position is open to criticism, but that's how it is. I remember a particular scandal at the Sorbonne in Paris about ten years ago, when I expressed some very distinctive ideas about the behavior of the great artisans of the Middle Ages.

I close believing that I'm giving you some documents which will be useful for your project, if they don't arrive too late.

Cordially,

F. Léger

[*envelope*]

Mr. Roger Christe
 Courfaivre
 Switzerland

Photograph of Fernand Léger in his Studio. © H. Roger-Viollet.

Fernand Léger (1881-1955)

In a somewhat light-hearted note, a young—but already well-known and confident—Fernand Léger, writing just after the First World War, discusses another artist's work and personality with his dealer, Léonce Rosenberg. Léger is scathingly critical, describing the other artist as having "armor made essentially of charm," and "old at 38." (Identified only as a "noble Southerner," the unknown artist may well be Léger's Spanish colleague Picasso, who was indeed turning 38; Léger had begun exhibiting with Braque and Picasso as early as 1910, but their paths diverged.)

Rosenberg had a gallery on rue de la Beaune in Paris. In a brief listing of their financial dealings, Léger writes an accounting that he has sold ten paintings—including paintings and drawings of clowns, factories, and circus scenes, adding up to a total of "three thousand, two hundred and seventy francs," but has received only 500 francs as a deposit.

The second letter in the collection contains the thoughts of a more serious and mature artist. It would be hard to find an artist's letter more revealing of aesthetic ideas and attitudes than Léger's 1955 communication with Roger Christe, who was arranging a commission for the artist to decorate a small church in Courfaivre, Switzerland. The idea had been proposed by a distinguished priest named Father Couturier, who had become a patron of contemporary art, and had previously invited Léger to decorate a church in Assy.

In this long and thoughtful letter, Léger, one of the great figures in twentieth century art and a seminal modernist, discusses the meaning of abstract art, his concept of art in relation to architecture, "liberated color," and its success in media other than easel painting. While best known as a painter and muralist, Léger also worked in mosaics, stained glass, ceramic reliefs, and tapestry design; he believed in a fusion of art and architectural design. This is a remarkably generous and explanatory letter, indicating Léger's unusually intellectual approach to his art, and his willingness to extend his talents in different directions.

Though Léger was openly not a man of faith, he remarks that in the past he has always found working with Father Couturier agreeable, and that the priest understood perfectly well that the artist's collaboration on an ecclesiastical commission was to him simply like creating art for any public building. "While such a position is open to criticism," he adds, "that is how it is." Léger, who made no secret of his left-wing political leanings, was painting large pro-

letariat figures in the fifties. And despite his political activities (including attending the Communist Front Peace Congress in Poland a few years before), he saw no conflict between his political beliefs and working with religious symbols. Just the year before this commission he had written, "I was not double-faced. For me it was not an evasion to glorify sacred symbols...or to make my subject Christ's passion. I am perfectly sound and healthy; my spirit has no need of crutches. It was quite simply that I was given an unhoped-for opportunity to decorate vast surfaces, following my own artistic ideals."

What he seeks most of all is the "freedom that is completely new to the painting of a subject" to use color and design as he wishes. Today the stained glass windows at the little church in Courfaivre are a notable attraction.

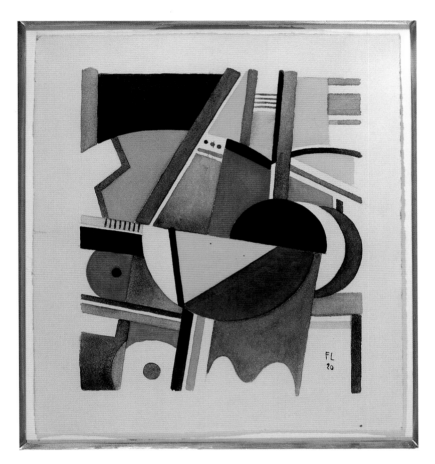

Abstract, 1922, gouache by Fernand Leger. © private collection.

Graphology notes on Fernand Léger

This artists relates well to others and can be very sympathetic to their needs.
He is a logical and methodical thinker with strong analytical skills.
He is very decisive and can take the initiative, but with caution.
He is open-minded to new ideas and is usually optimistic.
His goals are high, and his follow through is very strong.
His energy level is high, and it is reflected in his strong enthusiasm level.
He is a generous and sharing person.
He has wonderful line and color appreciation and works very well with his hands.
He has good attention to details and a consistent rhythm.
He is tenacious holding on to his values and beliefs.

André Dunoyer de Segonzac
Letter to Sam Salz in 1968

28 Juin 1968

13, RUE BONAPARTE. VI!

Mon cher Sam,

que devenez vous, après tous ces
évènements??

J'ai bien compris que vous
ayiez remis votre venue en Europe
à plus tard – et que votre voyage
du 22 Mai ait été reporté –
Paris a été très bouleversé et se
remet tout doucement –
A Saint-Tropez on n'a pas été
trop éprouvé – et j'ai pu rester
à travailler tranquillement –
Je suis rentré pour Voter –
Je ne pense pas quitter Chaville
et Paris cet été –

2/

Je me réjouis de vous voir
quand vous viendrez –
L'été va être très handicapé
par tout ce qui s'est passé en
Mai et début Juin 1968 –
Thérèse se joint à moi
pour vous dire nos très amicales
et affectueuses pensées –

A. Dunoyer de Segonzac

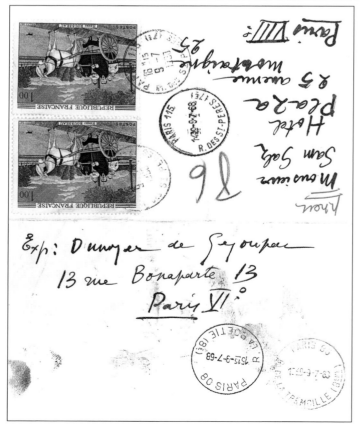

Exp: Dunoyer de Segonzac
13 rue Bonaparte 13
Paris VI°

Ed. note: Moving beyond a century of letters, these two notes from Segonzac interest us as they reveal yet again the gift of an artist to put aside world happenings and to continue to paint in his own style. Segonzac writes of the tumultuous events of '68 in France and shows how little the high drama affected his own cheerful canvasses. (See Introduction, pp. 11 and 12.)

28 juin 1968
Mon cher Sam,

Que devenez vous, après tous ces événements?

J'ai bien compris que vous aviez remis votre venue en Europe à plus tard—et que votre voyage du 22 mai ait été rapporté.

Paris a été très bouleversé et se remet tout doucement.

A Saint-Tropez on n'a pas été très éprouvé, et j'ai pu rester à travailler tranquillement.

Je suis rentré pour voter. Je ne pense pas quitter Chaville et Paris cet été.

Je me réjouis de vous voir quand vous viendrez.

L'été va être très handicapé par tout ce qui c'est passé en mai et début juin 1968.

Thérèse se joint à moi pour vous dire nos très amicales et affectueuses pensées.

A. Dunoyer de Segonzac

June 28, 1968
My dear Sam,

How are you, after all these events?

I understood well that you had postponed your coming to Europe—and that your May 22nd date of travel was put off until later.

Paris was very shaken and is recovering very slowly.

We did not suffer much in St. Tropez, and I was able to keep working quietly.

I came back to vote. I don't think I'll be away from either Chaville or Paris this summer.

I look forward to seeing you when you come.

Summer will be very difficult after what happened in May and at the beginning of June, 1968.

Thérèse joins me in sending you friendly and affectionate regards.

A. Dunoyer de Segonzac

Letter to Sam Salz in 1968

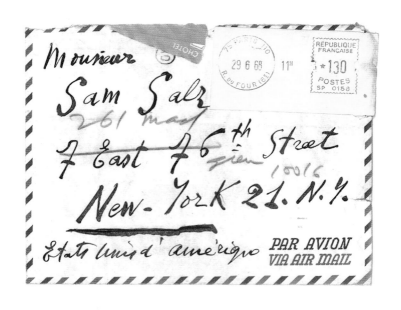

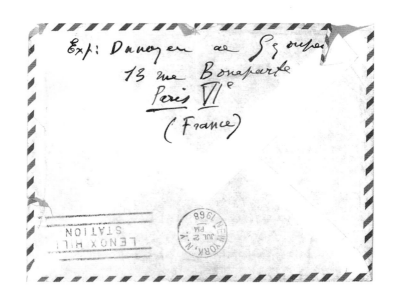

9 juillet 1968

Mon cher Sam—Je vous ferai porter demain mercredi 4 aquarelles et 2 dessins que j'ai choisiès—c'est mon petit porteur créole qui vous les apportera vers midi 1/2.

Je vous téléphonerai, et nous prendrons rendez-vous. A très bientôt.

Très affectueusement à vous,

André

––––––––––

July 9, 1968

My dear Sam—Tomorrow Wednesday I'll have 4 watercolors and 2 drawings that I chose myself brought to you. My young Creole will be the one to deliver them around 12:30.

I'll call you and we'll make a date. See you very soon.

Very affectionately yours,

André

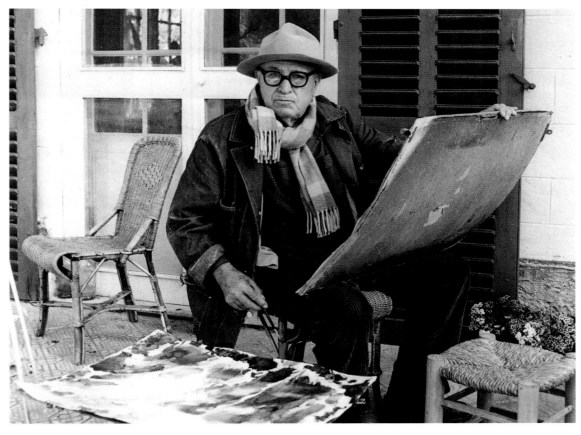

Photograph of André-Albert-Marie Dunoyer de Segonzac.
© Collection Viollet, Paris.

André Dunoyer de Segonzac (1884-1974)

In these two letters to his American dealer, Sam Salz, the French painter André Dunoyer de Segonzac indicates a pleasant, friendly relationship, unlike those of so many artists with their dealers. The artist seems to have felt warmly toward the long-time Madison Avenue gallery owner, Salz, who postponed one trip due to the 1968 upheaval in Paris, then came later to collect more of his works. Indeed, although Dunoyer de Segonzac is quoted by the dealer René Gimpel as saying "it's a frightful thing for an artist to have a dealer; it's horrible to have someone pushing you to produce at any cost." He is apparently on very good terms with Salz. (In fact, Segonzac hardly needed to be pushed to create; he was noted for producing as many as fifty drawings in two months.)

Segonzac was a landscape and figure painter who began painting just as modernism took hold in Paris. But he was quite independent of the major art movements of his time. Rejecting the brilliant colors of the Fauves or the angular abstractions of the Cubists, he painted in muted, harmonious tones, employing forms that suggested Northern classicism. His style, developed in the first decades of the twentieth century, was expressive, and it remained unchanged throughout his career. Beautiful line was especially important to him, as is evident from his hundreds of drawings and many engravings (over 2000 of them). Though he worked with many different subjects, it was for his capturing of the moods and forces of nature and the forms of landscape that he was particularly admired.

Though he remained outside of the ever-changing Parisian art movements, he nonetheless had a very satisfactory career, exhibiting widely and enjoying close relationships with other artists. He contributed copperplate engravings to numerous books. His works were regularly shown in France in the company of such painters as Matisse and Derain, and he was invited to be a juror for the prestigious Carnegie Prize in the United States. His work was not universally admired, however; Picasso is known to have called one of his paintings "provincial band music." Segonzac did not make his home in Paris but spent a good deal of time in St. Tropez in the south of France.

In the spring of 1968 Paris was in turmoil. The first of these two letters is dated June 28. Segonzac notes that Salz has put off his original plan to arrive in Paris in May, and says that "Paris was very shaken and is recovering slowly." The events of May, 1968 had begun as a student revolt to reform the universities, but they triggered a massive general strike, and with both students and workers moving against the government. De Gaulle's government, style, and policies were severely threatened. Polarization between the various revolutionary factors eventually brought the crisis to an end, and Gaullist law and order were reaffirmed in parliamentary elections at the end of June. Paris, though, had been severely unsettled by the near revolution. Segonzac, who had been living in St Tropez, returned to vote, finding Paris "seriously shaken up."

Salz did arrive some weeks later. By July 9th he was staying at the Hotel Plaza on the Avenue Montaigne in Paris, when the artist writes another letter to Salz, now in Paris, sending him new work at his hotel and suggesting they make a date.

Provençal Still Life, by André Dunoyer de Segonzac. © Visual Arts Library/Art Resource, New York.

Graphology notes on Andrè Dunoyer de Segonzac

This artist is a fast and comprehensive thinker. He picks up new information rapidly.

He is enthusiastic and optimistic. These traits are bound to inspire others.

He appears to have trouble dealing with stressful situations. Problems and pressures stay with him for some time and will affect his personality. Others will feel the affects of his stress.

He is not always frank within himself and therefore not always straightforward with others. He tends to rationalize unpleasantness away instead of facing it.

He moves quickly with a boundless energy.

He is decisive but will yield to others if they make sense to him. This adds to his flexibility.

He expresses himself well on paper.

Index

Patmos, Summer in Greece, 1995, pastel on paper, by Pierre Simon.